Red Scare

The making of
Tobe Hooper's *I'm Dangerous Tonight*

by
Stan Giesea

Library of Congress Cataloging-in-Publication Data

Giesea, Stan, Red Scare: The making of Tobe Hooper's *I'm Dangerous Tonight,* movies, film production, entertainment

Summary: A chronicle of the making of the USA TV movie *I'm Dangerous Tonight,* directed by Tobe Hooper and starring Mädchen Amick and Anthony Perkins

ISBN: 978-1-387-77655-9
Imprint: Lulu.com

Published by Murietta Press, Sherman Oaks, California
Copyright 2022 Stan Giesea

Cover art by Patrick Horvath

All rights reserved under International and Pan-American Copyright Conventions. By payment of the required fees, you have been granted the non-exclusive, non-transferable right to access and read this book on-screen or in print. No part of this text may be reproduced, transmitted, downloaded, decompiled, reverse-engineered, or stored in or introduced into any information storage and retrieval system, in any form or by any means, whether electronic or mechanical, now known or hereinafter invented, without the express written permission of Stan Giesea. For information regarding permission, write to Loopypow@gmail.com.

First edition July 2022

dedicated to the memory of
Tobe Hooper

Table of Contents

INTRODUCTION: *DANGEROUS DAYS* i
FOREWORD: *SOURCE MATERIAL* vi
ONE: *PINS AND NEEDLES* 1
TWO: *OUT FIT* 16
THREE: *IVY LEAGUE TWEED* 26
FOUR: *WHOLE CLOTH* 37
FIVE: *A TANGLED WEB* 48
SIX: *SATIN DOLL* 56
SEVEN: *HOUND'S TOOTH* 70
EIGHT: *GIVE 'EM THE SLIP* 79
NINE: *LOOSE THREADS* 86
TEN: *NIGHT GOWN* 92
ELEVEN: *SPINNING WHEEL* 99
TWELVE: *HAND-ME-DOWNS* 115
THIRTEEN: *SEW AND SEW* 123
FOURTEEN: *APART AT THE SEAMS* 130
FIFTEEN: *DRESS FOR SUCCESS* 139
SIXTEEN: *KNITTED BROW* 150
SEVENTEEN: *BOBBIN' AND WEAVIN'* 158
EIGHTEEN: *ATTIRE BURN* 167
NINETEEN: *PATCHWORK* 183
AFTERWORD: *ALL DOLLED UP AND NO PLACE TO GO* . .
. ix
APPENDIX 1: *CREDITS* xiii
APPENDIX 2: *CROODOODLES* xvii

INTRODUCTION

DANGEROUS DAYS

Wars were fought on TV and ratings were excellent, punk rock was going permanently off the cultural radar, most of the dangerous authors were dying or dead, and horror was losing its ability to shock. The early 90s probably looked like the start of a draught, the end of a mainstream with patience for the politically subversive, for degenerates in blood-stained shirts. Kurt Cobain would be gone before the spectrum of his intimate radicalism had been analyzed or understood. Things would turn around when the left had another enemy worth fighting, but by then the scales had been weighted, each crisis serving up a culture ill-equipped to combat a complacent citizenry.

In Vietnam, America invents its own class of gore movie and psychedelic rock, both of which find their apotheosis in the blistering sound design of the blood caked *The Texas Chain Saw Massacre* by a young Texan documentarian named Tobe Hooper. In the 80s, as Ronald Reagan and George W. Bush wage clandestine war on everyone who looks at fascism askance, horror movies start indiscriminately slaughtering party girls and beer-swilling guys as punk and hair metal become the bullhorn for the outraged and outnumbered. In the 2000s, horror gets even nastier and metal subgenres replicate like a germ culture. None of these things work and people start to think that maybe there's a more

form of resistance for more polite times.

Then Donald Trump is elected and American art spins in place like a haunted carousel. Horror becomes about trauma, something you can't fix or fight. It's a bespoke suit young chic artists try on for an Instagram picture before throwing it back where they found it. One clue that most missed that we were headed to a place of toothless nightmares and unsparing, unyielding terror in our waking lives (plague, American police like an army dispatched against the people, rights, and protections for the vulnerable ripped out of the Constitution) can be found in a forgotten dispatch from the wing of the ICU in which horror films found themselves as the 80s became the 90s. John Carpenter and George Romero go from household names to niche specialists who couldn't find willing buyers with a flashlight. Every great slasher director is run out of town or forced into the straight jacket of 90s studio filmmaking. Wes Craven strikes gold when he makes horror overtly about itself rather than about the culture producing it and the genre never recovers. And Tobe Hooper, the maverick hellion who changed horror forever with *Texas Chain Saw*? He was working for the USA Network because he wasn't viewed as an artist in need of freedom and patronage but rather, a hired gun.

The elegant form of 1990's *I'm Dangerous Tonight* will only surprise people who believe the Pauline Kael version of the Tobe Hooper story, and I mean that in two ways. Kael tried to take credit from Orson Welles on *Citizen Kane* to give to his collaborators, which relies on the assumption that Welles never made another movie as good as Kane again, which was never true. Kael also, in reviewing *Poltergeist* joined the wave of writers who credited all the film's personality to writer/producer Steven Spielberg. Kael wasn't even down on horror, she liked *Re-Animator* and *The Stepfather*, but the line on Hooper was whatever talent he possessed when making *The Texas Chain Saw*

Massacre was too pervasive to be combatted. How do you fight a lie written a thousand times? At that point it's just the truth locked in a cage with no key. Hooper became a director for hire, and though he spoke warmly about having the opportunities he had - for all his movies' abrasive commentary on life in "God's country," he was a sweetheart, eager and happy to be nice to one and all - there's no denying that in America he was following one kind of career path and it wasn't the one the powers that be allowed "artists" to follow. Woody Allen never "had" to work for TV.

And still, denied the life of an artist, the art kept coming. Some of Hooper's most expressive work came during his years working for the small screen, from his Welles-inspired episode of *Tales From the Crypt* to his Mario Bava influenced pilot for Craven's TV program *Freddy's Nightmares*, but the best of the best was *I'm Dangerous Tonight*. Mädchen Amick, one of the venomous sirens of *Twin Peaks*, an old school movie star, 1000-watt charisma and Rita Hayworth good looks carried like a record store employee holding too much vinyl, plays a college student who comes in contact with an accursed shroud that brings out the demon in people. Try as she might, she can't escape it, because people want that power. They crave it. They want to be on top looking down, deciding who lives and dies, who exists for their pleasure and who doesn't. Amick's Amy touches it like the third rail and can't stand who she became. She's the only one who seems able to put it down.

Hooper directs with clarity, beautiful images of debauchery in a beatific college town, from Amy's stark appearance at a school function's chess board pattern dance floor between the monochrome drabness of every stuffed shirt and social climber in school to the murders captured like the memories of bad dreams. It's a movie about the kind of person Hooper refused to be, driven by the desire to have power. He may have remained one of the most elegant stylists in the American cinema throughout his

career, but his heart was always with the suffering, the dying, the forgotten, the forsaken. His films act like high tragedy, but the conflict couldn't be simpler. Power corrupts, get a taste and you'll be killing everyone who grabs for some. Like a Dead Kennedys song come to life, "Sliced with a machete, from the breast of our homeland, our new world tries to spit us out, but it sure beats the chicken farm."

Way back when, you had to hang out at a video store for a few minutes too long to find guys who'd cop to loving Hooper's brand of high formalism and higher body counts. Today you can find them online with ease, thank heaven, or in most cases, *they* find you. Stan Giesea found me when I was trying to publish my own book on Hooper, from the purely analytical side of things. He was a crucial resource during the editing process. Stan was luckier than I ever got; he'd met Tobe Hooper. He'd seen him work on more than one occasion. The enduring image of *Red Scare*, his instantly engrossing second volume written from one of Hooper's sets, is of the director of *I'm Dangerous Tonight* riding the dolly, like a mix of a cowboy and a punk drummer, holding onto the equipment with ease, playing the next song with care and concern. Legends pass by him every day and he and his crew have to squeeze into closets to shoot while better funded productions shoot just next door. Hooper the unwavering professional just getting the job done, open to the suggestions of a cast and crew of hugely varying experience, because he lived his philosophy. Everybody is worth hearing from, everybody is important. It was probably easy for the system to spit him out. As mean as a movie like *I'm Dangerous Tonight* can get, Hooper wasn't mean. He didn't have the killer instinct that kept some people on top, he didn't have the big personality that made him a perpetual talk show guest, didn't have his name above the title of most of his movies, and he didn't have it in him to say "fuck the system" in interviews. He never lied in his work, though. *I'm Dangerous*

Tonight is about the everyday fears that come with being a woman surrounded by men, full stop, but men who think they know you better than you do especially. Nice guy boyfriends concealing voracious appetites, condescending professors after immortality, police detectives with no imagination, young artists who take and take, people who don't see you in their future because they don't have to. The future is always theirs. Hooper shows what happens when you're given the fullness of confidence in that attitude. When you see no reason not to kill and abuse to get your way.

Now you can read about the painstaking everyday, the minutes that pass, the discussions that occur when creating something that hides a blistering core of anger inside a conventional shape. Anthony Perkins, the film's heel, talks with Hooper at one point in the book about trying to experiment visually as a director and how often the crews looked at him like he was crazy when he tried. The world will say "no" to artists because it can. Because the status quo is easier. It always is. The more we say "no" to risks, to art that challenges us, the harder the status quo becomes to beat and crack. American horror is in a bad way, few formal chances are taken, few original ideas get scripted, few movies not drenched in irony and nostalgia get in front of appreciative eyeballs. It's a posture, a secondhand leather jacket. Tobe Hooper meant it. And when people, critics, audiences, producers, curators, stopped believing him, we lost a battle for a better horror culture.

Step back in time and live through a few weeks in the life of the kind of artist we'll never see emerge again.

Scout Tafoya, author of *Cinemaphagy: On the Psychedelic Classical Form of Tobe Hooper*

FOREWORD

SOURCE MATERIAL

Cornell Woolrich (1903-1968) was a prolific writer of crime fiction perhaps best known for his 1942 short story, *It Had to Be Murder,* which formed the basis for Alfred Hitchcock's classic motion picture, *Rear Window*. Similarly, his novel *Black Alibi* was the source material for Jacques Tourneur's psychological thriller, *The Leopard Man*.

Woolrich's fiction was highly influential to the cinematic movement of the 1940s and 50s known as film noir. In fact, more noir films were adapted from the works of Woolrich than from any other writer, including such notables as Dashiell Hammett and Raymond Chandler.

Originally published in the 1927 issue of pulp magazine *All American Fiction*, Woolrich's novelette *I'm Dangerous Tonight* is a tawdry tale of a world-weary yet determined federal agent's attempts to capture and incarcerate his brother's murderer, but who is thwarted at every turn by the machinations of numerous femmes fatale operating under the malevolent influence of a mysterious red garment.

In 1989, producers and screenwriters Bruce Lansbury and Philip John Taylor adapted the story into a teleplay for the

then-fledgling USA Network, tossing out virtually everything but the central conceit of the enchanted crimson cloth while weaving in elements of various fairy tales and myths and updating it to the present day. Taylor was a successful television writer specializing in situation comedy, making his mark in shows such as *All in the Family* spin-off *Good Times* (1974-79), Don Rickles' short-lived series *CPO Sharkey* (1976-78), and as writer and story editor on cultural phenomenon *Mork & Mindy* (1978-82), starring the then-unknown stand-up comedian Robin Williams, as well as a slew of others. Lansbury cut his teeth as a producer in 1960s TV series *The Wild, Wild West*, continuing through the 70s and 80s with *Wonder Woman*, *Buck Rogers*, and perhaps most notably, *Murder, She Wrote*, starring his sister, acclaimed actress Angela Lansbury.

To direct, Lansbury and Taylor enlisted filmmaker Tobe Hooper. Hooper's reputation as a genre stylist preceded him, his name having been thrust into the public consciousness in 1974 by the phenomenal success of *The Texas Chain Saw Massacre*, a still shocking film of black humor relentless terror. While principally a director of feature films, Hooper had previously had one of his greatest critical successes with his 1979 television adaptation of Stephen King's novel, *Salem's Lot*. Since then, he had periodically ventured into episodic television, directing episodes of Steven Spielberg's *Amazing Stories*, *The Equalizer*, and the short-lived *A Nightmare on Elm Street* spin-off, *Freddy's Nightmares*, so he was well up to the task of bringing the fantasy thriller *I'm Dangerous Tonight* to the small screen.

Hooper's eclectic cast ran the gamut from screen icons to fresh-faced newcomers; Mädchen Amick, the strikingly beautiful young actress from David Lynch's *Twin Peaks*, R. Lee Ermey, unforgettable as the iconic D.I. from Stanley Kubrick's superlative existential meditation on war, *Full Metal Jacket*, Natalie Schafer, the fabulously wealthy Mrs. Howell from the

inexplicably popular 1960s sitcom *Gilligan's Island*, and Norman Bates himself, Anthony Perkins, along with a cadre of recognizable supporting players.

As with virtually any production, the making of *I'm Dangerous Tonight* is the story of long days and nights, creative clashes, happy accidents, a cast and crew of idiosyncratic characters, and a seemingly endless litany of show-biz anecdotes; with the resulting film turning out to be an alternately charming and unsettling modern-day fable of puppy love and uncontrollable desire.

The following is a casual chronicle of events occurring from April 23rd, 1990, to May 16th, 1990, during the filming of Tobe Hooper's *I'm Dangerous Tonight* in and around Los Angeles. No names have been changed to protect the innocent, as no one is entirely innocent.

ONE

PINS AND NEEDLES

Monday, April 23, 1990

Shooting begins on Tobe Hooper's *I'm Dangerous Tonight* on the grounds of the University of California at Los Angeles (UCLA), a sprawling campus of grassy hills and neo-classical architecture.

Assembled at the rear loading dock of Royce Hall, the historic site of innumerable musical, academic, literary, and theatrical performances over the decades (and perhaps UCLA's most famous building, having been among the first erected on the Westwood campus in the 1920s), the crew sets up for the first shot of the day and the first shot of the production.

Scene 27: Amy, a pretty young co-ed, arrives at the back of the theatre with a crusty old trunk strapped in the hatchback of her car. She has been cajoled into gathering props for the college's production of *Romeo and Juliet* by the snooty student director and has stumbled on the ruddy hope chest at a local estate sale. At the bottom of the trunk lies a mysterious, silky red garment.

Mädchen Amick, not only a wonderful actress but also an accomplished musician and dancer (not to mention being stunningly beautiful), plays Amy. After a few incidental television appearances (*Star Trek: The Next Generation, Baywatch*), she was discovered by iconoclastic filmmaker David Lynch and cast as Shelley the waitress in his groundbreaking TV series *Twin Peaks*.

The first set-up is a relatively simple dolly shot. Amy pulls her car up to the loading dock, gets out and regards the chest with some apprehension as the camera moves into a slow close-up on the old relic.

Director of photography (DP) Levie Isaacks and his team, 1st assistant cameraman (AC) Wayne Trimble and 2nd assistant cameraman Bill Roberts, make short work of the shot and capture Mädchen's quiet moment of hesitation quickly and professionally. Isaacks was also the DP on Hooper's recently completed feature film *Spontaneous Combustion*, has been a friend and colleague of Tobe's since their days together in Austin, Texas, and is as friendly and unassuming a man as you could care to meet. (It's a little-known fact that Levie, a news reporter at the time, is the deceptively calm voice of the radio announcer in Hooper's *The Texas Chainsaw Massacre*.)

Once the shot is in the can, the grip crew breaks down the equipment and prepares to move the company to the campus quadrangle for the next scene, which continues to the colonnade of Royce Hall.

Scene 19: Amy and Eddie cross the quad toward the theater. Eddie is an energetic political science major who seems to have bitten off more than he can chew, academically speaking. He and Amy have serendipitously been chosen as partners on a research project for their shared psychology class, and Eddie smoothly manipulates Amy into volunteering to do the lion's share. Not having yet learned his lines for the role of Mercutio, he slyly wheedles Amy into taking on the responsibilities of property mistress for the production of *Romeo and Juliet*.

Corey Parker gained some notoriety acting opposite Matthew Broderick in director Mike Nichols' acclaimed film adaptation of Neil Simon's autobiographical play *Biloxi Blues*. As nebbishy Arnold Epstein, Parker proved to be a natural born scene-stealer. In the role of Eddie in *I'm Dangerous Tonight*, he gets the

opportunity to play an apparently charming and confident young man who turns out to have a seething darkness festering inside him.

The grips have laid dolly tracks along the length of the exterior corridor outside Royce Hall under the supervision of key grip Michael Colwell. Michael is an affable fellow who approaches every task with great good humor. Colwell is the son of noted cinematographer Chuck Colwell (*The Terminator, Near Dark*) and is fond of saying that he literally grew up on film sets.[1]

Director Hooper has devised an efficient and economical way to capture the scene. The gliding dolly follows Mädchen and Corey as they stroll across the quad, chatting. The camera watches their progress through the passing columns of the portico, coming to a gradual stop as they ascend the shallow brick steps to the building's entrance. It's a lovely and uncomplicated shot that Isaacks and his team pull off with ease.

Stuart Fratkin plays Victor, the unctuous and manipulative student director. As a young actor, Stuart has made the rounds in Hollywood, taking on small roles in various genre TV series (*Alien Nation, Quantum Leap*, and also, interestingly, appearing in an episode of *Freddy's Nightmares*, for which Hooper directed the pilot episode). Fratkin is also recognizable from his role as Stiles in the 1987 comedy/horror film *Teen Wolf Too* (replacing Jerry Levine from the original). His prickly demeanor is perfect for the role.

The scene continues briefly at the entrance to the theater. On an easel in the background, a large hand-painted wooden poster announces:

[1] It should be noted that, although they never met at the time, both Michael Colwell and the author worked on *Lambada*, a truly awful film, a cynical effort designed to cash-in on the ludicrous dance craze of 1990.

The Tiverton Players

presents
ROMEO & JULIET
Directed by Victor Morrison[2]

Fratkin plays the young director with an air of smug superiority, but still manages to make the character somewhat likeable. Victor's bright yellow turtleneck, however, speaks volumes about his high opinion of himself, and his blithely misnaming Amy as "Annie" is an amusing and telling example of his oblivious self-absorption.

With the camera mounted on a tripod for stability, the young cast comport themselves well while shooting the required two-shots and close-ups, and the scene is neatly wrapped within a matter of minutes.

When Hooper calls "Cut!" on the last shot of the morning, the cast and crew regroup onstage in the luxurious interior of Royce Hall.

Established in 1929 and designed by the architectural firm of Allison & Allison (brothers James Edward Allison and David Clark Allison), Royce Hall's twin-towered façade is perhaps UCLA's defining image. Originally intended as an auditorium for lectures and speeches, through successive remodeling over the decades it became a renowned venue for concerts and theatrical performances. The theater's 1800 seats are lushly appointed, and the intricate coffered ceilings are not only strikingly spectacular

[2]Incidentally, the *ROMEO & JULIET* poster was claimed by still photographer Eric Lasher, and it hung in the living room of his home for decades before crumbling away due to the vicissitudes of time and exposure to the elements.

but also acoustically sound.

Its rich history includes musical performances by the likes of George Gershwin, Leonard Bernstein, Benny Goodman and Ella Fitzgerald, as well as appearances by speakers Albert Einstein and John F. Kennedy. Royce Hall was also the primary home of the California Chamber Symphony, which mounted over 100 concerts, including premieres of major works by such luminaries as composers Aaron Copeland and Dmitri Shostakovich. More recently, actor Patrick Stewart (who coincidentally appears as the unfortunate Dr. Armstrong in Hooper's film *Lifeforce*) gave a literary reading of scenes from Shakespeare's plays, and the Los Angeles Philharmonic recorded performances of Sergei Prokofiev's *Symphony #1* and *Symphony #5*.

There are many ghosts onstage where the company of *I'm Dangerous Tonight* has assembled to rehearse the next scene, which includes a violent swordfight between characters from William Shakespeare's *Romeo and Juliet*.[3]

The clang of metal-on-metal echoes through Royce Hall's cavernous interior as the cast rehearses for the upcoming scene.

Scene 29: Eddie and his fellow cast members rehearse Mercutio's confrontation with Tybalt, which culminates in a brutal rapier battle, leaving Tybalt mortally wounded. As they choreograph the fight, Amy arrives backstage with the old trunk from Jonas Wilson's posthumous yard sale. Taking a brief break, Eddie and Victor amble over to admire Amy's fortuitous acquisition. Impulsively, Eddie opens the trunk and discovers the vibrant red cloak lingering at the bottom. At Victor's urging, Eddie drapes the cloak over his shoulders like a cape. Suddenly overcome with a powerful feeling of euphoria, Eddie insists on

[3]In 1994, as a result of damages caused by the calamitous Northridge earthquake (which measured a whopping 6.7 on the Richter scale), Royce Hall underwent extensive renovation.

rehearsing the swordfight immediately. The stagecraft of fencing, however, becomes frighteningly real as Eddie uncharacteristically loses all control, furiously slashing his rapier at everyone around him and actually drawing blood from the shocked young actor playing Tybalt.

Stunt coordinator John Moio, a rugged man with matinee-idol good looks, watches closely as Corey and his fellow actors (Bill Madden[4] as Tybalt and Ivan Gueron as Romeo) rehearse his fight choreography. Moio has had a long and storied career as a stunt performer and coordinator (*Motel Hell*, *The Howling*, *Escape from New York*, going as far back as Peter Bogdanovich's 1972 screwball comedy *What's Up, Doc?*) and has worked with director Tobe Hooper previously on his 1986 sequel *The Texas Chainsaw Massacre, Part 2*. The young men perform the fight at roughly half-speed, with Moio occasionally stepping in to demonstrate or to make an adjustment for safety. While the tips of the rapiers being used are snubbed, there is always the potential for an injury to occur, and safety is the chief concern.

Meanwhile, mustachioed DP Levie Isaacks and his assistant cameramen, Wayne Trimble (1st AC) and Bill Roberts (2nd AC), rehearse the camera movement for the first shot, in which the

The strengthened structural systems and reconfigured sidewalls of the auditorium improved the theater's acoustics and new skylights in the gallery restored natural light to the now brightly illuminated ceiling. Royce Hall has since continued to be a premiere setting for the performing arts, hosting over the years performances by Philip Glass (with his orchestra performing the score to the acclaimed film *Koyaanisqatsi* live as the motion picture is projected onscreen), eccentric filmmakers John Waters and Werner Herzog, and Ian McKellen's highly regarded stage production of *King Lear*, among many, many others.

antique trunk is brought into the theater. The lens focuses on the trunk and dollies back and around as two college boys carry it in and set it on the stage floor, with Mädchen following close behind. As the camera swivels, the fight rehearsal is seen in the background.

Presiding over the barely controlled chaos is 1st assistant director Tom Blank, a veteran of numerous TV series (*The Bionic Woman*, *Murder, She Wrote*), and whose quiet authority manages to keep things rolling along without ever so much as raising his voice.

While waiting for the crew to complete their preparations for the upcoming shots, Corey sits in the first row of the auditorium, thoughtfully studying his script.

Hooper prowls the stage, ubiquitous can of Dr. Pepper in hand, touching base with all the department heads, conferring with Isaacks and Moio about the series of shots on the day's roster, and finally settling into his director's chair to examine his notes for the upcoming scene before the company breaks for lunch.

Grip Marcus "Roo" Flower (also a veteran of Hooper's *Spontaneous Combustion*) regales his fellow crew members with his vulgar rendition of the song "Try to Remember" from the classic Off-Broadway musical *The Fantasticks*, singing:

> "Try to remember,
> The size of my member,
> And swallow,
> Swallow, swallow, swallow . . ."

[4]Incorrectly identified as "Xavier Barquet" in the film's credits. Previously, Madden had also applied his rapier-wielding skills in such films as Peter Medak's *Zorro, the Gay Blade* (1981) and later Mel Brook's parody misfire *Robin Hood: Men in Tights* (1993).

Roo is a husky and garrulous young man with an unruly mop of blond hair and a rakish sense of humor, always quick to laugh and even quicker to show off his ample belly.[5]

After lunch, the company reconvenes beneath the proscenium stage. Still situated on the dolly, the camera now faces the auditorium in order to shoot the stage fight. The shot begins with Corey and Stuart in a close two-shot, standing above the antique chest. Corey retrieves the cloak from the chest as Stuart says admiringly, "Try it on. It's got 'Mercutio' written all over it." Corey wraps the cloak loosely around his neck like a cape, and practically growls with new-found enthusiasm. He snatches his foil from Stuart's hand and eagerly heads toward center stage, insisting, "Let's do the fight!"[6]

What had been a rather lackluster rehearsal quickly turns deadly as Corey's character surrenders to the influence of the cloak and viciously assaults his acting partners. Seemingly possessed, he whips the air with his sword and lunges ferociously at Tybalt as the crimson cape swirls around his body like liquid metal.

Victor's ineffectual cries of "Enough's enough! That's enough, for God's sake, Eddie!" go unheeded by the wild-eyed Eddie as he savagely hacks and slices at his unwitting victim.

"Cut!" shouts Hooper as Corey forces Bill Madden (clad in grey sweatpants and a "Tiverton University" sweatshirt) onto the thrust stage and leaps down after him, "Okay, good. Great!"

"Were we rolling?" asks Mädchen from her position beside the dolly. "Yep," chuckles an unidentified voice from behind the camera.

[5]Roo's father is George "Buck" Flower, noted character actor probably best known for his role as the Bum in Robert Zemeckis' *Back to the Future* films, but who has over 100 movies to his credit. Interestingly, Flower also played the voice of the evangelical radio preacher in *Spontaneous Combustion* as well.

After speaking briefly with DP Levie Isaacks, Hooper instructs script supervisor Sandy Mazzola to print the take, and they move on to the next set-up. The shot consists of just the brief prelude to the fight scene. As Corey takes the cloak from the antique trunk and tries it on for size, the camera smoothly dollies into a low close-up.

Between takes, Hooper sidles up beside Corey for a quick, whispered conversation. Corey listens intently, nodding almost imperceptibly. On the next take, he is noticeably less garrulous as he dons the cloak. In fact, the entire scene has become more natural; conversational rather than theatrical.

The next set-up is a tight shot looking down into the trunk as Eddie removes the cloak. Tobe demonstrates the action for Levie in preparation for setting the shot. He slowly opens the lid to reveal the cape nestled at the bottom of the trunk and reaches in to retrieve it.

Still on the dolly, the camera is rolled into position, lens pointed directly downward into the trunk. Tobe takes a seat on the dolly and checks the shot through the viewfinder while the crew mulls around. Pleased with the composition, and being the hands-on director that he is, Tobe kneels and arranges the red satin material at the bottom of the trunk to his satisfaction.

1st AD Tom Blank announces that the shot is "<u>not</u> MOS[7]," meaning that they are recording live sound, so it is very quiet in

[6]The caped, swashbuckling character of Mercutio presents Eddie as a kind of "Prince Charming," one of many allusions to Grimm's Fairy Tales to be found in the screenplay. Incidentally, producer/co-screenwriter Philip John Taylor had studied acting at London's Royal Academy of Dramatic Arts (RADA) alongside future James Bond Timothy Dalton and actually understudied the role of Mercutio with international touring company The Bristol Old Vic before later joining the Royal Shakespeare Company (RSC).

the theater's vast confines as the camera rolls on the first take.

Corey stands to the side, rapier in hand, as he waits for his cue. 2nd AC Bill Roberts slates the shot. Tobe whispers, "Go," and Corey steps up to the trunk, hesitantly opens the lid and slowly draws the silken cloth out, draping it across his body. "Cut!" says Tobe, and the stage is suddenly abuzz with conversation.

Levie pipes up, "Yeah, I didn't like the . . ." Tobe interrupts, "Yeah, uh, let me, let me try something, though," and moves in to readjust the trunk. "Again!" shouts Tom.

On the second take, Corey raises the cloak across the camera lens before clutching it tightly to his chest. "Cut!" Levie speaks again, "Now, I could have sworn I saw the . . . shadow of a sword there . . ." "Uh, yeah," says Tobe dryly, "He's holding a sword." And the whole crew erupts with laughter.

"That's fine?" Tom asks Tobe. "Yeah, that's fine," says Tobe, and he instructs script supervisor Sandy Mazzola to print the take. Meanwhile, Tom advises Levie that the next set-up will be Corey's close-ups for the fight scene.

The camera is placed "on sticks" (essentially a sturdy tripod) for the next series of shots. Tobe, Levie, and Tom watch intently as Corey and Bill Madden once again rehearse Mercutio's taunting of Tybalt, which degenerates into real violence as Eddie loses control. They perform the fight first at half-speed for the benefit of the camera crew. Once the shot is set, the rest of the cast is called to the stage to shoot.

Production photographer Eric Lasher has a brief, friendly conversation with a photographer from the USA Network, who has been sent over to shoot some promotional stills for the cable outlet. (*I'm Dangerous Tonight* is the network's first foray into feature filmmaking, and they evidently want to use the occasion to promote future projects.) Lasher welcomes him to the set and

[7]Minus Optical Stripe.

assures him that there will be no contention or competition between them. They both have jobs to do and both are free to perform their respective tasks.

With his trademark ponytail, Lasher is another member of director Tobe Hooper's repertory crew, having first worked with him on *Invaders from Mars*, his retro-remake of William Cameron Menzies' classic science-fiction film of adolescence and dread. He was subsequently enlisted as photographer on *The Texas Chainsaw Massacre, Part 2*, the pilot to the short-lived TV series *Freddy's Nightmares*, and *Spontaneous Combustion*, Hooper's ill-fated meditation on the horror and persistence of the Cold War mentality in post-modern America.

"All right, get ready! Stand by. *Watching*." Tom's gentle baritone echoes through the theater, quieting the crew and focusing their attention on the scene.

On Hooper's call of "Action!" Corey lunges at Bill, knocking the sword from his hand and brazenly swiping at his shoulders and cheeks with his own rapier. Bill recoils from each strike as if wounded. Corey fends off the protests of the other actors with crazed swipes of his foil. Glaring wild-eyed at Bill, he points to the fallen sword and insists, "Pick it up!" Reluctantly, Bill takes up his sword again, raising it above his head just in time to defend against Corey's sudden vicious assault, which forces him off his feet and sends him thudding heavily to the floor. "Cut!"

Levie compliments Bill on his convincing reactions to being sliced across the arms and face. "Looks real."

There is a lot of activity between takes. 1st AC Wayne Trimble measures and re-measures the distance between the camera lens and the action in order to calibrate the focus, make-up artist Emily Katz and hair stylist Nina Paskowitz hurriedly touch up the actors, the grip crew tweaks the lighting set-up at gaffer Robert Moreno's instruction (Moreno had previously worked as the 2nd unit lighting director on Hooper's film *Spontaneous Combustion*, but has been

elevated to gaffer for this assignment), and Hooper speaks briefly with Stuart about his placement in the frame and his spatial relationship to the camera. In fact, the energetic director is constantly in motion between takes, instructing the actors, conferring with the crew, adjusting props, etc. But when the camera rolls, he watches the action with fierce intensity, as still and silent as a sphinx.

When the wider shot of the swordfight is "in the can,"[8] they move on to the close-up on Bill, as Tybalt, having his cheeks scarred by the tip of Romeo's blade. The foil is wielded by John Moio's assistant stunt coordinator, an unimposing fellow sporting a sweatshirt emblazoned with the phrase, "I'M <u>ALL</u> FOR HALF-NELSON."

Before they roll, the assistant makeup artist, a Ms. Yonkers, spritzes Bill's face with glycerine to make him appear beaded with sweat. Tobe calls "Action!" and Bill winces as the stuntman makes two quick swipes across his cheeks with the bloodied tip of the rapier. After the second take, Levie observes that Bill somewhat anticipated the second stroke. 1st AD Tom offers that they can simply "overlap" the two takes between cuts, eliminating the need for another take and allowing them to move on, a time-saving suggestion to which Tobe readily agrees.

A second camera ("B-camera") is mounted atop a tall ladder for the next shot, in which Eddie forces Tybalt off the thrust stage and into the auditorium with a fusillade of brutal sword blows as the malevolent red cape billows behind him. Corey and Bill rehearse repeatedly with John Moio as Tobe and the crew prepare. After a particularly good rehearsal, with the cameras, of course, not rolling, Moio turns to Levie with a chuckle and asks, "Did you get that?"

[8]Movie parlance for "finished," referring to the film having been exposed in the canister and the shot completed.

Tobe ascends the ladder to peer through the B-camera lens and check the frame. With the shot set, he calls for a rehearsal at half-speed so that both cameras can initially follow the action more smoothly. All this rehearsal proves advantageous, as they manage to capture the shot in one excellent take.

The next shot is to be hand-held, so 1st AC Wayne assists Levie in hoisting the camera onto his shoulder. From behind Corey, essentially from his point of view (POV), the camera looks down upon Bill as he cowers from Corey's threatening countenance.

In this sequence, Eddie looms over the student actor playing Tybalt, the tip of his foil a fraction of an inch from his eyeball, coldly intoning, "So you lose one. You still have one more." As Eddie draws back his arm to strike, the red cloak falls from his shoulders, breaking the spell and leaving him bleary and disoriented. Only one take is necessary, and they quickly move on to the next shot.

Levie kneels in the aisle and once again takes the camera onto his shoulder for Bill's close-up, sprawled over a theater seat with the tip of the weapon hovering perilously close to his eye. Once again, although the tip of the foil is snubbed, it's still potentially dangerous, so it is the assistant stunt coordinator, rather than Corey, that handles the rapier in the shot. Bill's eyes widen and he trembles convincingly as the tip of the sword advances steadily toward his naked retina. Fortunately, the shot comes off without a hitch.

Meanwhile, onstage, costume designer Carin Hooper and wardrobe supervisor Julia Gombert are doing a fitting with Mädchen, now wearing the alluring blood-red dress which, according to the script, the evil cloak will ultimately be transformed into.

One of Carin's early efforts was 1982's *The Last American Virgin*, a silly teen sex comedy written and directed by Boaz Davidson (who would later serve as Tobe Hooper's liaison with

Cannon Films). Since then, she has been costume designer on several of Hooper's projects, including *Lifeforce*, *Invaders from Mars*, and *Spontaneous Combustion*. Her design skills are especially applicable to this film, considering the importance of the "killer" red dress to the plot. Carin is also, not incidentally, Hooper's wife.[9] She and Hooper had met through screenwriter/director Dan O'Bannon at the time that Hooper was slated to direct O'Bannon's script for *Return of the Living Dead* (but which duties he was forced to relinquish to O'Bannon due to scheduling conflicts with *Lifeforce*). Their first collaboration was British Rockabilly star Billy Idol's music video *Dancing with Myself*, on which Hooper also reunited with cinematographer Daniel Pearl, who had photographed Hooper's breakthrough film *The Texas Chain Saw Massacre* and also went on to shoot *Invaders from Mars*.

Corey and the other "student actors" return to the stage, ready to shoot a reverse angle of the climax of the swordfight. Mädchen, featured in the background, has changed out of the scorching red dress and back into her far more modest wardrobe of charcoal-grey slacks and warm yellow sweater.

Maybe to save time or possibly to add some dynamics to the scene, Levie continues to shoot hand-held, following the action spontaneously. Having been well-rehearsed over the course of the day, the performers hit their marks and the shots are accomplished with efficiency and relative speed.

Tobe gathers the cast and blocks the end of the sequence, in which Eddie lapses back to normal and is banished from the play. The choreography is slightly complicated; Tybalt bounds from his seat and angrily warns Eddie, "Keep away from me, man!" as

[9]At least she was at the time of shooting *I'm Dangerous Tonight*. She and Hooper have subsequently divorced, and she is now credited as "Carin Berger," her maiden name.

Victor and the rest of the cast charge downstage to confront him. "You're <u>off</u> this show, Eddie!" spits Victor, while, virtually unnoticed, Amy snatches up the cloak, stuffs it in a large shopping bag and hurries up the theater aisle and out the front door.

Waiting for the scene to be lit, Stuart passes the time toying with one of the rapiers while Corey, seated in the auditorium, engages in another of his quiet but intense conversations with Hooper. Perhaps as a result of this discussion, when the scene is shot, Corey has a strange, heavy-lidded affect as he emerges from his trance, as if waking from a discomfiting dream; a tic that was not evident in earlier rehearsals.

The company moves very quickly to the next shot, in which Amy escapes the theater clutching the bag containing the cloak and Eddie pleadingly calls out after her. The shot requires only one take, and they move on to the last set-up of the day, the "martini."

Moving back onto the stage, with the camera once again mounted on the dolly, the day's final shot is a close-up on Mädchen as she stands over the antique chest. She watches with great apprehension as Corey retrieves the cloak and slings it over his shoulder. The camera dollies in even closer as she reacts with increasing alarm to the swordfight's escalating violence, eventually crying out, "Eddie! Eddie, <u>stop it</u>!"

At the end of the take, Mädchen seems not particularly pleased with her performance. She leans forward with her elbows on the open lid of the chest, giving Tobe a quizzical look; but he is perfectly satisfied and nods to 1st AD Tom Blank.

"That's a wrap!" shouts Tom, thankfully declaring the end to a very long first day of shooting.

TWO

OUT FIT

Tuesday, April 24, 1990

It's a cool morning amid the trails and evergreens of Los Angeles' Franklin Canyon on this second day of principal photography. There is a palpable sense of anticipation as the crew awaits the arrival of legendary actor Anthony Perkins, cast in the film as Buchanan, an effete and diffident university psychology professor with a particular fascination for the occult.

Among certain members of the crew, there is some conjecture about the state of Perkin's health. Rumors of his having been diagnosed with AIDS have led some to question whether he is up to the physical challenge of even this relatively small (but important) featured role.

When, however, he soon makes his appearance on the set, dashingly attired in his khaki safari jacket, he is robust, alert, full of energy, and eager to get on with it.

Perkins is no doubt best known for his role as Norman Bates, the titular anti-hero of Alfred Hitchcock's seminal horror thriller, *Psycho*. But, despite his often having been typecast as the quirky weirdo in lesser film projects, Perkins had managed to add an impressively diverse cast of characters to his resume over the course of his long and varied career. From the hapless naïf Josef K. in Orson Welles' enigmatic adaptation of Franz Kafka's existential novel of a dehumanizing legal system *The Trial*, to

Chaplain Tapmann, the befuddled military counselor in Mike Nichols' film version of Joseph Heller's hilariously ironic book *Catch-22*, to McQueen, Richard Widmark's scheming gentleman's gentleman in Sidney Lumet's star-studded adaptation of Agatha Christie's mystery bestseller *Murder on the Orient Express*, to the cold and calculating political operative John Cerruti in *Winter Kills*, director William Richert's film version of Richard Condon's literary deconstruction of the JFK assassination, Perkins continually demonstrates his passionate intelligence, wit, and striking versatility as an actor.

The day also marks R. Lee Ermey's first appearance on the set. Ermey's striking and unforgettable performance as the uncompromising drill instructor in Stanley Kubrick's *Full Metal Jacket* permanently emblazoned him on the public consciousness.[10] In *I'm Dangerous Tonight*, he has been cast as Captain Aickman, an idiosyncratic and ironically ineffective police detective.

The character of Aickman might be a bit of a nod to Woolrich's original story, in which the central figure is a law enforcement officer whose efforts to seek justice are consistently thwarted by the machinations of those in the thrall of the evil red fabric, but that is where any similarity ends.

For the day's shooting, the producers have arranged the use of a Louma crane, a remote-controlled camera crane that allows for extremely smooth and flexible movement, designed to be operated

[10]Interestingly, having been a military adviser on Francis Ford Coppola's *Apocalypse Now*, Ermey was originally contracted by Kubrick as a technical adviser and asked to read opposite other actors being considered for the role. He proved to be so flamboyantly perfect for the part, however, that Kubrick cast him as the DI, and in the process made cinematic history.

distantly in tandem with a video assist monitor.

The first scene on the schedule occurs very late in the script.[11] Aickman is leaving the cemetery after the unceremonious burial of Wanda Thatcher, an unfortunate character particularly susceptible to the malicious power of the red dress. As he approaches his car, Amy arrives, apparently to pay her respects to Wanda.

The crane figures prominently in the first shot. Behind a whitewashed latticework arch, the graveyard[12] is situated in a small clearing at the bottom of a gently sloping pathway made up of wooden steps inlaid into the hillside. High on the crane, the camera descends as Aickman, dressed in a shabby brown tweed jacket and gnawing on a smoldering cigar, climbs the path and passes through the archway into the parking area. The camera settles low as he reaches his vehicle and turns at the approach of Amy's car.

Despite the potential for complications in the use of the crane, the shot comes off without a hitch. The crew moves quickly to mount the camera "on sticks" to proceed with the close-ups on Mädchen and R. Lee.

"You were the last person I expected to see here," Aickman says to Amy as she pulls up to the site in her car. R. Lee does a wonder-

[11]Actually, the first scene listed on the day's call sheet is Scene 64, in which Amy and Eddie stroll along the lakeshore and Eddie reveals some disturbing insight into his family history, hinting at his desire to attain "power" over others. This scene does not appear in the final film, and as much as can be determined, was never shot.

[12]Wanda's "grave" at the bottom of the hill is actually nothing more than a large rectangle of plywood painted black and laid on the ground. The trick is a simple one, but surprisingly effective. When asked about it, Hooper responds, "Everything's a cheat."

ful job of simultaneously being surprised, pleased, and suspicious at her presence as he speaks his line.

Mädchen's reply, "You said she had no family," brings a wisp of a smile to his face, and he responds softly as he turns to regard her while leaving, "Nice thought."

Despite the potential for complications in the use of the crane, the shot comes off without a hitch. The crew moves quickly to mount the camera "on sticks" to proceed with the close-ups on Mädchen and R. Lee.

"You were the last person I expected to see here," Aickman says to Amy as she pulls up to the site in her car. R. Lee does a wonderful job of simultaneously being surprised, pleased, and suspicious at her presence as he speaks his line.

Mädchen's reply, "You said she had no family," brings a wisp of a smile to his face, and he responds softly as he turns to regard her while leaving, "Nice thought."

Scene 80: Amy is startled during her morning jog by the sudden appearance of a huge, snarling black Mastiff in her path. The dog turns out to belong to Professor Buchanan, who emerges mysteriously from the mist, "coincidentally" happening upon Amy during her morning ritual. They walk and talk together, with Buchanan steering the conversation toward the psychology of religious rites and the susceptibility of some individuals to the possessive powers of certain religious relics.

This cat-and-mouse scene has some of the best dialogue in the script, and gives Perkins plenty to chew on.

The scene is filmed in sequence and with great economy. Thanks to the efforts of the visual effects crew, the area is enveloped in gently billowing morning mist.

Mädchen is lovely in her pale blue leotard, gray hooded sweatshirt and navy-blue sweatpants, with her hair pulled back into a tight ponytail. For the first shot, the camera glides along beside her on dolly tracks as she jogs the wooded pathway, glanc-

ing warily around her as she goes. Suddenly startled by something in her path, she gasps and stops short.

"Cut!" shouts Hooper from behind the camera, "Next set-up!," and the crew hurriedly prepare for the next shot.

The camera is removed from the dolly, mounted on the tripod, and placed in the path. Dog trainer Steven Ritt leads "Sigmund,"[13] a friendly but intimidating Doberman Pincer, to his mark in front of the camera. Ritt is perhaps the premier animal trainer in Hollywood, with dozens of films and TV shows to his credit. Notably, he is the owner/trainer of Buck, the shaggy sheepdog from Fox TV's risqué sitcom, *Married with Children*.

They're ready to roll. With Hooper's distinctive cry of "Action!," Ritt gestures from off-camera, and the dog ferociously bares its teeth. Perkins' distinctive voice pierces the morning air. "Sigmund!" he shouts, and the camera tilts up to catch him as he emerges from the mist like an apparition.

Perkins has come fully prepared and is the complete professional. His ease in performance comes as the result of literally hundreds of hours in front of the camera. He's a bit distant with most of the crew, but that's to be expected from anyone on their first day of shooting.

The remainder of the sequence consists of a long walk and talk between Buchanan and Amy. Buchanan's conversation dances circuitously around his real plan, i.e., to sound out Amy on the power of the red cloak. Perkins is particularly hilarious with his stilted delivery, pregnant pauses, and sidelong glances, while Mädchen plays it as if Amy is naively unaware of Buchanan's agenda.

[13] It's appropriate, but perhaps a trifle "on the nose" for Buchanan, the unassuming psychology professor, to have named his potentially vicious pet after the father of modern psychoanalysis, Sigmund Freud.

At the end of the scene as written, as Amy jogs off into the distance, Buchanan mumbles in German to Sigmund, "Es ist in ordnung," which translates roughly to "It's fine." (This wry and ambivalent utterance, however, does not appear in the final cut of the film.)

The company now moves down into the graveyard set, no mean feat considering the weight of the necessary camera equipment. Key grip Michael Colwell and his team struggle a bit with the steps but manage to expeditiously get everything to the site in one piece and without incident.

In this continuation of the day's first shots, Detective Aickman leans on a shovel dug into a pile of dirt, gnaws on his mangled cigar and pensively regards Wanda's final resting place. An eager gravedigger relieves him of the shovel and Aickman ambles toward the steps leading to the parking lot overlooking the graveyard. (The role of the gravedigger is played by Frank DiElsi, a young actor who tells anyone who will listen that he is Michael Keaton's regular stand-in and that they are, in fact, the best of friends.)

Mädchen returns to the set, with her hair now attractively unfurled, no longer clad in jogging togs, but instead wearing a lovely, rust-colored, flowered summer dress and dark brown velveteen jacket. She also carries a black shopping bag which contains red satin shards.

According to the script, Amy has come to the graveside to "pay her respects" to Wanda by burying the remaining scraps of the haunted red dress along with her. She shyly asks the gravedigger for some privacy, not quite lying when she tells the gravedigger, "I knew her."

Fortuitously, as Mädchen stands above Wanda's grave, a slight breeze kicks up, sending spring leaves fluttering across the burial grounds. She looks around furtively before lifting the shopping bag and pouring out its contents, sending torn strips of red cloth

rippling in the wind and settling into the furrow.

For her final shot of the day, the camera is brought close and set below Mädchen, beautifully haloed in gold by the late-afternoon sun as she ambivalently looks down into the grave.

As the sun descends behind the mountains, the crew prepares for the final set-up of the day, a remarkably conceived crane shot (and what is to be the final shot of the film). In the scene, Buchanan returns to the graveyard in the dead of night to retrieve the remnants of the Aztec sacrificial cloak that Amy had disposed of in Wanda's grave.

The camera actually begins the shot *within* the grave, gazing up at Perkins as he runs his fingers through the dirt, lit only by the weak beam of his flashlight, greedily snatching up discarded fragments of the cloak. Then, as he furtively stuffs the remnants into his jacket, the camera slowly rises up out of the grave, tilting downward and twisting slightly as it ascends higher, ultimately revealing the entire cemetery and the long, dark, moonlit shadows of the headstones that creep across the graveyard's grassy mounds.

A few clever gimmicks are used to achieve the illusion of the camera rising out of an enclosed grave. Since the original burial ground was merely the result of some cinematic sleight-of-hand, an actual rectangular hole has been dug at another location, a nearby field in which the crew has relocated the headstones and statuary. The grave itself is really more of a trench. The shot begins with the camera, mounted at the end of the arm of the Louma crane, lowered into the trench, effectively *inside* the grave. As it rises up and out, the grips slide into place a wooden panel covered in patchy soil, making the grave seem, from the camera's POV, fully enclosed, and rendering the shot apparently impossible.

But before they embark on this grand undertaking, the crew execute two other, less complicated and demanding shots. The first is Amy's POV as she discards the remnants of the red dress

into Wanda's open grave, and requires that it be brightly lit as if bathed in morning sunlight. As a result, the gravesite stands out like a shining beacon in the surrounding darkness. Mounted onto the tripod, the camera looks down onto the casket as assistant prop man Ray Anthony pours the shredded remnants of the dress into the grave like red satin snowflakes, subsequently followed by two shovelfuls of dirt as the gravedigger ostensibly resumes his duties.

The second set-up is basically a preamble to the night's ultimate shot. Now firmly mounted onto the crane, the camera hangs high above, facing straight down onto the tombstone and gravesite. On cue, it descends rapidly as a mysterious long moonlit shadow slinks across the grave and a shovel blade enters the frame, digging into the freshly buried mound and dislodging scoop after scoop of dirt. The shot effectively poses the question, "Who is this curious figure desecrating a grave under cover of night?"

While waiting for lighting tweaks, Perkins and Hooper have a discussion regarding Perkins' experience as the director of *Psycho III*, the second sequel to Hitchcock's masterpiece. Perkins bemoans the fact that his crew seemed unwilling to try new things, and that his ideas were consistently shot down as being "unworkable." Hooper commiserates with the actor, noting how difficult it can be to get jaded film veterans to move out of their comfort zone.

Meanwhile, the second unit crew sets up on a nearby dirt roadway to shoot a "live" stand-up of a newscaster reporting on a "drug-related slaying" that has occurred on the hilltops overlooking the town of Tiverton (an "eyewitness news report" to be used as a playback later in the film). The reporter is played by Henry C. Brown, looking every bit the part in his stylish, steel-gray business suit and tie.

Preparations are relatively simple and straightforward; the drug

dealer's Mustang convertible is parked on the road, "caution" tape is strung across the scene, a "corpse" is wrapped in a black bag and laid in the road, and R. Lee and two extras playing the coroner and a uniformed policeman stand by.

Tobe stops by briefly to approve the set-up, then leaves the shooting to the second unit.

On "Action!," the reporter addresses the camera, microphone in hand, and relates the gruesome details of the murder while behind him Detective Aickman distractedly confers with the coroner and the cop over the black-bagged corpse of the drug dealer. Brown delivers his lines in a direct, professional manner, and they get the shot in two quick takes.

Back at the makeshift cemetery, Tobe watches on the video assist monitor as DP Levie Isaacks and his crew rehearse the camera movement of the spectacular "rising from the grave" shot. Isaacks operates the camera via remote control while the crew manipulate the crane manually. It's a kind of waltz in which they all coordinate to get the timing right and to achieve the desired illusion.[14]

The effects team lays down a layer of ground fog, which catches the moonlight and lends a ghostly blue patina to the night.

The extensive rehearsal pays off. They get the shot in only a few attempts, effectively capturing the film's powerful final image: Buchanan's frightful desperation in disinterring the tattered

[14]Further complicating the shot, as revealed by Isaacks in a later interview, was the requirement (dictated by the Mountains Recreation and Conservation Authority [MRCA], which oversees the preservation of the land and its flora and fauna) that the crew at all times must remain at least 100 feet away from a towering ancient oak tree, which necessitated the grave being dug in a less-than-convenient spot.

remains of the ancient crimson sacrificial cloak.

And so, the curtain falls on the second day of principal photography on *I'm Dangerous Tonight*.[15]

[15] Hooper would revisit the Franklin Canyon location two years later to make a cameo appearance as a forensic technician alongside fellow horror stalwarts Stephen King and Clive Barker in director Mick Garris' 1992 film *Sleepwalkers*, based on an original screenplay by King and also starring Mädchen Amick.

THREE

IVY LEAGUE TWEED

Wednesday, April 25, 1990

It's a clear spring day and the bright afternoon sun illuminates the rich green lawns of UCLA's vast and expansive campus. The film crew has returned to the grounds of the world-class university to continue principal photography.

The day's first shots are relatively simple. They begin with a static shot of one of Royce Hall's Romanesque twin towers that tilts down into a diminishing view through the colonnade. The camera rolls as dozens of college-age extras, backpacks on backs and textbooks in hand, ostensibly rush to their respective classes, and the shot is accomplished with little muss and fuss.

Next up on the call sheet is an establishing shot of the Tiverton College psychology building. The art department, under the guidance of production designer Lenny Mazzola, have fabricated a sign reading "Department of Psychology" and mounted it onto the curved brick façade of UCLA's Powell Library, complementing the style of the architecture perfectly. Mazzola is a well-respected veteran of series television and film, but he's probably best known for his work on Dan Curtis' memorable TV movie *Trilogy of Terror*, which features actress Karen Black portraying four different women beset by horrific circumstances, most notably in the final segment in which she does battle with a relentless, snarling, razor-toothed Zulu doll.

Dolly tracks are laid perpendicular to the library, which is meant to represent the exterior of the lecture hall in which Professor Buchanan addresses his students. Two towering conifer trees stand bestride the landing of the low brick steps leading to the library. A bulletin board has been erected at the foot of the two alternate brick staircases to the entrance, an important piece of set dressing for a subsequent scene.

The first shot of this set-up is a gentle push in and tilt up to the "Department of Psychology" sign, artfully obscured by the shade of one of the huge conifers. As the day is clear and bright, there is little need for enhanced lighting, and the shot comes off smoothly and without a hitch.

The second shot of the sequence is slightly more complex, as it requires a large group of student extras to emerge from the building and descend the stairs. 2nd assistant director Keri McIntyre takes a few selected extras aside and gives them some "business" to perform during the shot; either to briefly check out the bulletin board or to scamper down the steps and head directly off to their next class.

McIntyre is a young, statuesque woman already sporting an impressive resume. She began her career auspiciously as a DGA trainee on famed special effects wizard-turned-director Stan Winston's unique horror film *Pumpkinhead*, and subsequently went on to act as an assistant director on Christopher Guest's acidic ode to aspiring filmmakers, *The Big Picture*. She possesses the ideal qualities for the job, an even temper, and a firm sense of urgency.

At the tail end of the shot, Amy descends the steps and approaches the bulletin board.

The crew moves onto the landing for the next series of shots, in which Amy and Eddie "meet cute," having been randomly assigned as study partners by Buchanan.

Corey, with his tightly curled black hair and lightly freckled

face, seems to all appearances to be the ideal suitor; his Eddie is handsome and masculine, but glib and non-threatening. Costumer Carin Hooper has chosen to dress him in stark black and white, possibly a nod to the dual nature of his character once he comes under the dark influence of the enchanted red cloak.

The scene consists of three relatively straightforward shots: individual medium close-ups on Mädchen and Corey and a close-up insert on Amy's finger as she scans the list of "Term Paper Work Partners" posted on the board.

The weather continues to cooperate and there are no hitches in the shooting. The shots are accomplished without impediment, although Corey does seem strangely distant between takes.

According to the script, the next scene on the schedule is meant to take place in the college cafeteria. However, to take advantage of the options available on the UCLA campus, it has been relocated to a terrace on the quad, where students study at picnic tables while dining on vending machine snacks.

Scene 18: A brief encounter in which Eddie reveals to Amy that he has been cast as Mercutio in the school's production of *Romeo and Juliet* and begins to subtly manipulate her into doing the lion's share of the work on their collaborative psychology project. Eddie seems horrified at Amy's assumption that he might be a theater major.

The scene consists entirely of three shots: a long tracking shot as Eddie and Amy approach the vending machines, and individual close-ups of them both as their conversation continues. For this very brief scene, Hooper has little to say to his actors, preferring instead to allow them to rely upon their instincts. Instead, he lingers behind the camera, smoking his ever-present cigar and nursing his favored beverage, a frosty can of Dr. Pepper.

Mädchen and Corey are a study in contrasts. Before the camera rolls, she is gregarious and affable while he is largely withdrawn and introspective. He seems more of a "method" actor, and she is

mostly intuitive.

Once this relatively uncomplicated sequence is in the can, the crew packs up their equipment in preparation for a move across campus for the next scene on the day's schedule.

From the previous scene, which takes place comparatively early in the script, the company prepares to shoot virtually the last scene of the film. Scene 153: After all of the mystic confusion and tragedy have ended, Amy encounters Professor Buchanan on her way off campus to meet up with Eddie. They chat amiably, and Amy inadvertently reveals that the remnants of the enchanted red cloak have been buried in Wanda Thatcher's grave. Buchanan is suspiciously charming. (It should be remembered that the scene in which Buchanan plunders Wanda's grave and retrieves the torn fragments of the cloak has already been filmed.)

Michael Colwell and his grips have laid dolly tracks along the sidewalk running adjacent to Royce Hall and mounted the camera dolly on the tracks. Hooper sits on the dolly, cigar, and Dr. Pepper close at hand as always, discussing the first shot of the sequence with director of photography Levie Isaacks.

Mädchen is fresh-faced and sports a change of clothes, powder-blue blouse, white slacks and slim black vest. Perkins is smartly dressed in a gray tweed jacket, brown tie and beige pants. (Costumer Carin Hooper continues her assiduous effort to refrain from using shades of red in anything other than the ceremonial Aztec cloak and the seductive party dress that Amy assembles from it.)

As the scene begins, Amy, blue book bag slung over her shoulder, passes by the faculty building as Dr. Buchanan descends the paved-brick steps and calls out to her. (This is a recurring theme in the script; people seem to be forever calling after her, "Miss O'Neill!" or "Amy!")

Strolling together along the pathway (possibly an echo of their earlier meeting during Amy's morning jog), they exchange a few

awkward pleasantries. Buchanan congratulates her on final paper ("I gave it an '<u>A</u>!,'" Perkins intones with boyish enthusiasm) and enquires about Eddie's well-being in the wake of the preceding tragic events.

Mädchen and Perkins have developed an easy chemistry between them, making their dialogue relaxed and thoroughly believable. Perkins especially is quite sly in cloaking his character's efforts to glean the whereabouts of the remains of the red dress in easy banter and not-so-subtle compliments.

As the camera rolls, dolly grip David "Foots" Footman tracks along with the actors in one long, smooth shot. At the tail end of the shot, Perkins stops dramatically and looks directly into the camera.

Perkins' fierce intensity seems to suck up all of the energy in the area and channel it outward into the camera lens. Suddenly, it's perfectly obvious why he's considered to be a living legend. He brings something more profound to the table than mere professionalism or celebrity charisma or practiced ease, something almost metaphysical. He comes thrillingly alive under the camera's watchful gaze. Even the industry vets on the crew are unable to take their eyes off of him.

When he paraphrases philosopher Frederick Nietzsche's famous quotation, "Battle not with monsters, lest you become a monster, and if you gaze into the abyss, the abyss also gazes into *you*,"[16] his penetrating dark eyes pierce the camera, breaking the

[16]The version of the quotation used in the film, "Whoever fights monsters should see to it that in the process he does not become a monster. And when you look long into an abyss, the abyss also looks into you," may derive from a different translation from the original German and appears in this form on the title page of the teleplay.

fourth wall, to striking effect.

Isaacks' close-up on Perkins is lovingly composed, crisply focused and backlit in warm hues of orange and yellow. Watching on the sidelines through the video monitor, Hooper can barely contain his appreciation for the shot. "Beautiful, Levie," he murmurs, "Beautiful."

The last shot of the sequence is relatively simple; Eddie pulls up to a nearby curb in Amy's hatchback to pick her up for their shared journey out of town, ostensibly (as a nod to the film's fairy tale aesthetic) to live happily ever after. To save time, the camera remains on the dolly and is simply swiveled to face the curb.

Only one take is necessary to catch Corey pulling up and waving goofily towards the camera from the driver's seat as Mädchen scurries up to the car, kisses him lightly and gets in.

The scene is completed just before the late afternoon sun begins to slip behind the horizon, and the crew breaks for lunch.

Night has fallen. The film crew assembles in a small parking lot at the foot of a grassy hill to shoot Scene 98: Amy warily makes her way across the darkened campus to her car. Hearing footsteps behind her, she turns and is startled by the approach of the school librarian, seeking a companion for the walk to the parking lot. After seeing the librarian safely to her vehicle, Amy is startled by the sudden unexpected appearance beside her of Professor Buchanan, clearly agitated and strangely cold. He attempts to grill her, demanding to know the whereabouts of the enchanted red dress. Amy resists his efforts and drives off into the night as Buchanan desperately shouts after her, "Miss O'Neill!"

In the first shot of the evening, the camera tilts down from a long view of one of the university's tall towers to discover Mädchen as she walks the shadowy path down the hill, worriedly glancing back, seemingly certain that she is being followed. Hear-

ing the fast-approaching sound of heels on pavement, she quickens her pace, but then stops suddenly, wheeling around to confront her pursuer. But it turns out to be only the affable school librarian that emerges from the shadows. "I hate this walk, don't you?" she says breathlessly. "Yes," replies Amy with a relieved sigh.

The role of the librarian is played by Felicia Lansbury, screenwriter Bruce Lansbury's daughter. She is a tall, lean woman with intelligent eyes and a gentle manner. Her large-rimmed spectacles and oversize sweater serve to make her appear frumpier than she actually is.

The sequence requires numerous set-ups: from behind Mädchen as she descends the hill, furtively looking back (with a change of lenses), close up on Felicia as she steps out of the darkness, a dolly shot of the two young ladies walking together as they discuss the need for better lighting on campus, and finally a static shot with the camera mounted to the tripod as they arrive at Amy's vehicle and the librarian requests that Amy watch her as she gets to her own. Lansbury manages to create a full-bodied character with just a few lines of dialogue and makes an indelible mark on the film with her brief appearance. (Interestingly, Felicia once worked as a backstage assistant to postmodern magicians Penn and Teller [née Penn Gillette and Raymond Joseph Teller]).

The night has grown chilly and most of the crew have bundled themselves up in thick jackets, sweatshirts, mittens, scarves, and knit caps. With the preamble in the can, they prepare to shoot the bulk of the scene - the uncomfortable encounter between Amy and Buchanan.

The first set-up is complicated; the shot begins on the back of Amy's head, large in the foreground as she watches the librarian get safely to her car in the distance. As Amy turns to get into her own vehicle, the camera dollies back while simultaneously panning left to abruptly reveal Buchanan's imposing figure loom-

ing over her. She flinches and gasps at his sudden presence, as he demurs ironically, "I . . . didn't mean to frighten you."

Hooper oversees camera rehearsal with Mädchen and stand-in Mark San Filipo (filling in for Anthony Perkins until his arrival on the set). Timing is particularly important with this shot. Perkins' presence should not be telegraphed in any way. (The script is cleverly constructed in this regard. Amy has been startled twice already within a few brief moments, so Buchanan's sudden appearance is that much more unexpected and effective.)

Hooper rides the dolly and operates the camera during rehearsals, checking the frame through the viewfinder and conferring with DP Isaacks on the composition of the shot. Mädchen's stand-in, young Courtney Wulfe, takes her place for the lighting crew's final adjustments while Mädchen steps out for hair and make-up.

When Perkins arrives on the set, dapper in his tweed blazer and pale gray scarf, he dispenses with any small talk and goes straight to the business of reviewing and tweaking the scene's blocking with Hooper and Isaacks. He's eager to please and brings his decades of experience to bear on the task at hand. He listens carefully, anxious to give Hooper what he wants while freely offering suggestions of his own.

"Picture, please!," calls 1st AD Tom Blank, alerting the crew for their first attempt at this fairly complicated shot. Hooper calls for "Action!" and Mädchen gives a little wave toward the librarian's car, but the take is cut short. "Let's cut," says Hooper, "Cut, cut, cut!" There seems to be an issue with the librarian's car ignition, which is meant to drive off at the top of the shot. Blank suggests that they simply leave the car idling and have Felicia just get in, turn the lights on and "fake starting it." This works well, but on take 2, Mädchen is slow to turn as the car drives off. Hooper cuts the take short and instructs her, "As soon as that car starts to move . . .," but she cuts him off with a nod of her head and an

impatient, "Yeah, yeah."

Sound mixer Craig Felberg is impatient for the night's shoot to end, constantly bemoaning the time ("Have we worked twelve hours *yet*?") and even surreptitiously taping a crude drawing of a martini[17] to dolly grip Dave "Foots" Footman's back. "Foots" is a stout, gregarious fellow with a quick wit and a ready laugh, prone to burst into song or break out the dance moves.

Perkins stops take 3, thrown off by some clumsy business with the car door. "We have to have this door open, don't we?" he asks innocently.

Both actors flub their lines on the following three attempts, but Perkins is thoroughly unflustered, basically considering the aborted takes as rehearsal. These "extra rehearsals" pay big dividends in subsequent takes, where, through repetition, the scene begins to come alive in the hands of these two performers with widely varied experience.

No longer the kindly professor, Buchanan instead evinces a dark menace and singularity of purpose not even hinted at in his previous appearances. Perkins' delivery of the line, "I . . . didn't mean to *frighten* you," lends the scene a humorous and yet appropriately sinister twist.

After getting Buchanan's complicated reveal in the can, the crew sets up for more conventional, "over-the-shoulder" close-ups on Perkins and Amick. Perkins has a way of preserving his nervous energy between takes so that he can release it full bore when the camera is rolling. His Buchanan is deceptively calm and soft spoken as the scene begins, but commences to get more and more agitated and desperate as it proceeds. Mädchen is particularly good at evoking Amy's guilt and unease while also projecting her deep inner strength. Her chest heaves, gasping for

[17]"Martini" is industry parlance for the final shot of the day.

breath as she struggles to maintain her equilibrium in the face of Buchanan's invective. There is something positively reptilian about Perkins' rendition of Buchanan in this scene, with a faint smirk crossing his lips and a disturbing glee in his eyes as he hisses "You must have heard about these *savage drug murders . . . the woman in the RED dress!*"

Hooper lines up the next shot, which features Mädchen sitting in the driver's seat, looking up at Perkins. Having been his own director of photography in the past, he operates the camera with fluid ease.

The first take is cut quickly when there is some question as to the position of Perkins' arm in the shot. Take two comes off without a hitch, with Mädchen forcefully challenging Buchanan's all-consuming desire to acquire the cloak, asserting, "I saw it go up in flames!," and demanding of him, "But if it really exists, <u>why</u> do you want it? What are *YOU* going to do with it?" At the tail-end of the shot, as she drives off, the camera tilts up into a close-up of Perkins as he shouts after her, "Miss O'Neill!"

Perkins' eyeballs practically roll out of their sockets as he spits out Buchanan's dialogue, "You have sensed the <u>power of the cloak</u>! Imagine it in the hands of someone more vulnerable to its power than *you* are! Someone utterly *evil*!" He rarely speaks his lines the same way twice. In this way, he might be compared to Billie Holiday, who famously never sang the same song the same way more than once (although it's likely that Perkins would rankle at the comparison).

At the end of the last take, Tom announces to the company, "All right, wrap it up, please! Tomorrow we'll be working outside at the top of this hill, looking down during the daylight hours. Thank you all very much. <u>Wrap it up</u>!" The crew disbands and retires into the cool, dark night.

Due to the lateness of the hour, the remaining three sequences on the day's call sheet (Scene 97: Amy leaves the school library,

Scene 96: Amy studies late in the library, and Scene 123: Buchanan frantically calls Amy from a phone booth) are postponed until later in the shooting schedule.

FOUR

WHOLE CLOTH

Thursday, April 26, 1990

It's a beautiful, clear, sunny day on the UCLA quad, where the film crew has gathered to shoot Scene 43, in which Amy and Eddie discuss Eddie's bizarre episode during the swordfight rehearsal. There's a lot of subtext in this deceptively simple scene. Eddie is remorseful about his behavior in rehearsal and is quick to promise that ". . . it'll never happen again," but almost immediately inquires as to the whereabouts of the props that Amy had collected for the play. Apparently, the cloak still exerts a powerful influence on him, even though he may not be consciously aware of it. For her part, Amy is wary of Eddie's attempts to explain away his violent actions, and while she finds him charming and attractive, is possibly relieved that she has a ready excuse to turn down his invitation to the school dance.

In the screenplay, the scene takes place in a pancake house. On the call sheet, it's variously notated as taking place at either a pretzel cart or a hot dog cart. Instead, the scene is set to be shot at a picnic table on the quad, with Mädchen and Corey sitting across from each other.

2nd AD Keri McIntyre busies herself wrangling the student extras while the camera crew prepares to shoot. The set-ups are relatively simple: one wide shot of the actors at the table with the

campus stretching out behind them, as well as one medium shot and one close-up each for them both. In keeping with the costumer's color scheme, Corey wears a white pinstripe button-down shirt and black jeans while Mädchen sports a lightweight, emerald-green sweater.

Hooper speaks very briefly with them about the scene, then takes his place beside the camera, eager to shoot. Although not technically complex, the scene is a potential minefield of crossed signals and suppressed emotions. Corey clearly considers himself a "serious" actor, with a capital *S*, and is always quite intense and focused. By contrast, Mädchen's process is more relaxed and intuitive. She never seems to take herself too seriously. Despite (or possibly because of) these differences in approach, they have excellent on-camera chemistry.

Very cleverly, Corey has given Eddie a "tell," a subconscious tic to indicate duplicity; whenever Eddie is feeling anxious or deceitful, Corey flashes a shy, disarming smile. He often seems most sincere when he is at his most evasive, which effectively suggests the darkness lurking beneath his earnest, cheerful façade. Mädchen's Amy, on the other hand, is naïve and trusting, though niggling doubts about her assessment of others are beginning to percolate in her brain.

The crew share a pleasant and relaxed afternoon as the shoot progresses easily. With no hiccups or interruptions, the scene is "in the can" in a few brief hours.

The late afternoon has given way to dusk. A small second unit, comprised mainly of DP Levie Isaacks, 2nd AC Bill Roberts, and best boy grip Daniel Colwell, assemble on a side street adjacent to the UCLA campus to shoot Scenes 137, 138, and 145, three short sequences featuring Detective Aickman racing along the road in his unmarked police car (a nondescript brown Buick) and executing a screeching U-turn after having received an urgent radio notification of violent events at the O'Neill household.

R. Lee Ermey is on hand for Aickman's close-up, in which he hangs up the radio mike, places a flashing red "cherry" light[18] on the car's roof, and, muttering to himself "Come on, come on!," squeals off into the night. (The vehicle's dangerous maneuvers are actually performed in long shot by stunt coordinator John Moio.)

While the second unit completes the "drive-bys," the remainder of the film crew prepare for what is designed to be the opening of the film. The prop department has manufactured a large, ivy-covered faux-granite sign reading "Tiverton College Museum" and placed it on a grassy easement aside yet another adjacent street to signify the entrance to the film's fictional institution of higher learning.

Tasked with lighting a very wide area of road, the lighting crew have their work cut out for them. Most of their preparation time is spent in erecting an array of large halogen lamps, diffusers and bounce boards at DP Levie Isaack's and gaffer Robert Moreno's direction in order to illuminate the road, the truck, and the surrounding environment.

The sequence consists of two shots: the first in which a large semi-trailer truck travels down the road, and the second in which the truck passes by with the museum sign prominent in the foreground, the streetlights casting its shadow on the sign and obscuring it in darkness.

In the opening shot, according to the teleplay, as the truck advances the camera is meant to pan up to focus on the driver, Enrique, played by Juan Garcia. Since the actor is not present, it appears that the shot has been reimagined to obscure the face of the driver in favor of leaving his identity in doubt while also generating a sense of mystery as to the contents of the freight

[18]This flashing light is a rare instance of the use of red in the film apart from the Aztec cloak and Amy's radiant party dress, a clear indication of danger afoot.

container (which turns out to be the ancient Aztec sacrificial altar in which the malevolent red cloak is purloined).

The camera is mounted on the tripod and situated in the middle of the street, tilted down at the broken white lines separating the two-lane road that adjoins the campus. At Hooper's signal, the stunt driver behind the wheel of the Kenworth hauler revs the motor and lurches forward. At first, only the reflection of the truck's headlights on the pavement can be seen. But as the camera tilts up, the truck's massive chrome grille approaches perilously close, engulfing the frame and skidding to a halt just short of contact.

"Whew!" sighs Isaacks, "That was close!"

After the lunch break, the film crew regroups to one of UCLA's many lecture theaters to shoot Scene 16: Professor Buchanan pontificates to his class of psychology students on the subject of animism (a concept in which all things, even inanimate objects, are imbued with spirit and intention) and assigns them their final project, an extensive term paper based on a voluminous book by Buchanan's late colleague, Professor Jonas Wilson. (The prop is actually a copy of the Oxford English Dictionary wrapped in a gold-leaf dust jacket fabricated by the art department.)

The room is large, capable of accommodating upwards of 200 students. Wooden chairs are arranged in ascending rows of fixed-tier seating, each with an armchair writing tablet affixed for ease of taking notes. The instructor teaches from the "well" of the theater, a sunken platform provided with a dusty blackboard, two bulky desks and a lectern from which to address the class.

The gallery is populated with dozens of student extras. All of the standard collegiate types are represented: jocks, preppies, nerds, frat boys and sorority girls. Corey sits alone, studying his script intently while a few seats away Mädchen chats with 2nd AD Keri McIntyre.

As the camera and lighting crews make their final adjustments, Perkins, outfitted in yet another tweedy ensemble, rehearses his speech at the lectern, seemingly oblivious to wardrobe supervisor Julia Gombert's and hairdresser Nina Paskowitz's incessant grooming.

Conferring with his assistant Rita Bartlett, director Hooper sits just below the camera, which is mounted on the tripod at the back of the gallery, positioned for a wide shot of the entire room. He gnaws on a stogie as they examine the script together.

Perkins is fully engaged and has plenty of ideas of his own to offer. In a discussion with Hooper (which has them speaking loudly back and forth across the room over the din of preparations) regarding the breaking of a small pocket mirror in order to demonstrate Buchanan's point about arcane superstitions, Perkins asks, "Wouldn't you prefer to see it broken on the lectern?"

"I would love that," mutters Hooper. "You would?" asks Perkins. Hooper nods in assent, saying, "Let . . . let's . . . let's try it." Perkins responds with polite refinement, "By all means."

In rehearsal, Perkins produces a horseshoe and a rabbit's foot, both of which he tosses blithely aside, then mimes breaking the mirror on the podium. He is word-perfect and his tone projects an affable condescension toward the students.

At Hooper's urging, 1st AD Thomas Blank addresses the student extras, reminding them to stand at the end of Buchanan's lecture, gather their books and papers and head for the exit. "And remember, the exit is up!" he adds, gesturing to the two doors at the top of the aisles at the back of the hall.

The camera rolls on the wide shot. During the take, when Perkins shatters the mirror on the corner of the lectern, audible gasps arise from the gallery. In a happy surprise, a small triangular shard of the broken mirror remains poised on the corner of the lectern, gleaming like a tiny, shiny dagger.

"Cut! Moving on!" shouts Hooper. "Okay, now we're on the dolly!" Blank calls out, and the bulk of the crew move into the well of the hall to prepare for Perkin's close-up.

As Perkins idly perches on the edge of the desk and waggles his feet like a child in a highchair, he and Hooper discuss Thomas Harris' novel, *The Silence of The Lambs*. Perkins refers to it as "fine literature" and clearly covets the role of Hannibal Lecter in the recently announced film version to be directed by Jonathan Demme but bemoans the fact that his inescapable association with the character of Norman Bates[19] renders his being even considered for the role of yet another infamous serial killer particularly unlikely.[20]

Hooper rides the dolly as they set-up for the close-up, which includes a slow push forward as Buchanan makes his speech. Perkins remains seated on the desk, pensive and patient, yawning occasionally (the hour is late) while stand-in Mark San Filipo takes his place for lighting and camera adjustments.

When Hooper calls for a camera rehearsal, Perkins provides an amusing running commentary as he walks through his blocking for the shot; "Well, the first position is here . . . he talks, he talks, he talks, he talks . . . right after he goes to here." As he raises the horseshoe and rabbit's foot into frame, "You wanna see these? Right here? Is this . . . is this where we show them? Yes? See the mirror. Break the mirror." He mimes

[19] It's interesting to note that here we have the director of *The Texas Chainsaw Massacre* and the lead actor from *Psycho* discussing *The Silence of the Lambs*; all three films having been based on the notorious career of serial murderer Ed Gein.

[20] The role ultimately went to British actor Anthony Hopkins, who gave a gleefully menacing performance as Lecter and subsequently won the 1991 Academy Award for Best Actor.

breaking the mirror on the podium, then steps back and picks up the dauntingly thick book, which he reveals to the camera. "Like this, Levie? Is that right? I dunno, I'm not sure. Mm? Yes?"

DP Levie Isaacks requests a full rehearsal with dialogue. Perkins is only too happy to oblige and instantly launches into the speech, fully committed. The dolly moves slowly into a tight close-up as he plays the scene. Satisfied, Isaacks indicates that he's ready to shoot.

Nina Paskowitz and Emily Katz make last minute touch-ups to Perkins' hair and make-up as Ray Anthony ensures that all the props are in order.

Ever the professional, just before the camera rolls, Perkins confirms his eyeline with Hooper, "Both sides of the camera okay for you?" Hooper nods in the affirmative and the crew proceeds to make their last-minute adjustments in preparation for the final shot. (While standing by, Hooper uncharacteristically sips on a Pepsi instead of his usual Dr. Pepper.)

Once again, when the camera rolls, Perkins seems almost possessed by the character of Buchanan. He assays the speech with sly bravado and bemused condescension, addressing the students as if they were simultaneously respected colleagues and vapid kindergartners.

As Hooper calls "Cut!" on the last take, Perkins retreats to his makeshift dressing room to await the call to shoot his final scenes, which amount to little more than a few brief inserts.[21]

Making an appearance on the set for a wardrobe fitting is

[21] As Perkins climbs the steps to leave the lecture hall, the author seizes the moment to approach him and express what a unique privilege it's been to watch him work. Perkins is wary but gracious, offering a watery handshake, a polite nod and a birdlike smile before scurrying off.

William Berger, the actor cast as the obsessive and disheveled Professor Jonas Wilson. Berger is a stalwart of Italian cinema, a protégé of famed filmmaker Bernardo Bertolucci and, not incidentally, the father of costumer Carin Hooper and father-in-law of director Tobe Hooper.

Born in 1928 into a wealthy Austrian family and originally christened Wilhelm, as a child Berger was inducted into the Hitler Youth through the Catholic school system, although as World War II progressed, the family fled to New York City. Living a colorful life, he majored in engineering at Columbia University and even competed for a spot on the 1948 Olympic running team. Years later, pursuing a career in acting, he landed the job as understudy to George Grizzard's Nick in the premiere Broadway production of Edward Albee's acerbic case study of fractured relationships, *Who's Afraid of Virginia Woolf?* Among his numerous roles in Italy, he often appeared as a "bad hombre" in such films as *His Pistol Smoked*, *They Called Him Cemetery*, *Fast Hand*, and *If You Meet Sartana, Pray for Your Death* (in which he appeared alongside manic German actor Klaus Kinski, who would much later go on to star in *Venom*, on which Hooper was originally engaged as director, but was replaced by Piers Haggard under contentious circumstances).

Here, Berger looks appropriately academic in his rumpled corduroy blazer and brown cotton slacks.

In the interim, while still on the dolly in the well of the auditorium, the camera is turned around to face the students seated in the gallery for their reaction shots. In a relatively straightforward series of individual shots, Corey, Mädchen, and the assembled class react as script supervisor Sandy Mazzola reads Buchanan's dialogue. Once completed, the cast is released, with the notable exception of Perkins, for whom a few crucial shots remain.

Production designer Lenny Mazzola and set decorator Richard

Spero and his team (including his brother Anthony Spero) have constructed a white lattice-work façade on the concourse just outside the lecture hall. This serves as the backdrop for Professor Buchanan's entrance to the school dance, where he catches a glimpse of Amy gyrating with abandon in her scandalous red dress and immediately realizes (to his horror) what's become of the Aztec sacrificial cloak.

This mini-set is lit by blue and green gelled lights and a mirrored "disco ball" to replicate the atmosphere of the ballroom at the Ambassador Hotel, where the actual dance is scheduled to be filmed next week. (Perkins will have completed his stint by that time, so it has been decided to shoot what amounts to his very brief insert here.)

Perkins is outfitted in black tie and tuxedo jacket (as he will be seen only from the waist up). Several similarly dressed young persons (extras from the lecture scene redressed in prom attire) are instructed to mill about behind him, chatting.

When Hooper calls "Action!," Perkins enters the frame, smiling and scanning the ballroom. The camera dollies slowly forward as he catches sight of Amy dancing and fawning over Mason, her ditsy cousin Gloria's jock boyfriend. The camera moves into a tight close-up as Perkins' brow furrows, and he glares at them as they leave the dance together. "Cut! Perfect!," calls Hooper, after the one and only take.[22]

[22] In his *I'm Dangerous Tonight* audio commentary, recorded for *The Pink Smoke Podcast* in August of 2021, cinephile John Cribbs quotes producer/screenwriter Philip John Taylor as saying that this insert shot of Buchanans' leering observation of Amy strutting in the red dress at the Spring Dance was filmed after principal photography had ended, purportedly costing the production $40,000 to recall Perkins and the crew. As delineated in this chronicle, this is patently false, but the discrepancy can likely be

Meanwhile, a portable telephone booth has been placed at one end of the walkway in order to shoot Perkin's side of Scene 123, in which Buchanan makes an urgent late-night call to Amy. (After all, what film crew doesn't bring along a phone booth with them wherever they go?)

Once again clad in his tweed jacket and scarf, Perkins is framed by the hard vertical lines of the phone booth with a soft-focus view of UCLA's iconic architecture and greenery in the background.

In the script, Buchanan's dialogue reads, "We have to talk. Are you alone?," but that has subsequently been amended to "We have to talk. <u>The dress is not destroyed</u>! Are you alone?" It is a small but significant addition which renders Buchanan's call both more desperate and more threatening.

Even at the end of this very long day, Hooper still has unflagging energy, which the crew seems to feed off of. The camera rolls, he calls for "Action!" and the dolly tracks in slowly as Perkins delivers his lines with his customary intensity, again nailing the scene in one take.

Up next, Scene 155: After Buchanan has unearthed Wanda Thatcher's grave, he gathers up the remaining shards of the enchanted red fabric, which seem then to have miraculously reconstituted themselves into the ancient sacrificial cloak. He gazes lovingly at his mystic acquisition, practically drooling as he basks in its overwhelming power.[23]

chalked up to Taylor's imperfect memory rather than to any attempt to deceive.

[23] Perkins' wild-eyed close-up of Buchanan's almost lascivious admiration of the now miraculously reconstituted cloak does not make it into the final cut, but is instead used as one of a series of "bumpers" between commercials when the film is broadcast, and also in promotional ads.

For this, the last shot of the night, Perkins' last shot of the show and, perhaps coincidentally, the last shot of the film, a folding table is set up in the walkway for Perkins to stand on and the camera is placed low pointing upwards at him in extreme close-up.

As he clambers up onto the table, he mutters, half joking, "I knew I was gonna' hafta' close this show every night!"[24]

[24]Anthony Perkins died on September 12, 1992, due to complications from AIDS. He was survived by his wife, Berry Berenson (who was herself tragically killed aboard American Airlines Flight 11 in the terrorist attacks on September 11, 2001) and two sons, Oz (named after his fraternal grandfather, actor Osgood Perkins) and Elvis, both of whom went on to careers in the entertainment industry, Oz in particular gaining acclaim as director of fantastical and lurid horror films *The Blackcoat's Daughter* and *Gretel & Hansel*.

FIVE

A TANGLED WEB

Friday, April 27, 1990

The Veteran's Administration (VA) has served American military personnel, their families, and the larger community for decades, since shortly after the cessation of World War I. Established in 1918, it has subsequently grown to encompass more than 150 hospitals and hundreds of outpatient clinics across the nation.

The VA Hospital in West Los Angeles is a sprawling six-story modernist structure situated on Wilshire Blvd in very close proximity to UCLA, which makes it a convenient shooting location for the production.

It's yet another gorgeous, sun-drenched afternoon when the film crew amasses outside the hospital to begin the day's shooting. Scheduled first on the call sheet is a relatively straightforward shot of Amy's car pulling up in front of City Hall and her entering the building on her way to pay a visit to the coroner.

Production designer Lenny Mazzola and his art department have fabricated a half-moon shaped sign to match the hospital's marbled façade, seamlessly incorporating it into one of the building's distinctive high-domed glass doorways. It reads, in large faux-carved Roman letters, TIVERTON CITY HALL.

It is decided that there is no need for the business of Amy pulling up in her car and entering the building in favor of a less complicated and more conventional establishing shot of City Hall. A few well-dressed extras are instructed to loiter just inside the

foyer as the camera rolls for perhaps 30 seconds, and then once again for "safety," that is, to be assured that they've got the shot.

Once the shot is in the can, the company proceeds to break down the equipment and move operations inside to the hospital cafeteria, where the bulk of the day's shooting is slated to take place.

Roughly two dozen student extras are seated at tables scattered around the lunchroom as the crew prepares to begin shooting Scene 85, in which Amy encounters Detective Aickman for the second time. Aickman's unexpected appearance and his persistent but ham-fisted questioning about her cousin Gloria's death and the provenance of the mysterious red dress are clearly intended to throw Amy off balance. She manages, though with some difficulty, to maintain her composure throughout their awkward exchange.

The first shot of the sequence begins with a close-up on a heaping plateful of ripe, *red* sliced tomatoes. (The film's color scheme, which by design generally accentuates browns, blues, and greens, features red only selectively in order to subliminally enhance the striking visual effect of the enchanted garment whenever it appears. In this instance, the bright red of the tomatoes serves as a signal that Aickman's investigation is skirting perilously close to the true nature of the red dress and to Amy's complicity in the deaths of her grandmother and cousin.)

Zooming out from the close-up, the camera dollies down the lunch counter, panning up to catch sight of Amy, tray in hand as she peruses the cafeteria's unappealing meal selection. Aickman sidles up beside her, puffing heavily on his cigar and engulfing them both in a cloud of thick smoke as he engages her in stilted conversation. Stifling a cough, Amy waves away the pungent vapor from Aickman's cheroot.

While rehearsing the camera move, director Hooper rides the dolly alongside DP Isaacs as key grip Michael Colwell pulls them slowly along the length of the steel steam table. Multiple takes will

be required to get the desired shot, coordinating the camera movement with the actor's blocking and dialogue.

As boom operator Cameron Hamza stands on the steam table adjusting for sound, Hooper (who doesn't miss a thing) warns, "Watch your foot! It'll go right through the top of that!" Looking on, assistant director Tom Blank calls for "Quiet!," attempting to reduce the crew's increasingly loud murmuring down to a dull roar. Sound mixer Craig Felberg also takes a turn riding the dolly and operating the camera, explaining when pressed, "Well, Levie's sittin' in my chair."

R. Lee is hilarious as he casually blows cigar smoke and drops ashes on the food warming on the hot plate, asking Mädchen, "Can I have lunch with you?," snidely adding, "Everything looks so good here." Actress Ellen Gerstein as the Server delivers her one line ("You can't smoke in here.") sternly, shaking her head with barely disguised disdain at Aickman's flippant reply, "I have special dispensation . . . *from the Pope.*"

In person, Ermey is nothing at all like his onscreen persona in *Full Metal Jacket.* Quite the opposite; he is charming and personable, self-deprecating, and quick to laugh. He interacts easily with the members of the crew and seems to know everybody by name.

Amy and Detective Aickman share a tiny table in the cafeteria as the scene continues. Aickman is almost Columbo-esque[25] in his affable misdirection as he deftly shifts his tone from sympathetic to confrontational and back, wolfing down his meal and picking at hers.

Mädchen's medium close-up is shot first. She manages to evoke

[25]*Columbo* was a television series in the 1970s featuring Peter Falk as the famously distracted Los Angeles homicide detective whose scattered demeanor is merely a pretext disguising his incisive observation skills and intuition.

anger and fear while also being stubbornly defensive and evasive, simultaneously maintaining Amy's essentially sweet nature. Hooper is extremely pleased with her multi-faceted performance, getting what he needs in very short order. The crew quickly repositions the camera and resets the lights for R. Lee's medium-close angle.

Mulling around in the background during the shot, the extras go about the business of filling their lunch trays, studying, or just chatting animatedly with one another. Ermey's face is delightfully expressive. He cocks his head, raises an eyebrow, and leans intently forward as Amy tries to deflect from his questions, savoring his cigar, chewing incessantly, and appearing alternately absorbed and dismissive.

Apart from his charming imposture of ineptitude, Aickman's most distinctive characteristic is his oral fixation, as evinced by his predilection for unhealthy snacks and the presence of a constantly smoldering stogie at the corner of his mouth (an affectation that may well have been inspired by director Tobe Hooper's near-legendary affection for fine cigars).

In the last take of the scene, R. Lee lights up his stogie and exhales a huge cloud of smoke, which slowly dissipates as he wraps up his casual interrogation of Mädchen. Aickman's line, "A death in the family is a terrible misfortune; but two deaths, in three days, Amy, well, that seems like . . . carelessness," is a sly paraphrase from Oscar Wilde's classic comedy of manners, *The Importance of Being Earnest*, wherein the haughty Lady Bracknell, reacting to John Worthing's explication of his orphanhood, intones, "To lose one parent, Mr. Worthing, may be regarded as a misfortune; to lose both looks like carelessness." Not exactly the kind of literary reference one might expect from a grizzled, small town police detective.[26]

[26]There was some speculation that *I'm Dangerous Tonight* might

When the scene is complete and Hooper calls out "Cut!," 1st AD Tom Blank announces the move to a different location in the hospital by saying, "All right, uh, what that means, uh, is that the company is now in the toilet!," to a hail of laughter from the cast and crew.

The hospital administration office has an adjacent private bathroom with a shower attached. This very small room is the location for Scene 72, which ostensibly takes place in Mason's bachelor pad apartment. Mason has just revealed to Gloria his "big secret" that, rather than proposing marriage as she had hoped, he intends to pursue a career in professional football. Mason is completely oblivious to the effect of his revelation on Gloria. But, fueled by consuming rage and the sway of the red dress, she brutally strangles, and then, fittingly, castrates him in the shower.

The role of Amy's flighty cousin Gloria is played by voluptuous young actress Daisy Hall, while newcomer Jason Brooks, making his film debut, has been cast as Mason, her hunky, self-absorbed boyfriend.

Interestingly, both Jason's and Daisy's first day of shooting features the scene that marks the definitive end of their character's relationship, Gloria's gruesome shower murder[27] of Mason while under the influence of the malevolent red dress. (Notably, this is

serve as a pilot for a television series featuring R. Lee Ermey as Detective Aickman, in which he would have confronted a different paranormal entity in each week's episode, similar to Darren McGavin's paranormal reporter Carl Kolchak in the classic 1970s TV program *The Night Stalker*. Sadly, this proposed series idea never came to fruition.

[27]An homage to Hitchcock's *Psycho*, perhaps? Hooper is on record as being an enthusiastic devotee of Hitchcock's oeuvre.

also the first time during production that anyone has appeared wearing that stunning garment.)

There being barely room enough in the bathroom for the camera, the DP, the 1st AC, and both actors while shooting the scene, director Hooper is relegated to hovering in the doorway as they roll.

No hot water is allowed while shooting, as the steam would tend to fog up the camera lens, so poor Jason is forced to endure a long afternoon of cold showers and tight quarters. Thankfully, he has been provided a pair of Speedos to wear for modesty's sake. Brooks is a trooper, but there is no overlooking his chattering teeth and shivering body between takes. (The day's call sheet calls for "lots of towels for wet actor.")

The first set-up consists of a low, slow dolly-in to a large close-up on Jason in the shower, dripping wet. (The tight close-ups and often low camera angles in this scene are, at least in part, necessitated by the cramped working conditions, especially the reverse shots of Daisy and the hand-held shots of Mason's strangulation, which require DP Levie Isaacks and 2nd AC Bill Roberts to squeeze together into the narrow shower stall along with their bulky camera rig, and also the use of wide-angle lenses.)

Mason thinks he hears noises but is oblivious to the havoc that Gloria is wreaking on his home, drowned out by the sound of running water. Sliding open the textured glass shower door, he calls out, "Hey, babe, you drop something?" Hearing no response, he shrugs and returns his attention to his shower.

Gloria enters the bathroom, fresh from trashing the apartment, fingering the stout sash cord that she has torn from the drapes during her destructive frenzy. The silken red dress hugs her body like a second skin. She leans against the cool tile wall outside the shower stall.

Fuming, Gloria demands to know, "How was she, Mason?"

"Who? <u>Amy</u>? I didn't touch her," he insists. (Mason may in

fact believe that he is telling the truth, since his desire to ravage Amy during the dance was never fully consummated. In the heat of the moment, when the red dress was removed, the spell was broken and Amy quickly reverted to her usual repressed self, escaping nearly naked into the night.)

Gloria sulks and upbraids him, "So . . . you're going to be a big football hero, huh, Mason?"

Snidely, he says, "That's what they tell me, babe," dismissively sliding the door closed and retreating behind the textured glass.

"Well, they told you wrong," she says simply, quiet rage overtaking her.

Gloria invades the shower from the sliding door behind Mason, looping the cord around his neck, pulling it tight and dragging him off his feet. He is an athlete in peak condition but seems no match for this slight female under the thrall of the demon-possessed Aztec cloak.

Hooper stages the scene so that when Gloria initially strangles Mason with the sash cord, they are both obscured behind the blurred glass of the shower door. (In the teleplay, none of this business with the shower doors is included. Instead, it seems to be Hooper's invention, conceived on seeing the set for the first time.)

Daisy cackles maniacally as she twists the sash cord tighter around Jason's neck.

Once Mason has sighed his dying breath, Gloria takes a shaver from the shower caddy, removes the razor and wields it menacingly.

As written, the scene ends with Gloria brandishing the razor blade, saying, "Our first and last night together . . . *babe*," leaving whatever happens next up to the imagination. But during the shoot, Hooper decides that castration is to be Gloria's fitting revenge for Mason's casual infidelity, directing Daisy to turn Jason over and slice at his crotch, eliciting cringes and uncomfortable laughter from several of the male crew members.

(Gloria's slaying of Mason in the shower is certainly an homage to Alfred Hitchcock's seminal film *Psycho*, in which female protagonist Marion Crane is shockingly and preemptively slaughtered by Norman Bates, and also likely a tip-of-the-hat to co-star Anthony Perkins.)

Incidentally, Hall's mother was actress Diana Lynn, who had enjoyed a robust film career during the 1940s and 50s. She had played opposite spitfire Betty Hutton as her little sister Emmy Kockenlocker in writer/director Preston Sturge's whimsical 1944 film *The Miracle of Morgan's Creek* and also co-starred with future U.S. president Ronald Reagan in the hit goofy chimpanzee comedy *Bedtime for Bonzo* (1951). Sadly, she passed away in 1971 as the result of suffering a stroke at the tender age of 45, when Daisy was still a toddler.

There is one final shot listed on the day's call sheet, an exterior of police headquarters. However, it is deemed unnecessary and scratched from the schedule, so the crew wraps for the day, thus ending the first week of principal photography on *I'm Dangerous Tonight*.

SIX

SATIN DOLL

Monday, April 30, 1990

The Ambassador Hotel is not only a legendary Hollywood hot spot, but also a historical landmark. It is both the location of the internationally famous Cocoanut Grove night club and the site of the tragic assassination of Senator Robert F. Kennedy.[28] The Ambassador opened its doors on January 1, 1921, and before long became the premiere destination for celebrities and jetsetters. Long fallen into disrepair, it is now primarily used for industrial parties and motion picture production. (In fact, director Mick Jackson's whimsical film *L.A. Story*, written by and starring comedian Steve Martin, is concurrently shooting at the hotel while *I'm Dangerous Tonight* is in production.)

 The set for the coroner's office is constructed in one corner of a large utility room in the sub-basement of the hotel, generally used for storing banquet tables and chairs between events. It is here where the crew have regrouped for an early morning call to begin the second week of principal photography.
 A small exterior reception office in the foreground is separated

[28] Kennedy was murdered on June 5, 1968, in the main ballroom of the Ambassador Hotel by Palestinian émigré Sirhan Sirhan (although there are conspiracy theorists that posit that Sirhan did not act alone).

by a gated chain-link fence from the records room in the background, lined with filing cabinets and banker's boxes. The place is a shambles, with chairs overturned and files and documents strewn about the floor, unmistakable evidence of an apparent burglary. In keeping with the color scheme of the film, the palate is muted earth tones and sickly greens; no red or blue. On a wheeled gurney shunted aside lies a dummy corpse, a prop which will ultimately not be used in the scene.

First up on the board for the day is Scene 94: Amy visits the coroner in an effort to retrieve the demonic red dress, only to find the office in a state of chaos, having ostensibly been vandalized and robbed, making it virtually impossible to trace the garment. Through a slightly convoluted bit of plot machinery, Wanda Thatcher (fresh out of drug rehab) is revealed to have been the technician that removed the still-intact red dress from Gloria's charred remains in the wake of her fiery accident. Learning that she has been absent since the recent advent of mysterious murders linked to a red dress, Amy takes advantage of the coroner's distraction by surreptitiously lifting Wanda's address from his rolodex and beating a hasty retreat.

Journeyman actor Lew Horn (whose name calls to mind a 1950s jazz trumpeter) is impeccably cast as the exasperated coroner (identified as Gilchrist in the script, but never actually called by that name), overwhelmed by disarray in the wake of the break-in at the morgue during the absence of his reliable but sketchy assistant Wanda Thatcher. Horn was a familiar face on series television throughout the 1980s, including appearances on *Fantasy Island*, *Matlock*, and *Night Court*, and a more recent foray into feature films as Lefty Moriarty in Warren Beatty's cartoonish adaptation of Chester Gould's *Dick Tracy* comic strip. In his white smock, spectacles, and pocket protector, Horn looks every bit the harried civil servant he's meant to portray.

DP Levie Isaacks and his team spend the day's first hour tweak-

ing the lighting and rehearsing the camera moves, with lighting doubles Mark San Filipo and Courtney Wulfe respectively standing in for Lew Horn and Mädchen Amick. With the camera mounted on the dolly, grip Dave Footman has very little space in which to execute the planned move, his back pressed up tightly against the room's far wall.

Hooper appears, bright-eyed and full of energy, clad in cap and leather jacket, with his trademark cigar and can of Dr. Pepper in hand. He drags his director's chair to a convenient vantage and immediately goes about inspecting the set. Absent-mindedly, he places his can of Dr. Pepper on the coroner's desk, removes his jacket and proceeds to confer with Levie regarding the specifics of the first shot. The room hums with activity. 1st AD Tom Blank's occasional gentle-but-insistent pleas of "Shush!" and "Quiet!" help to keep the noise of the rambunctious crew to manageable levels and the work on track.

"Let's rehearse, please!" Tom shouts as Levie asks Hooper, "You wanna ride this first one, Tobe?" "Yeah, man!" responds Hooper as they huddle together and review the scene. "Okay, here's where I am . . ." Levie continues, explaining his perspective on the shot.

Tom observes a foreign object visible in the shot and queries, "What's the deal with the Dr. Pepper can?" . . . prompting Hooper to sheepishly step over and remove it from the desk.

Hooper haltingly requests a particular prop, "Now, I, I need a book, uh, for, uh, for the coroner. 'The double-entry system.' A code book . . . he's checking." The art department hustles to provide an appropriate volume for the scene.

As San Filipo and Wulfe walk through the scene, Hooper mounts the dolly and gazes through the viewfinder to check the blocking and camera movement. "Let's try a rehearsal," Hooper says, then demurs, "We can't really have a rehearsal until we're ready with the lock," referring to the locking system that was busted purportedly during the "break-in." (It's not explicitly

stated, but it's clearly implied that the burglary was an "inside job," staged by Wanda in an effort to cover up her theft of the sinister red dress from the coroner's storage facility.)

Mädchen and Horn rehearse the scene multiple times before they roll film. Horn's characterization grows ever gruffer and more dismissive of Amy as they run the lines. He is also having considerable difficulty with a particular line, "The relatives get very upset when you hand them an *evening dress* and the deceased was a truck driver!" During one take, Horn stumbles, saying, ". . . see, the relatives get very upset if you hand them a *dressing gown*, uh, uh, uh . . . ah, shit!" eliciting a healthy dose of laughter from the crew. Says Horn, comically frustrated, "I don't know why I keep saying '*dressing gown*' instead of '*evening dress*.'"

They adjust the camera dolly for a new shot, a single favoring Horn. While key makeup artist Emily Katz touches him up, Hooper instructs Horn to simplify his business of tidying up the detritus of the vandalism to picking up only one or two documents.

Kneeling on the floor and rifling through the documents scattered around the office, the coroner bemoans his situation to Amy, who surreptitiously lifts Wanda's address card from the desktop rolodex and silently scurries off unnoticed. Glancing up from his rant, he finds that he is only talking to himself. "Miss O'Neill? Miss O'Neill?!," he shouts, a repeated trope in the script, in which Amy is forever dashing off as someone calls out after her.

At the end of the take, sound mixer Craig Felberg shouts, "Good for sound!" DP Isaacks is also satisfied, "Good for me!" But Hooper demurs, chuckling, "Uh, let's do one more for me!"

The next-to-last shot of the sequence is an extreme close-up on the Rolodex as Amy flips through the cards, searching for Wanda's address. Often shots like this might be saved as a pick-up[29] for a later date, or a stand-in would perform this action while the lead

actor relaxes in their trailer, but Mädchen is handy and keen to do it.

Once Tobe yells "Cut!," the crew instantly starts packing up their gear, eager to move out of the storage unit's dark, cramped space. Listed on the day's call sheet are two brief shots of Amy approaching and entering the coroner's office, but the producers, mindful of time and resources, have deemed them unnecessary, opting instead for a single shot of a clean frame to serve as the coroner's POV after Amy has already vanished.

The company moves immediately to the next scene: Amy's terse and unsatisfying meeting with a skeptical Detective Aickman at the police station.

Just down the hall, a spare, bare rental space has been transformed by the art department into the cluttered confines of Aickman's office, with light streaming through Venetian blinds, casting horizontal shadows on the wall, in a nod to the story's noir roots. The assembled cast and crew, as well as all of the lighting and camera equipment, only serve to make the tiny space even more claustrophobic.

In this brief scene, Amy meets with Aickman in his modest office, desperately attempting to convince him of the supernatural power of the red cloak without coming off like a crazy person. Aickman is more than just openly skeptical, he's dismissive and rude, even going so far as to suggest that perhaps Amy murdered her beloved grandmother for a paltry inheritance, leaving her shaken and in tears. (The scene as shot differs considerably from the script while still hitting all the salient points. Even so, the scene is somewhat truncated, having lost much of the opening

[29]A pick-up (or "insert") is a brief, usually mundane shot that conveys information necessary to the furtherance of the plot, e.g., picking up an object, opening a letter, answering a phone, etc., most often filmed after the completion of principal photography.

dialogue reiterating Wanda's role in Amy's wild tale of demonic fabric possession.)

Someone on the crew loudly notes that the glass on Aickman's office door has been erroneously inscribed "Homocide," rather than the correct "Homicide," sending set decorator Richard Spero scrambling to rectify the situation mere moments before the camera rolls, to the stifled amusement of the crew. (This correction is fortuitous, as the inscription can be read as a shadow on the wall when Amy exits the office and would have reflected poorly on the production.)

Fresh out of make-up and raring to go, R. Lee is a jovial presence on the set. Charming and rakish, he regales the crew with accounts of his storied career, particularly his work with maverick directors Francis Ford Coppola and Stanley Kubrick.

Ermey plays Aickman's oral fixation to perfection, whether gnawing voraciously on his cigar or stealing a stealthy bite of a hidden Mars bar. With his brusque manner, askew tie and slightly disheveled appearance, he hardly inspires confidence as a police officer, much less a lead detective. Ironically, as detailed in the script, his apparent shrewdness never quite pays off, as the ineffectual character always seems to be well behind significant events, and does not, in fact, intercede in any meaningful way.

Because of the tight quarters, camera movement is limited, but they do manage to squeeze the dolly into the room for a smooth opening tracking shot. The rest of the scene is captured and completed in two single shots of the principal players, with the camera mounted on a tripod ("on sticks").

In addition to the Cocoanut Grove and the Embassy Ballroom, the Ambassador Hotel also offers many deluxe accommodations for social or corporate events, including the Dolphin Court, a luxurious bar with adjoining dance hall/dining area (originally called The Spanish Patio and designed with a distinctly Latin

flavor, but ultimately redecorated and renamed), which serves as the venue for the Country Club Dance. The set decorator and his team have spent the morning dressing the room for the prom, including hanging an enormous mirrored disco ball from the ceiling. Also, fluorescent lighting has been tucked up under the bar for added illumination. With its checkerboard tile flooring, lush draperies, and stylish decor, the room provides a dazzling environment for the romantic drama of the upcoming scene to play out.

Scene 46/48: Impelled by the irresistible power of the ceremonial cloak, now repurposed into a sizzling crimson cocktail dress, Amy appears unannounced at the dance. Channeling Cinderella's arrival to the ball, haughty and resplendent in the shimmering red dress, backlit with a golden halo, she makes her grand entrance like a high fashion model prowling the catwalk. She takes her pick of one of the many potential suitors eagerly vying for her attention and together they hit the dance floor. Gloria is shocked to see Amy, meant to be at home tending to her elderly grandmother, twirling and grinding and making a spectacle of herself. Confronted between dance moves, Amy taunts Gloria and brazenly flirts with Mason, seducing him right out from under her, so to speak.

About 50 tuxedoed or formally dressed extras (all notably in dark shades of blue or black), from shaggy-haired surfers and well-groomed collegiate types to giddy schoolgirls and jaded partiers, are situated in and around the bar area for the first sequence, in which Amy arrives at the dance and causes a stir. Mädchen has spent the morning in wardrobe, hair, and makeup, getting all gussied up for her big moment. The first shot of the scene, however, focuses on Daisy Hall and Jason Brooks as Gloria and Mason respectively; the camera seeks them out on the dance floor, then dollies in to meet them in an intimate close-up as they register shock at Amy's ostentatious arrival.

Hooper has designed this sequence very economically, aiming to tell the story using as few "brush strokes" as necessary. This first shot begins on the bartender preparing a couple of drinks and placing them on a serving tray, then follows the waitress as she holds the tray aloft and navigates through the raucous crowd from the packed bar and onto the dance floor before settling on Gloria and Mason, lost in the music and each other's eyes. When Mason spies Amy, he forgets about Gloria and practically gawks at her now-steaming-hot cousin as she enters the bar. Miffed by his reaction, Gloria is clingy and petulant, her face contorted into a permanent pout.

The camera rig remains on the dolly for will be the next shot, *Amy's big entrance*. With her hair still up in curlers, Mädchen has arrived on the set for rehearsal. Hooper's blocking has Amy appearing in the archway, pausing a moment to be admired, then sauntering through the bar, every eye in the room watching her. Then, taking her chosen dance partner by the hand, she leads him right past Gloria and Mason, throwing a shady glance back at them as they pass.

Levie operates and 1st AD Wayne Trimble adjusts focus as they ride the dolly during camera rehearsal, following the tray of drinks while simultaneously tracking and panning. Once the camera move ends, dolly grip Dave "Foots" Footman undulates to the music until the playback stops, proudly parading his "MOVIE STUNTS TULSA" t-shirt. (In the finished film, the dance music is to be generic techno-pop, but to energize the partygoers during shooting, sound mixer Craig Felberg blares George Michael's infectious "I Want Your Sex" over the loudspeakers.)

1st AD Tom Blank has his hands full trying to keep the overly enthusiastic background players quiet between takes, insisting, "Keep the talk down! Can't hear anything but . . . a big *buzz*." But while the dozens of extras at first lower their voices, it's not long before their murmuring chatter once again fills the room with a

constant low-level hum, punctuated occasionally by Tom's cries of "Quiet! Please!"

"Cut!" yells Hooper after the first take is complete. "Good for me!" says Levie, as Hooper offers, "Okay, let's do, uh, do one more . . ." Interrupted by Craig asking the 1st AD whether he should shut the music down during the take or let it play, "Want me to cut it then, Tom?," Hooper answers instead, deciding, "No, we may as well keep it rolling." After a quick recalibration of the dolly move, Tom calls for another take, "Once again!"

"Sound speed!," shouts Craig. "46, take two, mark!" calls out 2nd AC Bill Roberts as he loudly slaps the clapboard shut. "And . . . background, *aaand* playback!" shouts Tom, cuing the music to play and the extras to dance. For this take, they've added an additional dolly move. The camera rolls forward toward the dance floor, catching Gloria and Mason swaying to the music, pulls back as they maneuver to the bar, then pushes into a large close-up as they register Amy's appearance.

The camera remains in place on the dolly for the next set-up, Amy's grand entrance. Radiant in red silk and backlit by a golden halo, Mädchen's magnetic allure makes a powerful statement about the attraction of evil. (Mädchen's contrasting vulnerability and strength invites comparison with iconic actress Gene Tierney, best known for her star-making role as a mysterious murder victim in Otto Preminger's 1944 noir classic *Laura,* with whom she also shares a captivating beauty.) She appears in the archway, shining like the rising sun, and sashays confidently into the bar while surveying the men for potential dance partners. Choosing an oblivious young man as a mate, she leads him by the hand right past Gloria and her boyfriend, glowering at them as they pass.

Mädchen engages in intense whispered conversation with Hooper in-between takes, adjusting and working out the details of her performance, which evolves with each subsequent attempt.

Cigar perennially in hand, Hooper stands on his toes and cranes

his neck to watch the action from behind the dolly. During one take, when he prematurely yells "Cut!," Mädchen looks to him quizzically, as if she thought that she might have done something wrong. "Not <u>you</u>," he reassures her, with a grin.

After 5 takes, Hooper huddles with the camera crew to review the shot while co-writer and executive producer Philip John Taylor stands by, watching pensively. "Checkin' the gate! Checkin' the gate!" Tom calls out, indicating that if there's nothing obstructing the lens, they're probably ready to move on to the next set-up. Through his tinny bullhorn, Tom announces to the restless background players, "Okay, now just hold your spots and be <u>quiet</u> while we check. <u>Thank you</u>!"

Eventually, the extras are temporarily dismissed, and the dance floor is cleared for rehearsal. As the scene continues, Amy leaves her mesmerized dance partner behind and twirls over to Gloria, eyes glaring at her with the heat of a thousand lasers, and Mason, staring lasciviously and slavering over her. Gloria confronts Amy, faking outrage about her having abandoned her aged grandmother at home, stammering "You left Gram all <u>alone</u>? -- What if she, what if she . . ." Amy interrupts her, wide-eyed with faux innocence, totally unrepentant, "What if she *what*? Breaks a <u>wheel</u>?," taking a kind of sinister glee in goading her. Gazing at her and grinning dopily, Mason likes this new, assertive Amy. Practically drooling, he makes no attempt to hide his infatuation from his girlfriend Gloria, who sulks and storms off.

The linoleum surface of the dance floor allows a smooth ride for the camera dolly, which is set for a tracking shot that glides in opposition to Gloria and Mason as they cross the room and settle in to keep a watchful eye on Amy as she uncharacteristically lets loose.

Exemplified in this scene is the film's clever color scheme: muted earth-tones, deep blues and striking blacks and whites (the checkerboard tile and the Art Deco ambiance) are contrasted with

the occasional distraction of brilliant red. In the luminous crimson dress and red-hot matching stiletto heels, Mädchen stands out from the crowd like a flame in the darkness while the mirrored disco ball sends flickering shards of reflected light dancing on the walls and ceiling as it spins. DP Levie Isaacks explains that the vibrant red color of the dress will be intensified even more by a special filter placed over the camera lens, appropriately referred to as "the enhancer."

2nd AD Keri McIntyre escorts select extras back to the set to continue with camera rehearsal. It's a bizarre sight when, after the playback is stopped, the dancers continue to shuffle and cavort as if the music were still playing, so that the actor's dialogue can be recorded clean (i.e., without ambient noise) by the boom mike hovering over their heads.

As realized by costume designer Carin Hooper, the garment at the center of the story is a classic satin cocktail dress with a fitted bodice and attached asymmetrical skirt, with two rosettes at the hip. In a darkened corner off the set, Carin is overheard responding to questions from an interested observer about the fabrication of the stunning red dress, "So, how many of those dresses did you make, er, have you ended up making?"

"Well, probably . . . about *fiiive*," stretching out the vowel sound, ". . . six?

"Wow, that's a lot!"

"Really? No."

"Six dresses? Six of the same dress?"

"Well . . . for two, three girls."

"Oh, that's right, I guess you're right. Anyway, it sure is pretty."

Director of photography Levie Isaack's fluid camera movement manages to capture quite a lot in this one shot: As Gloria and Mason huffily cross the dance floor, Amy disengages from her partner and the camera follows her to their side for their conten-

tious confrontation, remaining focused on Amy as they storm off.

Hooper spends a moment discussing and adjusting the blocking of the scene with the principal actors, indicating which direction he needs Daisy and Jason to exit the frame in order to set them up for the next shot of the sequence.

Meanwhile, Tom instructs the background extras on how to interact with the camera. "<u>Dancers</u>, what we wanna do, is make sure that we get a sense of movement . . . as the camera crosses . . ." he says as he designates their paths across the dance floor, also explaining that the playback will stop for the actor's dialogue, then start up again as the scene proceeds.

Meanwhile, Hooper has the actors run the scene at "half speed," so that the camera move can be finalized. He takes a seat in his director's chair to watch while enjoying his two favorite treats, a deep toke on a Havana cigar and a swig from a can of Dr. Pepper.

When Hooper yells "<u>Action</u>!," Footman expertly executes the dolly move, gliding in one direction as 1st AC Trimble pans the camera in another, following Mädchen as she twirls over to Daisy and Jason. Hooper sidles alongside, watching the actors intently as the scene plays out. At the song's end, the crowd applauds Amy and her anonymous partner for their sizzling dance moves, and she is quickly surrounded by hopeful suitors.

It's not often done, but, during one take, Isaacks interrupts the scene while rolling, explaining that one of the extras had blocked his view of Mädchen, who takes it in stride, shimmying over to Jason and playfully throwing her head back onto his shoulder, purring, "Oh, are we *cutting*?" Mädchen can barely contain her infectious enthusiasm as, even between takes, she continues to strut and sway while fetchingly running her fingers through her lustrous brunette hair.

In preparation for the next shot, best boy electrician Dickinson Luke, tall by any measure, stretches up to his full height and "winds up" the disco ball, setting it spinning as the camera rolls.

"Uh, Tom?," Levie asks just before they roll, "Make sure that the extras don't hit the camera!" To which Tom shrugs non-committally, "We'll do our best."

"Okay, here goes!" Tom shouts, "QUIET! <u>Rolling</u>!" 2nd AC Bill Roberts slates the shot as script supervisor Sandy Mazzola calls out, "Scene 48 *Baker*, take one!" ("Baker" standing for "B," meaning the second shot of the continuing scene.)

The loudspeakers no longer play George Michael's infectious pop tune, replaced instead by an energetic Salsa number, which inspires the dancers to surrender to the music.

As they enter the frame, the camera booms up and dollies forward into a large close-up of Amy and Mason as she lewdly caresses him. Driven by lust and unable to control his desire any longer (having been sexually frustrated by Gloria for months), Mason takes Amy by the hand and leads her from the place. (It's at this stage in the scene that the footage of Anthony Perkins as Buchanan arriving at the dance [which had been filmed the previous week on the UCLA campus] is to be inserted into the cut.)

This sequence has so many moving parts (the music, the dozens of extras, the delicate camera movement, the dialogue) that it's potentially a recipe for disaster, but the crew manages to skillfully address any complications that inevitably arise and efficiently get the scene "in the can."[30]

"<u>Cut it</u>!" shouts Hooper, pleased with being able to get the shot in one unencumbered take. With that, Tom announces what everybody's been waiting for. "Okay, we got some food out here!" he says, gesturing to the adjacent hallway, "Get somethin' to <u>eat</u>!" And the ravenous background players make a beeline for the exits.

With the room practically cleared, the company moves on to the

[30]"In the can" is filmspeak for the completion of a scene, referencing that the exposed footage is literally stored and sealed in a metal film can to be sent to the lab for processing.

last brief scene of the day. Scene 50: Retreating to a table off the dance floor, Mason fixates on Amy while Gloria stews, finally storming off in a huff. With Gloria off "powdering her nose," Amy cajoles Mason into dancing with her, practically dragging him onto the dance floor. Taken by Amy's new-found self-assurance, he needs little encouragement. In the script, this scene was intended to take place at the bar. However, for logistical reasons, it now occurs in a corner booth situated against the wall of the club, accented with decorative latticework and softly lit in shades of pastel blue and green (a motif that will return in the film's garden shed climax). The scene has been pre-lit by the electrical crew, so it's a simple matter of resetting the camera, and they're ready to roll.

Daisy is simply hilarious as the jilted girlfriend, jaw dropping in disbelief at Mason's boorish behavior. When she hisses at Mason, "Watch my drink!," and angrily bolts from the table, the drink may as well contain snake venom.

Mason's gaze never falters as Amy kittenishly slinks up to him. "Wanna do it with me, Mason?," Amy purrs brazenly into his ear, prompting his response, "You gotta ask?"

"Cut!," yells Hooper, and the long day's shooting comes to a satisfying end.

SEVEN

HOUND'S TOOTH

Tuesday, May 1, 1990

The Aztec Empire was a Mesoamerican culture that dominated what is now known as Mexico from the 1300s to the 1500s. Seeing death as an essential component of life, the Aztecs religiously practiced ritual human sacrifice and cannibalism in an effort to placate their various gods, and with a verve unprecedented in history. Over the course of a mere four days in 1487, it's reported that more than 80,000 prisoners were horribly flayed on a consecrated sacrificial altar. However, the idea that an Aztec sacrificial cloak might be imbued with evil is something that screenwriters Bruce Lansbury and Philip John Taylor made up out of, to coin a phrase, *whole cloth*. (In Woolrich's original story, the demonism of the fabric is vaguely ascribed to an ill-defined Satanic source.)

Scene 5/6: In the university's loading dock, tweedy Professor Jonas Wilson receives delivery of a large crate containing his much-anticipated treasure, an Aztec stone sarcophagus purportedly used in thousands of sacrificial rituals. Conveniently, the Ambassador Hotel's actual delivery bay doubles as the Tiverton College Museum's loading dock for the film. The place is dusty and dark, scattered with arcane statuary and historical artifacts and implements.

Cast as Frank, the hapless security guard, is character actor Dan

Leegant, an easygoing fellow who has previously appeared in many films and television shows, Clint Eastwood's *Escape from Alcatraz* and Francis Ford Coppola's *Peggy Sue Got Married* among them. In addition, young actor Juan Garcia[31] has been cast in one of his first film roles as delivery driver Enrique, who eerily and portentously warns the jumpy guard of the violent history of the altar.

Silver-haired and craggy, the picture of a small-town college teacher in his umber corduroy jacket and drab ensemble, William Berger is also on hand to assay the role of doomed professor Jonas Wilson. His daughter, Debra Berger[32] is present on-set to visit and to watch the proceedings, and has also brought along her teenage son, Tao.[33] (Additionally, Berger is serving as assistant costumer on the show.)

[31]Garcia has gone on to have an accomplished career, appearing in a broad assortment of films and television programs, notably as one of Cosmo Kramer's Columbian compatriots in a celebrated episode of *Seinfeld*, comedian Jerry Seinfeld's hyper-successful sitcom, which ran on NBC from 1989 to 1998.

[32]Debra Berger, in addition to being costume designer Carin Hooper's sister and therefore director Tobe Hooper's sister-in-law, is also an actress, having appeared in the small but memorable role of a rattled staff sergeant in Hooper's *Invaders from Mars* and earlier in Italian filmmaker Enzo G. Castellari's *The Inglorious Bastards* (the inspiration for Quentin Tarantino's intentionally misspelled reimagining *Inglourious Basterds*).

[33]Tao Ruspoli is the son of Debra Berger and aristocrat Alessandro Ruspoli, 9th Prince of Cerveteri of the Holy Roman Empire. He has since gone on to become a celebrated documentary filmmaker in his own right whose works include *Being in the World* and

Masterfully designed and built by uncredited artisan Daniel Miller (a veteran of Hooper's films, having also contributed his talents to the creation of the vast underground carnival mecca of *The Texas Chainsaw Massacre 2*), the altar is a solid stone block (though actually constructed from plywood and styrofoam) crudely carved with Aztec hieroglyphics of snakes and skulls and sacrificial victims. Sculpted at the four corners of the shrine's lid are images of Aztec dog Itcuintli, mythical guide for the dead, who accompanies the spirits of the deceased on their journey to the underworld. As the crew prepares to shoot, still photographer Eric Lasher circles the sarcophagus, snapping pictures from every conceivable angle.

Special makeup effects artist Steve Neill, who had previously worked with Hooper on *Spontaneous Combustion*, has designed and constructed the shriveled Aztec corpse that resides within the coffer, based on his own research into the process of mummification and preservation of cadavers throughout history. Although present on the set, time constraints dictate that the close-up shots in which the mummy/dummy is featured will be pushed to later in the schedule.[34]

The security office abuts a small platform a few steps above the bay's concrete floor. On the wall just outside the office door are displayed a Gothic battle axe and a medieval *flail*, a spiked metal ball attached to a wooden handle on a chain (often misidentified as a *mace* or *morning star*). The dolly has been lifted onto the platform for the first shot of the scene.

Flamenco: A Personal Journey, and was also famously wed to actress Olivia Wilde (*House*) from 2003 until 2011.

[34]In fact, these close-ups of the mummified cadaver were among the very last shots of principal photography captured on the film's final day of shooting.

The security office abuts a small platform a few steps above the bay's concrete floor. On the wall just outside the office door are displayed a Gothic battle axe and a medieval *flail*, a spiked metal ball attached to a wooden handle on a chain (often misidentified as a *mace* or *morning star*). The dolly has been lifted onto the platform for the first shot of the scene.

In the darkened room, the guard squats beside the altar, smoldering cigarette at his fingertips, curiously inspecting the detailed carvings, when he is startled by a sudden flood of light as Wilson emerges from the shadowy darkness, practically quivering with excitement.

Startled, the guard blurts out, "Gee, Dr. Wilson, you scared the hell out of me!," then, awkwardly attempting casual conversation, remarks, "That's some sacrificial altar, huh?" Abstracted, Wilson responds, "Indeed it is, Frank." Wilson seems to revel in the specifics of the Aztec blood sacrifice, fairly slavering as he describes how the victim's "hearts [are] torn from their living bodies," much to Frank's consternation, so he sheepishly retreats to his office.

Pinned to the bulletin board in the security office are provocative safety posters warning against choking hazards and instructions for carrying out the Heimlich Maneuver. As a Big Time Pro Wrestling match plays on the tiny screen of the portable TV set on the office desk, the brutal sounds of the contender's sweaty bodies hitting the mat fill the air.

Hooper prowls around the camera as they roll on the first take, craning his neck to get the best vantage point. Before the next take commences, he instructs Leegant to shut the office door behind him quicker and more forcefully.

Hooper's personal assistant Rita Bartlett[35] sits on the sidelines,

[35]Bartlett would not only go on to work with Hooper on several subsequent projects (*The Mangler, Tobe Hooper's Night Terrors*),

posing playfully and suggestively for the production's videographer.

With the camera still in place, they set up for a rolling dolly shot of the spot on the wall where the axe had been hung (but which is now conspicuously missing). Hooper holds the flail's spiked metal ball and allows it to swing from the chain before the camera rolls, moving swiftly into a tight close-up and revealing the absence of the axe.

Travelling smoothly on the track that the crew has laid, the camera dollies alongside the sarcophagus while Berger (as Hooper has demonstrated for him) runs his fingertips over the grotesque imagery of human suffering chiseled into the sides of the altar, ostensibly searching for a means to crack open the treasured relic. Watching intently from beside the camera, Hooper talks Berger through the motions, "Just . . . back off and just look at it a beat. Okay, now look over from there, look back at your work bench . . . okay, go get something *better*."

While consulting a pocket notebook, in an effort to dislodge the chest's locking mechanism, Wilson taps gingerly with a mallet on the skull symbol carved into the altar. According to Wilson's notes, the sarcophagus is meant to open automatically when the proper combination of actions occur and the mechanism is unlocked. Interior gears grinding, the great fanged jaws of the Aztec dogs at the artifact's four corners slowly drop down, gaping wide and spilling torrents of ancient desert sand into piles on the floor, discharging billows of stale air and uncoupling the

but she would also supplant Carin Berger as Hooper's new paramour once their divorce was finalized in 1990. Their tumultuous on-and-off relationship culminated in a short-lived marriage in 2008 that ended in divorce in 2010. She is also the author of a steamy romance novel entitled *The Cuban*, which was published in 2015.

ponderous lid from its moorings. On the first attempt, the jaws on one of the dogs opens precipitously, while on the second take another fails to open at all.

This effect is in fact achieved by having two unlucky crew members secreted inside, both simultaneously pushing up on the lid from within on Hooper's cue. Attaining the desired result requires many awkward attempts, but after several aborted takes, they finally get a shot that can be lived with. (On the last take, once Hooper yells "Cut!" the lid slams shut, spewing dust and sending an echoing THUD through the room, eliciting chortles from the crew.)

"Tonight, you've joined us," intones sound mixer Craig Felberg for the videographer's camera microphone, "on a major motion picture set, directed by Tobe Hooper . . .," but is then drowned out by the sounds of the crew hard at work in preparation for the next shot, in which the lid of the sarcophagus miraculously creaks open.

The loading dock has been trashed. Tables are overturned, broken pottery and statuary litter the floor and packing materials are strewn everywhere. The camera, however, is first turned in the opposite direction to film the arrival of the altar and the guard's conversation with the delivery driver. Discussing the series of events with 1st AD Tom Blank, Hooper details the sequence of shots, "Then we have to do, we have to take . . . this is not necessarily the sequence, but . . . Frank comes out, originally, and goes over there to let . . ." As he gestures to the dock's open door, Tom prompts helpfully, "To meet the sarcophagus coming in." "So that would be like a master," Hooper continues, ". . . and then <u>punch in</u> to get the close-up, with the lines . . . then, uh, then the truck is beyond <u>that</u>, let's say, with the headlights still on as he opens the door . . . okay, then the <u>murder</u>," conferring together so that they are all <u>literally</u> *on the same page*.

As the evening progresses and the cool night air suffuses the

dock, the crew bundles up and Hooper slips into his beaten leather flight jacket to guard against the encroaching cold. Meanwhile, awaiting the crew's readiness, he busies himself artfully arranging the debris scattered across the floor to his satisfaction.

Set onto a wooden pallet, the altar is forklifted through the wide doors of the bay and set in the middle of the dock. A large swath of Duvetyne (a velvety black twill fabric that absorbs light, often used in stage, film and television production) is draped just outside the door to simulate the darkness of night.

A conversation ensues about the delivery truck's headlights, seen in the background through the dock's open door. "Do you want the headlights on the truck <u>on</u>?," Tom asks Hooper. "Naw, not at this point . . . yeah, at this point he would turn 'em off," says Hooper. 2nd AD Keri McIntyre points out a possible continuity error and Tom agrees, "They were <u>on</u> in the shot where we looked out the window . . ." But Hooper avers, "Yeah, but he sits in [the truck], brings it over here . . .," explaining that amid all the activity, Enrique would likely have turned them off by now. It's finally decided that the lights should be left off for the shot.

Once complete, at Hooper's direction they move immediately to shoot Frank's close-up as he looks back at Wilson skeptically and retreats to the comforting confines of his cozy office.

Somehow Wilson has managed to strap the altar's heavy lid to a hydraulic lift in order to raise it above the floor of the loading dock. (An impossible feat for one man, an obvious fact which is simply glossed over by the filmmakers. When asked about this apparent discrepancy, Hooper responds with a sly grin, "Movie magic.")

Now sporting the silken sacrificial cloak slung over his shoulders and tied at the neck, Berger wildly brandishes the axe, leading Hooper to ponder aloud, "Is that thing, uh, <u>is the head screwed down on that thing</u> . . .?," bringing guffaws from the camera crew. Musing, he steps up and takes the implement from Berger (whom

he familiarly calls "Billy"), demonstrating for him how to play the moment, passing the implement furtively from hand to hand, feeling the weight of the weapon as if toying with the guard before lopping his head off.

Even before the camera rolls, Berger prepares by mimicking Hooper, hefting the axe from hand to hand and feeling its weight with homicidal anticipation. On "Action!" Leegant's guard descends the stairs, looking about, confused by the room's disarray. He calls out[36] for Dr. Wilson, warily approaching the now open sarcophagus and peering at the decaying human remains within, sickened by the sight. Suddenly, a flash of crimson from the surrounding darkness, Wilson emerges into the light and swings the heavy axe at his poor, unwitting victim.

Hooper is keen to catch Wilson's shadow on the wall as he approaches the guard with the axe raised, but since the desired affect cannot seem to be achieved, the idea is abandoned. Reimagining the scene, Hooper decides that the moment will be more effective if shot hand-held, so Isaacks hoists the camera onto his shoulder with 1st AC Wayne Trimble trundling along beside him to pull focus. When Hooper considers adjusting the shot, Levie chuckles, "It won't hurt my feelings if you don't like it."

Not entirely satisfied with the scene as staged, it's decided that Wilson should instead surprise Frank by barreling down the steps and instantly assaulting him with the axe, having effectively followed him from behind. The blocking is swiftly reworked and as a result the entire shot is faster and far more frightening.

As Frank is faced with Wilson's mad, murderous gaze and realizes his inescapable fate[37], he emits a choked, guttural scream,

[36]Frank's astonished exclamation, "Good Lord, what happened here?" would be over-dubbed in post-production.

[37]Frank's fate represents one of the film's few echoes from the

"*AAUUGGHHH!*" "Cut! Okay, print that, and one more, just for . . . *scaries*," quips Hooper.

(Listed on the day's call sheet is Scene 115, in which Amy flees Wanda's apartment by climbing down the building's rickety fire escape, originally intended to be filmed on the UCLA grounds. However [very probably due to time constraints], the scene will be rescheduled to be shot at a later date.)

original novella's narrative, in which a night watchman is also horrifically murdered (although in Woolrich's story, it is a killing committed by a woman under the influence of the red dress rather than by a crazed college professor in the thrall of an ancient Aztec sacrificial shroud).

EIGHT

GIVE 'EM THE SLIP

Wednesday, May 2, 1990

Closed to the public in 1989 due to urban decline, the Ambassador Hotel has since become a convenient Los Angeles locale for film, television and commercial production[38]. Many of its staggering 1,000 guest rooms and bungalows have been used for myriad movies and TV shows. One of these bungalows has been repurposed to serve as Wanda's dreary one-room flat for the *I'm Dangerous Tonight* shoot.

About fifteen people, including director of photography Levie Isaacks, his two camera assistants Wayne Trimble and Bill Roberts, 1st assistant director Tom Blank, script supervisor Sandy Mazzola, production designer Lenny Mazzola, producer Joe Bellotti, costumer Julia Gombert, still photographer Eric Lasher, director Tobe Hooper and others, are squeezed into the cramped cottage room, virtually bouncing off the walls and one another, when actress Dee Wallace-Stone arrives on the crowded set, sexily

[38] Following a protracted but failed legal effort by the Los Angeles Unified School District to preserve the historical landmark, it was largely demolished in 2005-2006, leaving only the hotel entrance and the east wall of the Cocoanut Grove remaining. In 2009-2010, six learning facilities were erected on the site, collectively named The Robert F. Kennedy Community Schools.

appointed in the revealing red dress, flashy feathered earrings (designed by Gombert), gaudy silver rings and bangles and bracelets, sheer dark stockings and jet-black fright wig.

Stone, certainly best remembered as the harried divorced mother of three in Steven Spielberg's 1982 film phenomenon *E.T.* (as Dee Wallace[39]), is cast defiantly against type as recovering drug addict Wanda Thatcher, who inadvertently succumbs to the power of the evil garment. She has enjoyed a successful genre career, notably appearing as a virtuous television reporter in director Joe Dante's seminal 1981 horror/comedy *The Howling* (in which she transforms into a particularly adorable werewolf at the film's climax), and as a suburban housewife terrorized by a rabid Saint Bernard in Lewis Teague's grueling adaptation of Stephen King's brutal novel *Cujo* (1983). She is also well-known for her role as the married daughter of the victimized family in Wes Craven's cruel and grimy *The Hills Have Eyes* (1977.)

Far from her more conventional roles as doting mother and/or wife, this opportunity to take on a darker and much more troubled character may well be what attracted her to the role of Wanda.

Lines of mock cocaine (actually crushed aspirin) have been drawn out onto a mirrored tray on the room's small kitchenette table, implying that while under the influence of the haunted garment Wanda has reverted to her former wicked ways. Hooper attempts to set the stage, "She's been, like . . . drinking . . .," only to be interrupted by Lenny, "Oh, I've got vodka bottles <u>all over the place</u>!" "Put 'em over there by her bedside!" instructs Hooper, intending to further highlight Wanda's addictive propensities.

[39]Wallace-Stone was married to actor Christopher Stone from 1980 until his untimely demise in 1995. They starred together in several films, including both *The Howling* and *Cujo*. After his death, she reverted to using the name "Dee Wallace" in credits for film and television appearances.

Always looking to minimize the presence of red in the film's color palette, Hooper expresses to Lenny his concern about the prevalence of it in the room's seedy decor (particularly in the generic still life paintings hung tilted on the walls), but quickly reconsiders, saying, "That's okay, Wanda can have some <u>red</u> in here. Actually, that's . . . I'd forgotten that I'd <u>asked</u> for some *red*."

Stand-in Courtney Wulfe reclines comfortably on the dingy bed while gaffer Robert Moreno tweaks the lighting, but immediately gives up her place to Dee when she enters. The camera (which Hooper impishly refers to as "the machine") is mounted on the dolly, which takes up considerable space in the already crowded room. Before rolling, Hooper looks through the viewfinder, gives Levie an approving thumbs-up, and they proceed to shoot Scene 100, in which Wanda abruptly ends her awkward, prying phone conversation with Amy (attempting to discern the fate of the cursed garment, which has presumptively been destroyed in the fiery crash that took Gloria's life). DP Isaacks stands on the dolly and operates the camera, boomed high and looking down into a large close-up on her face, which then pulls back wide and pans down the length of her body, revealing that she has been wearing the dress in question all along, and has become yet another unwitting vessel for its malevolent power.

Later, in a continuation of the scene, after having received Amy's ill-advised phone call fishing for information, Wanda makes a call of her own to her boss at the coroner's office, seeking an address for Amy's late cousin Gloria, from whose charred remains she retrieved the cursed red garment that now adorns her body. (Since she has just returned from her supply run to the corner market, she has donned her black raincoat.) Heavy-lidded, wavering, and noticeably slurring her words, Wanda dials the phone while absent-mindedly tugging at a stubborn strand of hair. Momentarily spacing on her lines, Dee queries Sandy, "<u>What's</u> her name?" before recalling on her own, giggling, "Oh, yeah, <u>Gloria</u>

Randolph. Duh."

The atmosphere on the set is relaxed and playful. Pleased with their progress, the director and his crew banter together. "Great, excellent," comments Hooper.

Tom joins in, "What could be better?"

"It's all falling into place," Hooper continues.

"We must be livin' right!" Levie chuckles.

Isaacks uses his light meter to check for the proper f-stop[40] and requests a change of lens, switching to a standard 35mm, which generally approximates reality, with no measurable distortion. Accordingly, Hooper suggests that he sit on the bed with the camera on his shoulder and then rise as Dee picks up the phone. Eventually the move is amended in reverse, so that Levie begins standing, then sits, the camera following the receiver as she lifts it to her ear.

Dee nails it on the next take and Hooper is noticeably pleased with her performance. After posing briefly for photographer Eric Lasher, she gives Hooper a big hug and graciously addresses the crew ("Thanks, everybody!") as she leaves to prepare for the next sequence.

Hooper and Isaacks opt to shoot the scenes in which Amy invades Wanda's apartment hand-held, for both economy and to evoke a sense of anxious immediacy. The room is moodily lit in pale blues, artificial moonlight streaming through the billowing diaphanous drapes.

Mädchen warily enters the room, her eyes scanning the threadbare apartment for any sign of the haunted red dress. The camera follows her movements as she searches in the closet, under

[40]The "f" in "f-stop" stands for "focal length," and a light meter is used to quantify the available light so that the camera's aperture may be optimally adjusted.

the bed, even checking the refrigerator, all to no avail. Startled when she hears the click of Wanda's key in the door, she barely manages to flee via the fire escape before she is spotted. Wanda enters, fairly sniffing the air for any trace of an intruder, but Amy is long gone.

Earlier in the day, another of the hotel's multitudinous guest rooms had been dressed as Mason's bedroom, a typical bachelor pad decorated in tastefully muted colors, featuring an enormous bed with fine linens, fine art prints on the walls, and expansive shelves filled with certificates and trophies and assorted football mementos. Scene 69: Gloria, having surrendered her virtue to Mason under the misapprehension that he was primed to propose marriage, is crushed by the revelation that his "big news" is instead the offer of a cherished NFL contract and his mocking intention to leave her high and dry to pursue fame and fortune as a football hero.

Scene 71: As Mason retires to the shower to wash away the memory of their sexual encounter, Gloria remains in the bedroom to process her predicament. In profound shock and disbelief, she rises from the bed, draped only in her sexy black lace slip. Distracted, she steps onto the demonic red dress, which lies in a post-coital heap on the floor, and its malignancy overtakes her. Shot from a strategically low angle, her breasts heaving in barely contained anger, she snuffs out her lit cigarette in the carpet with her bare foot, plotting revenge against her arrogant, self-obsessed boyfriend. Responding to Mason's invitation to join him in the shower, she whispers to herself with a sinister leer, "In a minute."

Clad once again in the evil red dress, Gloria trashes the pristine apartment, ripping the bedclothes to shreds, bouncing the expensive table lamps off the bed, smashing picture frames and sweeping assorted memorabilia from the mantle, sending them crashing to the floor, as Mason calls pitifully from the bathroom, "Hey, babe, you drop something!?"

Levie operates the camera hand-held while Daisy has a field day destroying the set with abandon, every actor's dream. Far from being drained by her exertions, between takes she instead seems rejuvenated by her efforts.

Tearing the curtains from the windows, Gloria happens on the knotted drapery cord, sparking a nasty idea in her distracted mind. Possessed, she pulls the rope taut with uncanny strength, then saunters directly to the bathroom to carry out the deadly deed.

Meanwhile, the opposite side of the same room has been dressed as Eddie's apartment, an unremarkable, sparely decorated dorm with tacky second-hand furniture and outdated shag carpeting. Scene 68: Eddie and Amy cuddle on the sofa, the remains of a romantic candlelit Italian meal spread across the coffee table. Under the pretense of confronting her about having attended the school dance despite her claim of having no intention to do so, Eddie rhapsodizes about how "incredible" she looked in the striking red dress, gently pressuring her to "wear it for me sometime . . . just for me." But when she lies, telling him that she had "got[ten] rid of it," his demeanor changes instantly, turning from a caring and concerned boyfriend into a disbelieving interrogator, very nearly ruining the evening with his accusatory tone before Amy brings him back to his senses by insisting, ". . . it was only a dress."

The scene is captured in a few beautifully composed tight close-ups of Mädchen and Corey, respectively, and a wider master shot; large in the foreground, Corey drops the needle on a vinyl record spinning on the turntable. As he returns to join Mädchen on the couch, the camera dollies forward and a crew member wheels the record player aside to allow the camera to continue forward into a two-shot of the tentative young lovers.[41]

(The day's call sheet indicates that "time permitting," two additional scenes remain to be filmed; Amy's narrow parking lot escape from Mason's lustful clutches and an establishing shot of the country club where the school dance takes place. However, time does <u>not</u> permit, and so those scenes will be pushed to later in the schedule. Which brings the film unit's sojourn at the Ambassador Hotel to an end.[42])

[41]This move is edited from the finished version of the film, instead cutting away before the camera begins its slow creep forward.

[42]Hooper would revisit the Ambassador in 2004 for *Toolbox Murders*, his superlative remake of Dennis Donnelly's 1978 grindhouse classic (which many consider far surpasses the original), and one of the last films to use the hotel as a shooting location.

NINE

LOOSE THREAD

Thursday, May 3, 1990

Established in 1924 and located in close proximity to the legendary Metro-Goldwyn-Mayer (MGM) Studios, The Culver Hotel is a once-luxurious destination serving the Hollywood elite that has certainly seen better days.[43] Its opulent Art Deco stone facade is the antithesis of the shabby flophouse in which Wanda Thatcher resides, so it is the hotel's modest rear entrance that serves as the building's lobby for today's shoot. Scheduled to be filmed here are a couple of scenes (103, 104) in which Amy finagles her way into infiltrating Wanda's threadbare apartment in an ultimately futile effort to retrieve the cursed red dress from her possession. Little does she know that Wanda has merely stepped out while wearing the dress for a brief excursion to the local convenience store to

[43]The Culver Hotel was also notorious as the site where, during the filming of Victor Fleming's classic adaptation of L. Frank Baum's fantasy novel *The Wizard of Oz* (1939), the little persons appearing as Munchkins were housed, famously reveling in unchecked havoc and debauchery, a situation which was dramatized in the 1981 film *Under the Rainbow* (director Steve Rash's woeful effort featuring Chevy Chase and Carrie Fisher), appropriately also filmed largely at The Culver. The hotel has since been fully renovated and has regained its prior reputation as an elegant and desirable tourist site.

replenish her ice cream supply. Shooting begins late in the day and will extend far into the night.

Playing the affable, easily manipulated landlord, short and stocky character actor Jack McGee is a familiar face to movie and television audiences. Beginning his career in director Bob Clark's (*Porky's*, *A Christmas Story*) *Turk 182,* he has since made his living assaying memorable roles in everything from straight drama such as *St. Elsewhere, L.A. Law,* and Oliver Stone's controversial *Born on the Fourth of July*, to situation comedies like *Night Court, Perfect Strangers*, and *Roseanne*, often reliably cast as a sympathetic sidekick or small-time crook.

Somewhat counter-intuitively, the scene in which Wanda arrives back at the hotel to be told by the landlord that he's granted Amy access to her apartment (111) is shot *before* the scene in which Amy arrives and cajoles her way in (which necessitates the art department painting some of the yellow portions of the wall a ghastly avocado green).

In the script, once Wanda realizes what the landlord has done, she takes the stairs "two-at-a-time, like a cat," but Hooper requests an additional beat for Wanda to express her anger, so instead Dee snaps her fingers at him dismissively and hisses "You jerk!" before racing upstairs, to which he responds saltily, "Jerk? I got yer 'jerk!"

Leaving the camera in place, they proceed to shoot Amy's entrance to the lobby and her wily conversation with the landlord, first in a master shot and then in two separate close-ups. She encounters him up on an aluminum ladder placed on the staircase landing as he applies paint to the lobby wall, trying to decide which option, either sickly yellow or sickly green, looks best. (It's perhaps noteworthy that the landlord engages Amy in a conversation regarding what color the hotel lobby should be painted in this film in which color plays such an important role.)

The scene ends with a lovely forward dolly shot that tilts up and follows Mädchen as she ascends the stairs.

The company moves outside to shoot the building exterior, in which Amy arrives at the precise moment that Wanda leaves, parking her hatchback right next to Wanda's Toyota. Neither of them knowing what the other looks like, they cross paths without either of them sparing a second look. (If Wanda hadn't dropped her purse on her way out [another added bit of business, as opposed to in the script, where they both simply miss each other], distracting her momentarily, things *might* have turned out differently.) With the scene already pre-lit and the camera pushed closer to the lobby entrance, the shot of Wanda's return with her indulgences in tow is captured quickly and easily in one take.

Jerry's Market on nearby Higuera Street in Culver City serves as the convenience store that Wanda patronizes before her abrupt return to her apartment. The clerk is played by an uncredited extra, a young Asian woman who seems perfectly suited to the part. She regards Wanda dubiously when she comes to the counter with her late-night purchase of three giant tubs of ice cream and two pints of vodka.

A local Chevron gas station at the intersection of Washington Blvd. and Ince Street serves as the location from which Amy makes her ill-advised phone call to Wanda, having surreptitiously lifted her number from the rolodex in the coroner's office. Amy grills Wanda about the disposition of the red dress, objecting when she contradicts herself in saying that it was "burned to ashes," but then asserting that she "took it off her myself," which leads Amy to probe, "But if it burned to ashes, how could . . .?" "*Who* is this!?," Wanda snaps, causing Amy to abruptly hang up and end the call.

The art department has brought along a coin-operated pay phone prop for the scene and placed it at a corner of the station's lot. The phone call is divided into two shots; a medium shot at eye level, and also from a high angle looking down on Mädchen, using

a wide lens, which slightly distorts the image. She struggles a bit with her lines as script supervisor Sandy Mazzola reads Wanda's dialogue (Dee's end of the call having been filmed the previous day on the set of Wanda's bedroom at the Ambassador Hotel), but eventually gets through the scene without error.

The crew now moves a few blocks away to the next location, a back alley near the corner of Higuera and Ince Streets. The lighting team have erected two flood lights at either end of the alley, conveying a sense of imminent danger and dread, as well as a few strategically placed tungsten lights to create contrasting pools of pale-yellow incandescence. A cursive blue neon sign reading "Lounge" hangs above the doorway of the distressed wooden entrance to a hole-in-the-wall dive bar, barely illuminating the otherwise dim alley in this seedy, crime-ridden part of town. Obviously up to no good, two belligerent punks (played respectively by Daniel "Xavier" Barquet and Matthew Walker) stumble out of the bar and into the alley, scouring the night for trouble.

Barquet[44] made his film debut in a small role in Troma's infamous *The Toxic Avenger,* played multiple characters in Michael Mann's inexplicably popular television show *Miami Vice* between the years of 1985-1989, then returned to Troma to appear as Sarge in their laughable low-rent actioner *Fortress of Amerikkka.*

Just prior to *I'm Dangerous Tonight*, Walker appeared as Spitz

[44]Barquet is incorrectly identified as Bill Madden in the film's credits and on IMDB (Internet Movie Database), his role having been mistakenly switched from "Punk #1" to "Tybalt" in the Romeo and Juliet rehearsal scene (actually played by Madden, as previously noted). Barquet eventually graduated from actor to producer, overseeing many film projects until his untimely death in 2006 at the tender age of 46.

in the fifth installment of John Carpenter's *Halloween* franchise, having previously been a series regular in the TV show *Supercarrier*, a dreary program about the adventurous lives and missions of sailors and pilots aboard a state-of-the-art United States aircraft carrier.[45]

Key grip Michael Colwell and his crew have laid a short section of dolly track for the first shot of the sequence, a brief tracking shot in which the young troublemakers exit the bar, laughing and grab-assing, with nothing much but mischief on their minds.

Scene 83/84: The two brazen punks, after trashing the alley and attempting to set off the car alarm of a Mercedes-Benz parked outside the bar, notice Wanda's shadowy figure as she emerges from an adjacent passageway and strolls carelessly down the alley. Seeing her as a potential conquest, they catcall and threaten, one even going so far as to brandish a switchblade when she fails to so much as acknowledge their presence, bellowing childishly, "Oh, I'm talkin' to YOU, sugar . . . and I got somethin' for you, honey!"

But it quickly becomes apparent that they've chosen the wrong target when an unidentified "well-dressed man" (played by yet another uncredited extra) staggers from the passage, holding his hand to his freshly slit throat and gurgling blood, an unfortunate victim of Wanda's unconstrained rage. His futile pleas for help result only in the two punks scampering from the scene as fast as their legs can carry them.

Meanwhile, Wanda continues on her way, never sparing a glance back at the violence left in her wake, eventually dropping her black slicker to reveal the shockingly radiant red dress underneath as she shrinks into the distance.[46]

[45]Walker has gone on to have a lengthy and varied career in film, television, and live theater, including a stint as a clown for traveling circus *The Greatest Show on Earth*.

Incidentally, the day's call sheet features a rough pencil sketch by an anonymous crew member of the Aztec dog from the sarcophagus scene that was filmed at UCLA a few days prior.

[46] This striking image of Dee strolling down the alley unfurling her black slicker like a cape and exposing the ripe red fabric of the dress was used as one of the "bumpers" between commercials when the film originally aired on the USA Network.

TEN

NIGHT GOWN

Friday, May 4, 1990

Situated on a quiet suburban street in sleepy Alta Dena, the location chosen as Aunt Martha's house is a classic American Craftsman home, easily identifiable by its gabled roof, distinctive porch and artful exterior stonework, as well as its cobblestone driveway and well-tended landscaping. Dubbed "The Hyde House," after its current occupants, it will serve as the production's home base for roughly the next week of principal photography.[47]

Amy resides there along with her elderly grandmother, an awkward arrangement necessitated by her parent's untimely demise, their presence barely tolerated by her parsimonious Aunt Martha and petulant cousin Gloria.

Outside in the still late afternoon air of the home's backyard, the art department has erected an avocado-colored lattice-work arbor and garden shed (a possible callback to the lattice decor at the school dance and the avocado paint in Wanda's hotel foyer), with store-bought foliage encasing the area. In this penultimate

[47]It's worth acknowledging that *I'm Dangerous Tonight* was shot entirely on location, utilizing no sets or stages (with the obvious exception being the literal stage of Royce Hall on the UCLA college campus).

sequence (Scenes 144, 146/147, 151), Amy discovers Wanda's dead body and faces off with Eddie in a final confrontation of good versus evil, passionately pleading with him to reject the enticement of the cloak and to battle it together with the powerful love that they share between them.

Awaiting the readiness of the crew, still photographer Eric Lasher and grip Marcus "Roo" Flower reminisce about their shared experiences working together on *Spontaneous Combustion* while Hooper and 1st AD Tom Blank review the evening's shot list. Meanwhile, make-up artist Emily Katz applies a nasty contusion to Dee's forehead, the "subdural hematoma" that Detective Aickman presumes to be the cause of Wanda's death. When Hooper is called over to evaluate the result, he looks it over and asks, "Now, is that going to look like a scar, or dried blood?," also suggesting that she have a little blood running out of her ear, which seems to amuse him no end.

While hairdresser Nina Paskowitz teases Dee's frizzy black wig, Julia entertains herself by hanging one of Dee's feathered earrings from her nose as if it were a one-sided mustache, eliciting a chuckle from Hooper and the observation that it makes her look a bit like Fu Manchu.

Noticing the videographer's new camera, Levie remarks, "Have you seen the new High-8?," referring to the latest advance in consumer video technology, "Oh, man, it's great!"

There are scads of equipment (lights, sound and electrical cables, generators, c-stands, apple boxes, etc.) littering the ground in what is yet another cramped environment, with space at a premium. An array of domestic plants, including ficus trees, marginata, philodendron, hanging grape ivy, and so on, surround the arbor in a sea of green. The entire area is draped in black felt cloth in order to hide the remaining remnants of sunlight in the pink twilight sky. The tool shed contains shelves filled with Italian terracotta pottery and assorted gardening tools and

supplies. An everyday household fan is used to create the illusion of a cool breeze on what promises to be, in fact, a particularly warm night.

The camera is set low to the ground in order to capture the moment when Amy opens the tool shed and Wanda's limp, dead-eyed form falls through the frame. Since Amy now wears the red dress (which apparently Eddie has slipped her into while she lay unconscious), Wanda is clad merely in her slinky, faux-satin and lace slip.

Not entirely satisfied with the first take, they reset so that Dee may tug the aluminum ladder with her as she tumbles through the shot and onto the mattress provided to break her fall. Also, Hooper instructs his lead actress, "So, take a little bit longer, Mädchen, before opening the door, a little more looks . . ." During the take, he instructs her where to look and when to react, gently guiding her through the moment.

Before the next shot, at Hooper's instruction, Mädchen takes a moment to practice with the pruning shears, which Amy snatches up to use as a weapon to protect herself against her unknown assailant.

Beneath the arboretum's archway, Hooper, in his halting manner, talks through the action of the next sequence with Mädchen and Corey while flipping through the pages of his heavily annotated script, "So, right at the end of <u>this</u>, 'Don't let this happen to us, Eddie,' start raising the knife . . . and then start to, uh, *raising the knife* . . . and then, when the knife's coming up . . . 'think about what we feel . . .'," then muttering, 'that's real power,' *aaand* . . . slash down . . ." as Corey demonstrates his fitful stabbing motion for the director.

Someone or something on the set emits a shrill, high-pitched whine, causing sound mixer Craig Felberg to cartoonishly toss off his headphones and sarcastically spout, "Er, *thank you.*"

For rehearsal, Mädchen has donned a plaid flannel shirt to

stave off the chilly night air while Corey stays warm in his royal blue pullover sweater. In this intense scene, as they struggle, Amy pleads with Eddie to fight his basest impulses and his desire to feel the cloak's power coursing through him once again, finally succeeding in convincing him to tear the dress to shreds using the massive kitchen knife.

After a couple of takes of a single shot of Dee sprawled out on the ground as Wanda's lifeless body while chiaroscuro shadows play across her placid face, Hooper offers, "Well, let's, let's, . . . I, I'm not convinced we got this," to which Dee enthusiastically responds, "Oh, let's do it <u>again</u>!"

Two takes and a lens change later, the shot is in the can, but 1st AD Tom Blank is reluctant to release Stone for the night, "Now, we need to keep Dee here for a while because we don't know what the Aickman shot is," referring to the pending moment when the ineffectual detective arrives on the scene, flustered and confused, as usual too late to have any effect on the outcome.

Director of photography Isaacks and gaffer Robert Moreno and his grip crew spend considerable time lovingly lighting the exterior of the home for a late-night establishing shot of the darkened Randolph house.[48]

Mädchen returns to the set, having exchanged her wardrobe of red satin dress and skimpy lingerie for a warm beige t-shirt and chocolate-brown blazer. The scene at hand takes place following Amy's having been startled by Eddie's unexpected appearance on her doorstep, after which she gently excuses herself and enters the

[48] According to the script, this shot is meant to take place on the night of Amy's marathon sewing session, wherein the last remaining light in the house (emanating from Amy's bedroom window as she works feverishly at her sewing machine) flicks off but is instead used just prior to Gloria's arrival home in Mason's truck.

house to answer the insistently ringing telephone residing on the tea table just inside the home's entryway.

It is Buchanan, desperately needing to speak with her. (Perkins' end of their brief conversation had been shot earlier during production at UCLA. In his absence, script supervisor Sandy Mazzola haltingly reads his lines to prompt Mädchen's performance.) Her suspicions raised, Amy lies (again), telling him that her aunt is ill (wholly unaware of how right she is, as she is momentarily to find out, when she literally trips over Martha's lifeless body lying in a pool of blood on the kitchen's hardwood floor), deftly putting him off until another time.

After Buchanan hangs up, Amy lingers with the phone to her ear, pondering the reason for his call, then is startled when she suddenly hears another *click* on the line and *then* the dial tone. Amy speaks into the receiver, "Aunt Martha, was that you?," assuming that it was she that had been listening in, but quickly realizes that it could not have been her and that someone else is in the house(!).

Remaining in the vestibule, the camera crew resets for a few brief shots featuring Mädchen in and around the entryway: Amy recoils in fear after discovering the front door locked and the keys missing, effectively rendering her a prisoner in her own home, trapped inside with a lunatic on the prowl, and also the scene in which, after awaking to find that Eddie had slipped her into the dress while she slept, she stumbles down the stairs in her bathrobe, headed outside, determined to destroy the demon fabric once and for all.

The camera is placed on a tripod in the transom between the anteroom and the kitchen, focused in the direction of the stairwell, beautifully lit in moonlight blue. Once more outfitted in the shimmering red dress, Mädchen cautiously descends the stairs, moving into a large close-up. Bathed in yellow light, she pauses briefly before she continues, her wide eyes darting about the room.

The camera swivels to follow her as she dashes through the kitchen, spooked once again by Martha's corpse, then makes her way out the back door into the yard.

R. Lee Ermey saunters onto the set with his hands in his pockets, whistling a happy tune, thoroughly relaxed and prepared, at ease in his wardrobe of ash-grey suit coat and matching steel-blue slacks and tie, unlit cigar dangling from his lips. He's been sitting in the makeup trailer since mid-afternoon but seems as fresh as a daisy and pleased as punch to be here, animatedly trading slightly filthy jokes with the crew.

Aickman's post-incident interview with Amy and Eddie, in which he reveals that Wanda died <u>not</u> from Eddie's defense of Amy, but instead from a "subdural hematoma" that she had suffered in her fall over the balustrade (but which was far more likely the result of Amy's cracking her over the skull with the bronze statuette), takes place at the dining table in the anteroom between the kitchen and the living room. They chat intensely while the forensics team, their job done, hovers about collecting their equipment and preparing to leave.

In a graceful bit of blocking, the camera dollies forward from a wide shot into a more intimate three-shot on the scene's principal actors, with Mädchen in the background and R. Lee looming over Corey, then slowly booms down, following Corey as he settles defeatedly into a chair at the table as he softly speaks his dialogue.

Eddie admits to hiding Wanda's body in the shed, claiming, "I <u>panicked,</u> I . . . thought I'd be arrested for murder." (Although he was more likely still operating under the influence of the red dress.) "Or *something*," Aickman responds sardonically.

"And . . . that's a <u>wrap</u> on R. Lee Ermey!" 1st AD Tom Blank announces, and many hugs and smiles and heartfelt, tearful goodbyes bring R. Lee's journey on *I'm Dangerous Tonight* to a bittersweet close.[49]

⁴⁹Ermey would once again work with Hooper in *The Apartment Complex*, his comedic cable TV thriller about bizarre goings-on at a labyrinthine low-rent co-op, playing a mercurial former military officer "assisting" new building manager Stan (Chad Lowe, former teen heartthrob Rob Lowe's younger brother) in his attempts to unravel a series of mysterious crimes on the grounds. (The film also features Hooper's future paramour Amanda Plummer [gifted daughter of legendary actor Christopher Plummer] as a flirtatious self-professed psychic.) After a long and varied career that saw him appearing in roles as diverse as a white supremacist politician in director Alan Parker's *Mississippi Burning* and an animated plastic sergeant in Pixar's *Toy Story* movies, sadly Ermey passed away in 2018 at the age of 74 from complications of pneumonia, having left behind an indelible footprint on the cinematic landscape.

ELEVEN

SPINNING WHEEL

Monday, May 7, 1990

Although she had previously had a storied career on Broadway and in film and television (including a memorable guest appearance on *I Love Lucy* as a diffident elocution instructor), Natalie Schafer is certainly best known for her seminal role as Mrs. Thurston Howell III ("Lovie") on the popular 1960s sitcom *Gilligan's Island*. Her last major role prior to *I'm Dangerous Tonight* was in John Schlesinger's controversial 1975 film adaptation of Nathaniel West's novel of Hollywood amorality, *The Day of the Locust*, appearing as elite bordello Madame Audrey Jennings.

Schafer is notoriously secretive about her date of birth, but speculation puts her age at hovering around 90 years. Although she is elderly and frail, her make-up for her portrayal of Amy's grandmother serves to make her appear far more decrepit and incapacitated than she actually is. Mute, palsied, and wheelchair-bound, "Gram" not only retains her cognitive faculties, but also senses the evil possessing the Aztec sacrificial cloak, attempting in vain to warn Amy of its dark and deadly influence.

Taking advantage of the bright afternoon sunlight, still photographer Eric Lasher assembles Mädchen, Natalie Schafer, production designer Lenny Mazzola and a woman believed to be his wife in the backyard of the Hyde House to take a "snapshot" of Amy's family enjoying a holiday barbeque in happier times. As the

mustachioed patriarch, Lenny stands in the background, sporting sunglasses, a chef's hat, a blue-and-white striped apron and wielding a grill fork, appearing to tend to the barbeque. (In a bit of movie magic, not only is the grill not lit, but the rack rests only on a crumpled up black trash bag and is dressed with raw hamburger patties.) Mädchen stands in the foreground, smiling broadly and wearing a mustard-yellow strapped tank-top and a denim skirt, with one hand on her "mother's" shoulder and the other on Natalie's, looking lovely in her perfectly coiffed wig, pearl necklace and earrings, summery blue print dress and glamourous makeup (a stark difference from how she appears in the film; drawn, withered, and untended), seated at a picnic table loaded with condiments and picnic supplies. (In keeping with the film's color palette and themes, the only subtle flashes of red in the picture are to be found in Natalie's lipstick, nail polish, and a bottle of ketchup on the table.) The photo will be framed and placed in prominent view on the dresser in Gram's bedroom for a later scene.

While Natalie endures two hours in the makeup chair being transformed from her glamorous self into Amy's aged invalid grandmother, DP Isaacks and his crew prepare to shoot a series of images of Dr. Jonas Wilson's savage murder of his misfortunate wife[50] (Amy's shocking visions upon first encountering the haunted red fabric at the estate sale), utilizing a room in the Hyde house as the interior of the Wilson home. The montage begins with a few discrete cuts from Wilson's attack on the security guard, then the script dictates the sequence of events in the following order:

[50]Rumored to have been played by producer and co-screenwriter Bruce Lansbury's wife, but that could not be verified as true. What can be verified is that Lansbury doubled as Jonas Wilson for this series of brief, violent shots.

- Night exterior of the front door of the Wilson house; camera creeps forward.
- Wilson's wife, sitting in a plush wingback chair, looks up smiling from her book, her expression rapidly changing to one of horror.
- Wilson, draped in the red cloak with his face obscured, raises the battle axe and hacks downward.
- Mrs. Wilson narrowly avoids the blow, but the chair's backrest is split in two by the blade.
- She recoils in terror.

Added to the list is a shot of Mrs. Wilson's dying spasms as her hand reaches out for her blood-spattered book. Also, the high-backed chair is pre-scored (sliced open by the art department prior to shooting, identified as the "stunt chair" on the call sheet), so that, through a clever bit of misdirection, when she dodges the trajectory of the blade, it appears as though the axe penetrates the chair, exposing the cotton stuffing beneath.

(In Woolrich's original story, one victim of the red dress suffers similar flashes of violent memories [her father wringing a chicken's neck and gruesome images of the casualties of a horrific traffic accident] when donning the garment.)

For the next sequence on the schedule (Scene 45), glimmering moonlight casts elongated horizontal shadows on the walls, a classic trope of neo-noir filmmaking since the 1940s. With the camera situated on the landing above the stairway, Amy climbs the stairs carrying a sliver tray that holds Gram's meal and a single long-stemmed red rose in an elegant glass tulip vase. All is silent. She pauses for a moment, paralyzed somehow by a compulsion she doesn't understand. The shot is beautifully composed by Hooper, with the bright red rose that occupies the center of the frame throwing a long, dark shadow across her breast, perhaps a portent of the horror to come.

Regrouping in the second-floor landing, the company prepares to shoot Amy's confrontation with Gram (Scene 54), in which they struggle for possession of the maleficent red cloak (now transformed into the sexy cocktail dress by Amy's prodigious sewing skills), resulting in Gram's breaking through the banister in her wheelchair and tumbling headlong down the stairs to her pitiless death.

"Okay, here we go . . . quiet, please, and . . . rolling," 2nd AD Keri McIntyre prompts the crew before the camera rolls. She is running the set while 1st AD Tom Blank meets with the producers downstairs. Natalie sits in Gram's wheelchair on the hallway landing and readies herself for her first take. Following her time in wardrobe, hair, and makeup, in her cheap blue cotton hospital nightgown and ratty white wig, she appears far frailer and more indigent than when she first arrived at the location earlier in the day.

Standing on the sidelines, in red stiletto heels and with her hair slightly mussed, Mädchen is draped in Mason's navy-blue sports poncho (emblazoned with the mascot of the college football team, the Tiverton Timberwolves), Amy having snatched it up from the floorboard of his Blazer after narrowly escaping his sexual advances while under the influence of the red dress, which she holds tight using the poncho to prevent contact with her bare skin.

After a false start on take one, Keri once again announces, "Okay, quiet, please. Here we go. And . . . roll, please." Kneeling near the camera, Hooper quietly whispers his terse instructions to Natalie, "Looking at the . . . red dress . . . [very quietly] *the terror* . . . wheelchair! <u>Reach</u>!" Leaning into the camera lens, Natalie grabs a corner of the dress with her trembling outstretched hand, clutching it in an unexpectedly firm grip. Holding the dress from behind the camera and resisting Natalie's grasp is Mädchen's stand-in, Courtney. "Keep struggling, Natalie . . .," Hooper continues, ". . . keep going, Nate . . . keep moving your arms!" As

Natalie breathlessly tugs on the fabric, he directs Courtney, "Move her all around . . . move her back . . . *aaand* cut! GREAT! Let's have one, one more."

The entire crew murmurs their appreciation for Schafer's surprisingly spirited performance. Her character has no dialogue, but Natalie speaks volumes with her pale, watery, wizened eyes.

"Okay, settle in please! Clear the lights!" Keri's voice hovers in the air. While the crew takes their last looks, Hooper and Schafer share an animated conversation about the action, he with his gruff Texas drawl and she with her dry, cultured enunciation.

"This is here, and I see the, I see the thing again," Natalie purrs, referring respectively to the wheelchair and the red dress, "And I grab it, and I get it . . .," acting out the motions, ". . . but I can't get it." Hooper interjects, "Right, and yes, and that hand comes, too . . . excellent! But that strength that's just . . . *automatic*, make a little bigger deal of grabbing for it . . ." "And I never wheel the left side?," she queries, not waiting for an answer, "Okay, I think I got it." They both seem to be having a ball, as if communicating with each other in a secret language.

The cameras roll on a second take, but have to restart when Levie requests a slight adjustment, "Okay, push her back to where the shadows are right over her eyes, man . . . over her left eye. That's it, just over her left eye. That's it right there, almost too far."

Before they roll again, Hooper has some last-minute instructions for Natalie, "So, at first, I want you to build that expression again, on the dress . . . and you just hold it, and you keep tugging with it until I say cut . . . and we'll maneuver the chair around, just like last time."

Hooper calls "Action!" and Natalie wheels reluctantly into the hallway from the darkness, gazing intensely at the demon fabric. "Looking at the dress with that . . . *look of terror* . . .," Hooper intones, motivating her to act. As she grapples with the dress, her

face becomes a shifting map of fear, hopelessness, desire, and righteous determination. Rather than succumb to the power of the cloak, she releases her grip and totters backward to her doom.

Between takes, in an adjacent room (which in the coming days will be employed as Amy's bedroom), Mädchen and makeup artist Emily Katz recline on the bed, heads together, whispering and giggling like teenagers at a slumber party.

Natalie really hits her stride on the third take, tugging on the dress with all of her might, hissing and grimacing and gasping for air until Hooper calls "Cut!," then looking to the director for approbation. "Is the breathing all right?" she asks timidly. "Oh, yes! Oh, yes! Looks great!" he responds enthusiastically, going on to instruct her further for the next take, "And this time, Natalie . . . uh, uh, uh, just struggle a bit with the right hand and then take it on your own . . . for the left . . . and then, uh, make a bit of a deal with it," once again speaking their own private lingo.

Attempting to make himself heard over the cross talk between takes, electrician Scott Jensen tries to make boom operator Cameron Hamza aware of a potential sound issue. Not really hearing him clearly, Cameron snarks, "You want to do *what* to me *where*?," inducing chuckles from the crew. It seems that a non-essential generator has just kicked on outside, creating an audible hum detectable by the sound equipment. Levie insists that the generator be turned off while the camera rolls. "Is Joe Bellotti around?," he asks, inquiring after the show's elusive production manager (aptly referred to as "scary eyes" by some members of the crew). "As far as I'm concerned," Levie continues, "we can take the damn thing and throw it out and send it back where it came from! I mean, I don't need it."

"Okay, here we go," says Hooper, "Back to *one*."[51] Before proceeding, Natalie asks Hooper where her left hand should be at

[51] A common phrase on a film set meaning, essentially, "from the

the top of the take. "Um, actually, it should be in your lap." he responds, "That way it'll have more to do when it 'comes alive.'"

Keri calls for silence, "Quiet all around! Okay, roll please." 2nd AC Bill Roberts slates the shot. Hooper speaks softly, "Eyes on the cloak . . . grab it!" Conjuring a reservoir of strength, she seizes the fabric with both hands, holding it tight in her vice-like grip, battling for dominance, determined to extract it from Amy's grasp. "CUT!," shouts Hooper, "Print! Let's go into hand-held mode now . . ."

Although noticeably tired from her exertions, Natalie is an old-school trooper and asks only for a drink of water before going on to complete the scene. Once done, she receives a sustained ovation from the crew as she is assisted down the stairs and back to her trailer for a well-deserved rest.

The narrow second-floor hallway landing is packed solid with crew members coming and going, including producer and co-screenwriter Philip John Taylor; some are hustling about or loitering or just clowning around, the hum of activity and conversation clogging the air. Stunt coordinator John Moio rehearses with Mädchen and Cris Palomino, Schafer's surrogate, while his team rig and prepare for the upcoming utility stunt (referred to as a "gag" in film jargon), in which Gram splinters the banister and plummets down the stairs in her wheelchair.

Grip "Roo" Flower, a hefty young man with a wild mane of blond hair, a prominent belly and a juvenile sense of humor (who also, it must be noted, bears little to no resemblance to Natalie Schafer), appears on the landing and announces his presence by asking loudly, "Somebody call for a stand-in?"

Mädchen is eager to shoot, telling Tom Blank, who has returned to the set to take charge once again, "I've been, like, hanging out here . . . for *hours* now." He responds sarcastically, "That's what

start."

most of us do, is just hang out." "Yeah, I _knooow_," she says, matching him sarcasm for sarcasm.

Using a bath towel in place of the red dress and standing in for Mädchen, Moio demonstrates for her how to engage in the tug-of-war with Cris, now bewigged and dressed in Gram's flimsy night shirt. He instructs her that the towel must snap back when she releases it to sell the illusion that it's slipped from her grasp. Observing from the sidelines, Taylor chimes in, "But it mustn't look like Amy let go on purpose," to which Moio nods in agreement, adding, "Yeah, it should be, struggle, struggle, struggle, then g_o_!"

At that moment, Hooper ascends the back stairs to the landing to oversee the proceedings, his assistant Rita Bartlett in tow, closely followed by facetious sound man Cameron Hamza and boisterous costumer Julia Gombert (whose resounding greetings prompt prickly shushes from Tom), all welcomed onto the set by stand-in Mark San Filipo, who is acting as a production assistant for the day, and also carries out his duties by helping Cris to situate her wheelchair properly, to which she trills appreciatively, "Thank you, honey!" by helping Cris to situate her wheelchair properly, to which she trills appreciatively, "Thank you, honey!"

Just prior to the first camera rehearsal, Moio shouts last minute instructions, "Uh, Cris? Make that snap really big_ . . .!" "Okay," she says, giving him an eager thumbs-up. On Hooper's cry of "Action!," Mädchen and Cris execute the face-off expertly, and he seems pleased with the result, crowing "Great! Great!"

Hooper verifies that the lens being used is 14mm, which provides a moderately wide view of the scene, slightly distorting the image. (He's such an expert filmmaker that he need not look through the viewfinder to know what the shot looks like.) Meanwhile, Isaacks calls on gaffer Robert Moreno to make some final tweaks to the lighting set-up before they roll.

"Flyin' in!," Emily announces as Mädchen re-enters the hallway after receiving last-minute touch-ups to her hair and makeup.

Tom settles the crew, "Okay, nice and quiet, please!" 2nd AC Bill Roberts shouts, "54 Charlie, take one!," and slaps the clapboard shut. On "Action!," Mädchen tangles with Cris in a desperate effort to extract the red dress from her grip, practically spitting her lines, "Gram, no! No! Let go of it! Gram! *What are you doing*?! Let go! Give it to me! Gram! Gram! *Let go*!" before letting the dress slip from her grasp, sending the wheelchair hurtling toward the camera.

Levie expresses some concern with the performer's alignment in relation to the camera. "Okay, let's do one more . . .," Hooper advises, and they go again right away. Mädchen is considerably less verbal during the second take, and the struggle is less frenetic. Between takes, Moio confers with her about the best approach to dragging the wheelchair across the landing, suggesting, "You can do it anytime, but when you really want to pull her around, reach in deeper." "Easy," jokes Mädchen, "don't just do this!," miming one quick, casual jerk. "Oh, *okay*," she purrs, dripping with lighthearted sarcasm.

As some of the crew relax in the den, waiting for the stunt prep to be completed, production designer Lenny Mazzola, seated at the antique upright piano, starts noodling at the keys, playing a catchy, honky-tonk melody. Somebody calls out, "Yes, it's Lenny on the piano!" and another hollers "Lenny the Lounge Lizard!" as Lenny sings in a husky voice reminiscent of blues great Mose Allison:

>"I can't love you any mo' . . .
>'cause 'dat's what you have done to me."

Someone in the crowd calls out, "Hey, Lenny! You want some dark sunglasses?" "Put 'em on him! Put 'em on him!" shouts someone else from the gallery as another crew member puts them over his eyes and set dresser Anthony Spero places a tip jar on the piano.

Swaying from side to side like iconic bluesman Ray Charles, Lenny goes on:

> "I can't love you any mo' . . .
> and that's the way it's gotta' be."

Drawn by the music, others slowly stream into the room, and soon the den is packed with grinning spectators.

> "And what the future has in sto' . . .
> is such a mystery.
> I can't love you any mo' . . .
> and that's the way it's gotta' be!"

Lenny pounds out a syncopated 12-bar rhythm on the keyboard and his voice rises an octave.

> "I can't change . . .
> the way we thought . . .
> and if I could I wouldn't know,
> 'cause that's the way it's gotta' be!"

Hoots and claps and catcalls from the crowd as Lenny ramps up for his big finish.

> "I can't love you any mo',
> <u>that's just the way I love you now</u> . . ."

"I gave you all my money, you <u>bitch</u>!," Lenny shouts, and the song degenerates into a hilariously vulgar rant, "I gave you <u>everything</u>! I say, hey, *honey*, what do you <u>want</u> from me?! God damn, *who do I have to fuck to get off this show*?!"

"That's it, boys!" He swivels around on the piano stool and soaks up the applause and laughter from his appreciative audience, becoming slightly self-conscious only when he realizes that his entire impromptu performance has been videotaped for posterity.

Heard from someone in the crowd, "Not many tips. 12 cents."

A wooden platform has been erected on the bottom stairwell and the stairs and landing between flights are piled high with empty cardboard packing boxes, strapped tight and carefully and strategically placed to break the stuntwoman's fall. The planning and preparation is a long, slow, sometimes tedious, but necessary process, as safety is paramount. Standing by is paramedic Richard Penn, just in case the unthinkable happens and an injury occurs. Stunt persons Paula Moody (yet another veteran of Hooper's *Spontaneous Combustion*) and Kerrie Cullen are also on hand to act as "spotters" at the bottom of the stairs to ensure Cris's safety in the event that something goes sideways.[52]

While waiting, the crew amuse themselves with various distractions: playing cards, catching a few winks, tinkling at the piano, etc. Ever the joker, Roo pulls up his ruddy t-shirt and with his hands puppeteers his bellybutton to speak. "Hello! I'm Roo's <u>stomach</u>. And I'm *huuuungry*!," he rumbles, prompting Eric Lasher to label his behavior a "*Roo-quake*."

[52]Perhaps understandably, in his audio commentary John Cribbs misidentifies Paula Moody as the stuntwoman performing Gram's vertiginous fall when it is in fact Cris Palomino who executes the stunt.

Aiming to keep the hubbub to a minimum, Keri gently asserts her authority, "If you <u>have</u> to talk, <u>go outside</u>," she says gravely, cocking a thumb toward the door.

The moment has finally come. The camera is set on a tripod and placed on the staircase mid landing, pointed up the stairwell. "Okay, quiet, please. Quiet all around," Keri exhorts the crew. 2nd camera operator Richard Hutchings activates the camera and hustles up the stairs and out of sight. (Another additional camera designed to withstand a significant impact [known in the trade as an Eyemo[53]] is secured within the pile of boxes to capture the subject falling directly into its lens.) "Rolling," comes the call from Tom. "Okay, any time," Moio cues Palomino. The entire house is hushed.

Suddenly, Cris violently crashes through the hallway railing in her specially equipped wheelchair, reaching vainly for purchase as she plummets through the air onto the furniture pads and boxes amassed to break her fall, landing in a clump of splintered wood and debris. After a moment of silence while the spotters check on her condition, she rises to tumultuous applause, looking back up the stairs for Hooper's approval and receiving his enthusiastic thumbs-up in return.

(In addition to their extensive training and natural resilience,

[53]Created in 1925, the Eyemo is a small, durable 35mm camera primarily used for newsreel and combat photography through the mid-20th Century, later adopted for feature films and documentaries whenever an inconspicuous recording device was required. It is occasionally still used in motion pictures as a "crash-cam" in situations involving explosions and dangerous stunts or when having to toss the camera from a tall building or airplane (a necessity mostly obviated by the recent advent of low-cost drones and GoPro cameras).

most stunt performers also have an innate ability to mimic the physical characteristics of those for whom they impersonate. This is true for Palomino, who, even in tumbling over the railing and plunging down the stairs, manages to suggest Natalie Schafer's particularly frail physicality.)

While the stunt team proceed with the clean-up of the detritus on the stairs, the camera and lighting crews move back onto the second-floor landing to set up for the next sequence on the schedule, a lengthy and involved series of events in which Amy, having just discovered her evil aunt's lifeless body in the kitchen, senses an unknown presence in the home. Apprehensively, she skulks the darkened upstairs hallway, when suddenly Wanda bolts from an empty room, brutally attacking her in a shocking, knife-wielding rage. She backs Amy against a wall, the gleaming kitchen knife mere inches from her eyes. With Wanda's red patent leather spike heels carving divots into the polished hardwood floor, she shrieks maniacally in Amy's fear-stricken face, "You wanted the <u>red dress</u>?! Well, ya' <u>got</u> it, *ain't ya'*? Ain't ya' just <u>got</u> it?!" (Dee's performance here is gleefully out of control.)

They grapple, and Amy manages to escape Wanda's clutches by cracking her across the skull with a bronze statuette from an accent table nearby. Dropping the figurine next to Wanda's prone form, she retreats to her room, locking the door behind her. She hurriedly dials the police, but her call is cut short by the crazed Wanda smashing against the door with the statuette.

Fleeing through the window onto the shingled eave outside, Amy disappears from sight just as Wanda crashes through the door and into the room. Confused by Amy's absence, Wanda returns to the hallway, her wild eyes piercing the gloom, watching and listening, catlike, for any trace of sound or movement.

Meanwhile, Amy gingerly climbs through the window into Gram's bedroom. The phone in the room unexpectedly rings, likely the police returning Amy's interrupted call. She reaches to

answer, but instantly thinks better of it, instead withdrawing behind the bed to hide.

Motionless, Wanda listens from the hallway for Amy to answer the phone. Once the ringing stops, she enters the room but fails to detect Amy's presence, noting only Gram's abandoned wheelchair. When she turns to leave, Amy springs into action, seizing the wheelchair and ramming Wanda with it, sending her tumbling over the balustrade and down the stairs, fittingly with the same trajectory as Gram's fatal fall.

Much of the sequence is shot hand-held, with the camera hoist onto Levie's shoulders and in long, well-considered takes. Not only is this time- and cost-efficient, but also brings a crackling energy to the scenes. (Unfortunately, union requirements dictate that a few necessary shots remaining to be filmed must be pushed to a more amenable time later in the schedule.)

In the foyer leading from the front door to the stairway, the crew assembles to shoot Amy's desperate attempt at calling Detective Aickman while, behind her, Wanda's previously dormant body "rises from the dead," swinging a heavy marble ashtray to the back of her head and knocking her to the floor, unconscious (Scene 136).

Wallace-Stone appears on the set, coming in from the cold with a pale blue bathrobe draped over her shoulders. She drops the robe, revealing the flaming red dress beneath, and immediately lies on her back at the foot of the stairs, the aftermath of Wanda's vertiginous fall.

"Settle," Hooper initiates the first take, "and, <u>action</u>!" Mädchen tiptoes down the stairs, skirting Dee's fallen body on her way to the hall cabinet where the telephone rests. "Cut!" Hooper stops the take, causing her to regard the director quizzically, "Mädchen, you have to come to a complete stop . . . so come down to, like, the bottom step, yeah, and then stop, okay?" "Okay," she chirps, turning on her heels and bouncing eagerly back up the steps for a

second attempt.

Mindful of his duty to the script as the assistant director, Tom approaches Hooper, whispering in his ear, "Does she know that she's checking her for signs of life?" "Yeah, she does," Hooper chirps, waving him off.

In the next take, Mädchen pauses at the bottom of the stairs as instructed, waiting until Hooper quietly says "Okay," then going straight for the phone, moving into a large close-up.

She dials quickly, speaking breathlessly into the receiver, her frenzied words tumbling out, "<u>Hello</u>, this is Amy O'Neill. I <u>have</u> to speak to Captain Aickman! <u>No</u>, don't put me on hold! No, please . . .!" Out of focus in the background, a blurry flash of red, Dee sits up and struggles to her feet, leaning against the banister for support. Mädchen continues, panic in her voice, "<u>Yes</u>, this is Amy O'Neill. This is an <u>emergency</u>!" Dee lifts the prop ashtray from its place on a nearby occasional table and staggers toward her, holding it aloft as she approaches. "Please," Mädchen goes on, "get ahold of Captain Aickman. <u>No</u>, he knows the . . . this is an emergency, <u>please</u>! Circle Drive! He <u>knows</u> my address!" WHAM! Swinging wide, Dee brings the ashtray down on her head. (Not actually making contact, as the well-chosen camera angle will "sell the gag.") Mädchen crumples to the floor and Dee displaces her in the frame, looming over her, quivering with rage and cackling like a madwoman. "<u>Cut</u>!"

Tugging thoughtfully on his greying beard, Hooper consults with his team, going over various particulars of the shot before attempting another take, on topics including but not limited to: whether the indicator light on the phone should be on or off, Dee's high heels, the composition of the shot, the sound department's concern with Dee's high-pitched screams and whether they'll be subject to ADR[54] in post-production, etc.

"Hold it <u>quiet</u>!" Tom's voice bellows as they ready to shoot, "Shh, <u>shh</u>!" Abstracted, Hooper murmurs, "Quiet, quiet, quiet, please!," then addresses director of photography Isaacks, straddling the dolly, "Um . . . okay, now . . . did Dee, did Dee's head come <u>into</u> the shot? There was a beat and then she came in?" When Isaacks shakes his head, Hooper nods and turns his attention to Dee, saying, "Dee, so once you *commit* to come up, just try to get on up, because, because I can't, uh, because when you pop up, I mean when you set up . . . your head was in it and there was a beat . . ." Dee listens intently, her eyes narrow, Hooper's meaning dawning on her, "Oh, I didn't understand, Tobe. I thought you wanted me just to pop up and sit there for a minute . . ." With a slight jerk of her head, she indicates what she had intended, and Hooper interjects, "Oh, like <u>that</u>? <u>No</u>, I mean by 'pop up', I mean up into the <u>shot</u>, into the standing position . . ." "Ohhh, okay.," Dee responds, slightly dismayed but now understanding fully, "So come straight up into a <u>stand</u> . . . oh, I'm *sorry* . . .," she apologizes profusely as she moves back to her first position.

"All right, <u>once again</u>," Tom advises the crew, "stand by." The camera rolls, and the next take is, as Hooper puts it, *"a thing of beauty."*

[54]Automated Dialogue Replacement (ADR), or "looping," is the process of replacing or enhancing an actor's dialogue or expressive sounds (e.g., gasps, groans, laughter) once principal photography is complete.

TWELVE

HAND-ME-DOWNS

Tuesday, May 8, 1990

Best known for her role as Bob Newhart's long-suffering wife in 1980s sitcom *Newhart*,[55] actress Mary Frann has been cast as Amy's insufferable Aunt Martha, the remaining scion of the Rudolph clan. Ironically, on this, her first day of shooting, her last appearance in the film will be shot, wherein her character is found by her niece, throat slit, lying dead on the kitchen floor in an expanding pool of her own blood.

Before it comes to that, though, the shooting day begins in the tiny confines of the Hyde kitchenette, only slightly redressed to stand in for the Randolph kitchen. Apart from two lengthy scenes in the home's living room, the schedule consists of small snippets of action with little or no dialogue. (In the script, one of these scenes originally occurred in Aunt Martha's bedroom but has subsequently been relocated to the living room area.)

Stylishly dressed in a black V-neck sweater and bright white slacks, Frann arrives on the set for the first time. Cursory greet-

[55] *Newhart* (1982-1990) was infamous for its notorious meta-finale, in which star Bob Newhart awakes in bed next to Suzanne Pleshette, his TV wife from his previous, highly successful sitcom, *The Bob Newhart Show*, the entire series apparently having been a long, befuddling dream.

ings are exchanged, and they get right to work on the first shot. Scene 6: While preparing dinner (a note on the call sheet indicates that the refrigerator must be fully stocked), Martha calls upstairs to her daughter Gloria, who is at that very moment in her bedroom trying the malignant red dress on for size. The shot is relatively straightforward, and they manage to get it in the can in two brief takes.

After a quick re-light, in which lighting director Robert Moreno and his team transform the scene from day into night (these changes are extremely well-planned, and the exceptionally professional crew manages to accomplish the shift in relatively little time), they proceed to the next item on the schedule, Scene 143, in which Eddie, madness in his eyes, stalks Amy through the darkened, moonlit house.

They begin with the camera facing from the kitchen into the hallway as Corey, channeling Eddie's manic energy, stomps down the stairs, angrily pursuing Amy, walks into a large close-up and pauses for a moment as his piercing eyes intensely scan the vicinity for her whereabouts. The camera follows him as he heads straight for the utensil drawer and impulsively removes a large, razor-sharp carving knife, its keen blade gleaming in the moonlight.[56] Following Hooper's precise instruction, Corey brings an appropriately creepy demeanor to the moment.

After the shot is completed, Parker shyly acknowledges Hooper's effusive compliments on his performance, then hurriedly departs the set, his day's work done, and not really being the sociable type.[57]

[56] A possible nod to Alfred Hitchcock's *Psycho*, which also features Anthony Perkins in his star-making turn as Norman Bates, who wields a similar knife in that film's iconic and unforgettable shower murder scene.

Greeting the crew with her usual vivacious energy, the ravishing Daisy Hall, stunning in her blue crushed-velvet summer dance get-up, springs onto the set to shoot the first of her few brief scenes on the day's schedule, with Jason Brooks, looking sharp in his rented tuxedo, following close behind.

The camera is locked off in the kitchen for the first shot of the scene (44), a simple set-up where Gloria and Mason "spontaneously" pop in for a moment, chiefly to lord it over Amy's head that while they're off to the dance and an evening of fun and frolic (and for Mason, possible sexual intercourse, fingers crossed), she is stuck at home to tend to her ailing grandmother.

Her hair up in a tidy bun, Mädchen (as Amy) puts the finishing touches on Gram's silver dinner tray, with a single long-stemmed rose in a glass fluted vase as a thoughtful accent, as Daisy and Jason (as Gloria and Mason, respectively), sashay in, hand in hand, both reeking with an attitude of superiority. Gloria says haughtily, ". . . We're off to the dance!," while Mason none-too-subtly gives Amy the once-over. As written in the script, Amy's single line is, "Enjoy yourselves," but in performance Mädchen instead says, "Okay, have a good time." It's unclear whether she has been instructed to change the line or has taken it upon herself to paraphrase, but since the change is inconsequential, the reason is unimportant.

The next sequence (Scene 124/125) entails Amy stumbling over Martha's freshly dead corpse, beginning with the camera facing from the kitchen into the hallway as Amy, having just hung up with Buchanan after hearing someone eavesdropping on the

[57] In his personal life, it seems that Corey Parker was considerably more affable. At the time, he was married to actress Linda Kerridge, who created quite a stir in her role as a Marilyn Monroe look-alike in the 1980 cult film *Fade to Black*, starring opposite Dennis Christopher as a psychopathic film fanatic.

phone, calls out tentatively to her aunt. Receiving no response, as the camera pans with her she makes her way to the kitchen and pours herself a glass of water from the tap. A simple enough set-up, and Hooper is satisfied with the first take, "<u>Cut</u>, print!"

The camera is then placed low at Mädchen's feet, essentially a POV shot from the perspective of Aunt Martha's dead eyes. On Hooper's call of "Action!," she drinks from the glass, turns, and falls forward out of frame. As the script has it, she "trips on something," i.e., her hateful aunt's lifeless body. The shot continues as Mädchen leans into a large close-up to register Amy's horrified reaction to the grim discovery and her dawning realization that she's <u>not alone in the house</u>, then scrambles to her feet and races from the kitchen.

Makeup artist Emily Katz has given Frann a frightfully pale complexion and drawn a slender line of blood across her throat. Vainly attempting to stifle a fit of the giggles, Mary lays down on her back in a puddle of Karo syrup, the industry standard for fake blood, and fixes her eyes in a blank glare. (Perhaps fittingly, the character wears the dress that she had insisted Amy make for her.) More laughter is forthcoming when Mädchen must virtually lay <u>on</u> Mary when she tumbles over the body.

Next up on the call sheet is a thoughtful moment with Amy immediately after having discovered her aunt unconscious on the sofa and being startled by the sound of breaking glass as Martha's empty drink falls from her limp fingers (Scene 90). Amy has retrieved the shards of glass and empties them into a trash receptacle, then goes to the refrigerator to pour herself a glass of milk. Overwhelmed by the events of the past few days, the deaths of her beloved grandmother and prickly cousin, her turbulent relationship with Eddie, her aunt's spiral into drunken oblivion, and most recently, the television news reports of a series of vicious murders by "a woman in a red dress," she needs desperately to take a moment for herself to consider her bizarre situation.[58]

The home's living room is tastefully decorated in traditional style, with classic furniture in warm earth tones, accents of rich wood grain and an abundance of knickknacks and mementos. It is the perfect setting for Aunt Martha's fiercely upwardly mobile lifestyle. The prop department has provided a videocassette player to play back the aforementioned news broadcast (which had been previously shot on the second day of principal photography) on the living room's old-fashioned console television. Since video and film frame rates differ (30 frames per second [fps] versus 24 frames per second), the videotape must be played back at 24fps to preclude a flutter in the image.

The camera is set moderately low, facing the television, ostensibly from Amy's POV. "Roll camera," Tom says quietly, "Playback." Propman Ray Anthony presses a button on the VCR and the tape rolls, featuring an on-the-scene correspondent reporting from a dark, remote location roped off with crime scene tape (and with Aickman in the background conferring with the coroner and a uniformed officer), reciting in a rich baritone, ". . . a report from Detective Captain Raleigh Aickman [the first and only time in the film that Aickman's full name is spoken aloud] on a *second* drug-related slaying in Tiverton . . ."

"Cut," blurts Tom, "Let's push in." Not moving the camera an inch, assistant cameraman Wayne Trimble simply zooms in until the image on the television set fills the screen, and they repeat the process.

The living room is also the site for the next scene on the docket, in which Martha and Gloria, having just arrived home from the morgue, confront Amy regarding her culpability in her grandmother's gruesome death (Scene 59).

Slumped in an armchair in front of the window, frumpily

[58] As so often happens, during the editing process this shot is determined to be superfluous and is cut from the finished film.

dressed in a tatty oversize sweater and faded jeans, Mädchen silently ruminates, breathing lightly, hoping to find the right emotional pitch for the upcoming scene. Meanwhile, Daisy sits idly nearby on the piano stool, lost in thought, filtering out the presence of the camera and crew as she silently recites her lines to herself.

Hooper begins with a master shot comprised of a wide angle encompassing the entire room, invitingly decorated in midwestern chic and earthy colors, with nary a trace of red in sight. Before they shoot, he and Mädchen thoughtfully go over the scene, kneeling with their heads together and speaking in hushed tones as they review his heavily notated script. Meanwhile, assistant director Tom Blank impatiently paces the floor, compulsively checking his watch.

"Looking and looking and looking . . .," Hooper primes Mädchen as they roll on the first take. Amy stares forlornly out the window, awaiting with dread anticipation the imminent return of her aunt and cousin, fresh from identifying her grandmother's broken body. When the headlight beams of the arriving taxicab cross the window, illuminating her sorrowful face, she settles into the chair, resigned, expecting the worst.

Still dressed in her skimpy outfit from the dance, Gloria enters the room with her back up, unable to contain her anger. She seems less upset with Gram's death than with Amy's efforts to "suck up to Mason the minute [her] back was turned!," delivering a blistering slap to her face, calling her a "little slut" and threatening to kill her if she were ever to go near him again. Her snide remark, "I don't know what got into you tonight, *cousin* . . .," skirts dangerously closer to the truth than she could possibly imagine.

With barely contained fury, Martha storms into the room as the camera dollies back, affording a wider view of the room. She heads directly to the well-stocked liquor cabinet to pour herself a

good, stiff drink. Directing her anger at Amy, she accuses her of being selfish, "I've asked you for very little . . ." she says, while ironically wearing the royal blue dress that she had essentially bullied Amy into making for her. Frann's performance is very brittle, with a hint of regret when Amy calls Martha out for her cavalier treatment of her grandmother.

Surprisingly, Gloria does not expose Amy's lie about going "for a walk" when in fact she had attended the dance, instead rolling her eyes flamboyantly and sulking on the divan.

Amy makes an emotional speech about her love for her grandmother, but quickly realizes that she may have gone too far in blurting out that Gram had died while trying to "warn" her, and suddenly dashes from the room, leaving Martha, in one of the film's repeating motifs, to call after her, shouting "Amy! <u>Amy</u>!"

After cutting, Hooper asks script supervisor Sandy Mazzola for the duration of the take. "Two minutes, twenty-six seconds," she confirms, and they ready for another round. "Okay, stand by," says Tom, settling the crew, "Get ready . . . number one . . . very quiet all around." Roo squirrels past the window outside just before Hooper gently calls, "Action."

The scene plays out again as Hooper sits on the dolly, watching it unfold with intense concentration, speaking barely above a whisper when he says, "Cut. Good, good."

With the master complete, they move on to singles (individual shots) on Mädchen, Daisy, and Mary, respectively, Hooper slightly modulating their performances with each subsequent take.

Time runs out before they can tackle the lengthy scene between Amy and her aunt in which Martha blithely reveals that she and her grandmother are essentially destitute while simultaneously denigrating Amy's character (Scene 23), as well as two shots featuring Daisy Hall, so they are all rescheduled to be shot at a

later date, which brings the day's shooting to a close at approximately 3AM, freeing the tired crew to travel to their respective homes in the crisp, cool darkness of the morning air.

THIRTEEN

SEW AND SEW

Wednesday, May 9, 1990

Natalie Schafer, fresh from the makeup trailer and looking her bedraggled worst, is escorted up the stairs and into Gram's room, where she nestles snugly into her wheelchair. Mädchen is back in her blue and gray sweater and white cowl neck, as this scene (24) takes place immediately following Amy's awkward conversation with Martha about the dispensation of her parent's estate, such as it is. The picture of Amy with her parents and grandmother in better days (photographed two days earlier and rushed through the developing process) has been framed and is displayed prominently on the dresser.[59]

Speaking barely above a whisper, Mädchen brings a melancholy quality to Amy's explanation to her grandmother that, for the foreseeable future at least, they are stuck together under the tutelage of her at best indifferent aunt and flippant cousin.

There have been a few small changes from the script. Rather than meatloaf, Gram's dinner consists of a watery brown broth, which Amy delicately spoon-feeds her. Also, in Amy's line

[59] The script calls for an insert of the photograph, but this is never shot, so it unfortunately never appears in the film, not even in passing.

of dialogue, "We're stuck here, Gram. Stranded, like *Robinson Crusoe*," the reference to Daniel Dafoe's fictional adventurer has been cut.

The bedrooms in the house are quite small, and with the camera equipment, essential crewmembers and actors crowded in, there's little space left for superfluous personnel, making objective observation difficult, to say the least.

Remaining in the tight quarters of Gram's bedroom, Mädchen and Natalie's next scene together (32) is a brief encounter in which Amy responds to Gram's insistent tinkling of the tiny bell she uses to communicate. This precipitates a quick wardrobe change for Mädchen from her gray V-neck pullover into her warm, mustard-colored sweater, while Natalie remains costumed in her drab night shirt. (In the script, this moment follows immediately after a scene that takes place in Amy's bedroom [yet to be shot] in which Amy, while sensually caressing the enchanted fabric, flirts coquettishly with Mason right under Gloria's oblivious nose.)

Scene 132: The last shot in Gram's room occurs much later in the film, during Wanda's home invasion, and entails Amy cowering terrified behind the bed, desperate to elude the drug-crazed woman's mad rage, necessitating a dramatic lighting shift and yet another hair and wardrobe change for Mädchen, doffing her yellow sweater in favor of her beige top and brown blazer.

The camera is very close to her as she cringes in the small space between the wall and the bed. Outside the window, one of the grips shakes a strategically placed overhanging tree branch, casting chiaroscuro shadows across her ashen face. As the camera rolls, Hooper whispers breathlessly to her, "She's out there . . . [you're] terrified. What do you do?," as Mädchen acts suitably frightened, her eyes darting from the window to the door. "Cut, beautiful."

The remainder of the day is devoted to the following assortment

of scenes that all take place in Amy's bedroom, which is decorated in pale pastel pinks and soft cream colors, accented with vintage wallpaper and furnished with a well-worn antique Singer sewing machine and a white-painted, Victorian metal-framed bed.

They begin in the bedroom with the aforementioned scene (31) in which Gloria's attempt to show off her burly boyfriend backfires spectacularly when, while seductively stroking the satin fabric, Amy's flirtation with Mason preys on his weakness, flattery. As aptly and suggestively put in the screenplay, "Amy gives him a smile that would melt an Eskimo's popsicle."

The scene starts with a shot of Amy's ancient sewing machine (provided by prop master Chalo Gonzales and his crack team), tilting up to Martha's royal blue garment in progress on the dress form, billowing in the breeze from the moonlit window (with a bright white 10-K light masquerading as moonlight), then dollying back to reveal Amy sitting at her desk, writing in her notebook and paging through Professor Wilson's huge tome, *The History of Animism* (essentially doing most of the work on her and Eddie's purportedly joint assignment). Under director of photography Levie Isaacks' instruction and dolly grip Dave "Foots" Footman's undeniable skill, the dolly move is smooth as silk. Her attention drawn to something offscreen, Mädchen rises from her chair and exits the frame. "Cut, print!" calls Hooper, obviously pleased. With only a slight adjustment to the position of the camera, they proceed to shoot the end of the scene from a similar angle. Unable to ignore the unmistakable spark between Amy and Mason, Gloria quickly steers her clear of him, in the process breaking Amy's contact with the cloak, after which she reverts to her shy, introverted self, both surprised and more than a little embarrassed at her own brazen behavior. It's at this point in the scene that Gloria reveals her true agenda, pawning off Gram's care and feeding onto Amy's shoulders so that she and Mason might enjoy a night out at the movies. (As usual, and as Gloria fully expects,

Amy acquiesces to her cousin's lugubrious pleas, knowing from experience that her refusal would result in anger and recrimination.) Gloria promises Amy, "I'll make it up to you," but of course she never does.

After that shot is in the can, the crew repositions the camera, still on the dolly, to face the bed for the scene's next shot, in which Amy, unable to resist, withdraws the red cloak from where it rests in a shopping bag at the foot of the bed, draping it over the bed's metal footboard and caressing it lovingly, suddenly in its thrall. At the top of the shot, "Foots" executes a flawless dolly move, cleanly pushing in close to Mädchen as she feels the fabric beneath her fingers. Although not present in the frame, Daisy and Jason instead feed their lines to her from offscreen as the scene plays out. Once the scene is complete and Mädchen has left the frame, the camera lingers for a long moment, slowly dollying in on the red cloak draped over the bed's metal footboard (an insert for the upcoming scene between Amy and Gram) before Hooper quietly says, "Cut."

For the penultimate shot of the sequence, the camera is turned to face the bedroom door to capture Gloria and Mason's entrance and their initial exchange with Amy. They enter from a distance while Mädchen sits at the foot of the bed, large in the foreground at the edge of the frame.

Finally, all that remains of the scene to be shot is Jason's close-up. Seen from a low angle, apparently towering over the women (appropriate for a character who is so full of himself), he brags and preens and comports himself in an arrogantly confident, self-congratulatory, off-putting manner. Yes, he's quite the catch.

The rest of the crew receives a 15-minute break while gaffer Robert Moreno and his team make slight adjustments to the room's lighting. When they return, they proceed to block and rehearse the next item on the call sheet (Scene 33), in which Amy has retrieved her grandmother from her lonely room and brought

her into her own bedroom to keep each other company. Gram sits placidly by, registering no expression, as Amy goes over the disquieting events of her day, specifically Eddie's strange and violent behavior onstage while rehearsing the swordfight for *Romeo and Juliet*, during which, while wearing the red cloak as a costume, he unexpectedly lashes out at his scene partner, very nearly seriously injuring him, and getting himself ejected from the play as a result.

"It's scary when you realize what's bottled up inside of us," Amy confides to her, "just waiting to get out." As she speaks, Gram's empty gaze is drawn to the crimson cloak, caught in the corner of her eye. Her posture stiffens, and she sits bolt upright in her wheelchair, fixating on dreaded cape, her heretofore lifeless eyes suddenly ablaze with awareness and terror.

The scene is far more complicated than it appears on paper. No less than seven separate set-ups are required to capture it on film: a wide, sweeping pan as Amy wheels her grandmother into the room, Amy's close-up in the mirror (with a slight pan over as she looks back at Gram), Gram's close-up as she watches Amy in the mirror, a high-angle shot over Gram's shoulder at Amy as she kneels at her feet, Amy's POV looking up at her grandmother, a wider shot as Amy goes over and kneels before her, and an intense close-up on Natalie glaring at the offending red garment.

The lengthy and involved shooting clearly takes its toll on Natalie Schafer, but Hooper defers to her every need while the hair and makeup teams tend to her like doting children, and so she manages to persevere like the old-school showbiz gypsy that she is. Her close-up is powerful and striking, while simultaneously a model of restraint.

Scene 40: In yet another striking fairy tale image evoking Disney's *Cinderella*, Amy sits in her room, hunched over her sewing machine, ferociously transforming the Aztec cloak into a shimmering cocktail dress, while Aunt Martha's finished garment

hangs on the dress form in the background as the diaphanous curtains waft in the breeze and moonlight streams through the open window. All that's missing is a cute cadre of animated chirping birds to assist her in her labors. Eyes fixed intensely on the sewing needle, Amy barely glances up when Gloria, drawn by the light spilling into the hallway from the bedroom, enters and asks, genuinely curious, "What are you doing up so late?," only to be dismissed by Amy's curt, robotic, "Working." Unable to resist, Gloria reaches out to touch the red satin fabric, but is repelled by Amy's snarling reaction, "KEEP YOUR HANDS OFF IT!" Turning on her heels to leave, Gloria is shocked to find Gram in the doorway, glaring at Amy with wide, accusing eyes, having by some miracle managed to wheel herself from her room to Amy's. "Get the old lady out of here," Amy coldly intones, turning back to her obsessive task, as a twisted, emotionless grin crosses her lips.

The day's final scene (88) finds Amy lying awake on her bed, lost in thought, listening to the chirping of crickets through her open window and the muffled sounds of the television creeping up from downstairs. She cannot seem to shake the dread that her uncomfortable conversation with Aickman in the cafeteria has instilled in her. Finally, unable to sleep, she throws on her bathrobe and heads downstairs, where she will discover her drunken aunt barely conscious on the sofa.

Several scenes had been postponed from yesterday's shoot and rescheduled for today, including Amy's fearful discovery that the front door keys are gone (effectively trapping her in the house with a mysterious predator), Gloria entering the home late at night after her date with Mason, some pick-ups of Amy's late night phone call from Buchanan, and, perhaps most importantly, Amy's uncomfortable interaction with Aunt Martha regarding her and her grandmother's fortunes. However, time overruns dictate that these scenes again be postponed, presumably for tomorrow's

shoot.

Additionally, two scenes appearing on today's schedule (Amy's failed effort to shred the dress, resulting in her secreting it in her closet, and her awakening from dark and disturbing dreams) have also been pushed to a later date.

FOURTEEN

APART AT THE SEAMS

Thursday, May 10, 1990

Two weeks into shooting finds the production still ensconced at the Hyde House. It's a bright, clear day as the crew prepares to shoot Eddie standing beneath Amy's bedroom window, like Romeo dallying under Juliet's balcony, pleading for his lady's attention in Shakespeare's best-known play of romance and tragedy, and even awkwardly quoting the Bard, "But soft, what light through yonder window breaks . . . ?"

Only Corey's side of the conversation is to be shot at this time, with Mädchen's angle to be filmed somewhere down the line. Dressed for a chilly morning (although in reality it's nearly 4pm) in button-down shirt, brown jacket and jeans, Corey stands in the yard's open gateway, looking up towards the camera, which has been secured in the bedroom window by "grip magic."

In the scene (42), Eddie has been tossing pebbles at Amy's window, endeavoring to get her attention. When she finally appears, he admits to finding her window only after "[trying] all the other ones first," and flashes his winning grin. (Mädchen feeds Corey her lines from behind the camera, well inside the room since she has no line of sight to see him.) Eddie, apparently back to his old self (after having freaked out during rehearsal the previous day), sheepishly implores Amy to join him for breakfast and a "talk." She considers for a long moment before, despite her

misgivings, reluctantly agreeing to come along.

Most of the time expended on the shot is in preparation, but once the camera rolls, it's in the can after only a few brief takes. However, the crew will need to wait until the sun sinks lower in the sky to move on to the next sequence on the call sheet.

At twilight on the front lawn, Hooper stands surrounded by and conversing animatedly with production manager Joe Bellotti, producer and co-screenwriter Philip John Taylor, 1st and 2nd assistant directors Tom Blank and Keri McIntyre, script supervisor Sandy Mazzola and his assistant Rita Bartlett while the crew buzzes around the exterior of the house in preparation for the pending set-up. Throughout the shoot, Hooper has been wearing a beige baseball cap with "I'm Dangerous Tonight" emblazoned on it in bright red letters. It seems to have become a fixture, as ubiquitous as his signature cigar and always-within-reach can of Dr. Pepper.

Upon seeing still photographer Eric Lasher strolling the grounds testing out his new video camera, director of photography Levie Isaacks approaches him, inquiring with infectious enthusiasm, "Have you seen the High-8, man? That is some *kick-ass shit*, man. It puts anything I've seen to shame!"

Up next on the schedule is a deceptively simple scene (61) between Amy and Eddie that takes place on the home's stone façade porch, in which, upon arriving home with her aunt and cousin from her grandmother's funeral, she discovers him waiting for her on the front stoop. Not having seen each other since the ill-fated Spring dance, their interaction is awkward, but, moved by his obvious concern for her well-being, she agrees to accompany him "for a drive."

The first shot to be filmed for the sequence is a wide establishing shot of the curved cobblestone driveway as the sleek, black limousine pulls up to the doorstep and its passengers

disembark, shrouded by the shadow of the massive oak tree with sprawling roots that dominates the yard.

The dolly is situated at one end of the curved driveway and the camera pans over as the limo, with Mary Frann and Daisy Hall in the back seat alongside Mädchen, approaches the front porch and stops. The driver gets out and comes around the front of the vehicle, professionally holding the car door open for the three women, Mary and Daisy each dressed in mourning black and Amy, somewhat disarmingly, in somber blue blazer and muted floral print dress.

With that shot easily in the can, the camera is reset to a closer position with the limousine's grill prominent in the foreground and the entire entranceway visible in the background. According to the script, Corey sits on the top step, hugging himself tightly, expectantly awaiting Amy's return. On emerging from the car on her way to the door, Gloria's flippant remark, "All I can say is, I hope there are a lot more people at <u>my</u> funeral," goes unacknowledged by Amy, who is instead focused on Eddie's unexpected presence. (It is a chillingly prescient comment, considering her imminent fate.) Barely acknowledging him, Martha and Gloria haughtily stroll past the two young lovers and into the house, furtively looking back with a disapproving glance as they pass.

Eddie begins their conversation with a tentative, "Hi . . . how you doing?" Uncertain of his intentions based on his prior behavior, Amy hesitates before responding wearily, "Not great." After a long, meaningful pause, he offers, "You want to go for a *drive* or something?," to which Amy's resistance thaws and she gives in, saying with a sigh, "Um . . . sure, maybe that's what I need."[60]

[60]In the shooting script, this "drive" leads into a lengthy scene in which Eddie reveals some particulars about his difficult childhood,

For Amy's side of the brief (but thick with meaning) conversation with Eddie, it's necessary for Mädchen to stand on an apple box (functional wooden boxes that come in assorted sizes, and which are essential tools on a movie set, used to elevate equipment or personnel, or as the odd seat on which to perch) so that the camera can get low enough to frame her lovely face with the leaves and branches of the great oak looming behind her in a kind of stained-glass window effect.

Reassembling in the home's interior, the crew prepares to shoot the next sequence on the schedule (Scene 21, having already been postponed <u>twice</u> since its first appearance on the call sheet two days earlier) which has Amy arriving home late, laden with schoolbooks and packaged accrued from her assigned errands. Aunt Martha calls to her from the kitchen while simultaneously Gloria sprints down the stairs to the foyer, squeezed into her tight electric-blue skirt and olive-green blazer, and, in her uncontained excitement, practically tears the box that Amy has brought for her to shreds. Loving the dress that she discovers inside, she gives Amy a perfunctory kiss on the cheek and scurries back up the

chiefly how he and his brother would often overhear their mother being abused by their father and how in later years it seems that his brother had followed in his father's footsteps in brutalizing his own wife. The scene also details how Eddie's interest in Political Science (his college major, as Amy had learned in their first meeting) stems from his desire for tactile, measurable *power* in the world, and ends with a cryptic reference to his experience with the red cloak. For reasons that are unclear, given that it provides Eddie's character with more background and lends some motivation for his actions, the scene does not appear in the finished film, and is, in fact, never shot. Instead, the narrative proceeds directly to their romantic Italian dinner in Eddie's collegiate apartment.

steps, leaving Amy to pick up after her.

Reassembling in the home's interior, the crew prepares to shoot the next sequence on the schedule (Scene 21, having already been postponed <u>twice</u> since its first appearance on the call sheet two days earlier) which has Amy arriving home late, laden with schoolbooks and packaged accrued from her assigned errands. Aunt Martha calls to her from the kitchen while simultaneously Gloria sprints down the stairs to the foyer, squeezed into her tight electric-blue skirt and olive-green blazer, and, in her uncontained excitement, practically tears the box that Amy has brought for her to shreds. Loving the dress that she discovers inside, she gives Amy a perfunctory kiss on the cheek and scurries back up the steps, leaving Amy to pick up after her.

Meeting in the adjacent room, Amy is met with Martha's frosty greeting, "Nice of you to come home *early*." Immaculately decked out in her snow-white designer outfit with inlaid gold trim and matching heels, nothing is ever good enough for Martha. She cruelly sheds doubt on Amy's abilities every chance she gets, even though Amy has consistently demonstrated her kindness, competence, and willingness to help. In this fairy-tale scenario, Amy is Cinderella[61], making Martha the equivalent of her evil stepmother and Gloria her ugly (at least on the inside) stepsister.

When Amy hesitates after Martha's selfish request that the dress she's agreed to make for her be finished much sooner than expected, Martha's tone changes from self-absorption to passive aggression. In the script, Martha's line is notated as a "veiled

[61]In *Video Watchdog*, his magazine dedicated to genre cinema, editor Tim Lucas compares *I'm Dangerous Tonight* less to *Cinderella* than to *The Red Shoes*, Hans Christian Andersen's fairy tale of obsession and desire, adapted for the screen in 1948 by Michael Powell and Emeric Pressburger, and a film that Hooper held in high esteem.

order." On the set, it is amended from, "Amy, please . . . be an angel," to the not-so-subtly demanding, "Oh, Amy . . . be an angel and say *yes*."

After dismissively informing Amy that her parent's estate amounts to essentially nothing and bemoaning the fact that she and her grandmother will be stranded at the Randolph's domicile for the foreseeable future, Martha casually tosses her black sable coat over her arm and departs with one final shot, "I'll probably be late. You know how these *charity events* [changed from the script's "Women's Auxiliary meetings"] are, they go on forever. So feed your grandmother for me, won't you? I've been so rushed."

As scripted, Martha initially calls to Amy from the upstairs landing and their scene together is played in the aunt's bedroom, but Hooper and his producers, once again concerned with economy and time, have restaged it to take place in the cozy dining area connecting the entryway to the kitchen, allowing for the entire sequence to be captured in one master shot before completing it with two medium singles, on Mädchen and Frann each in turn.

They next revisit Amy's desperate call from Buchanan (in the immediate wake of Eddie's declaring his love for her) in the downstairs hallway, shooting a new close-up of Mädchen on the phone with her distended shadow looming on the wall above and behind her. (After having viewed dailies, Hooper and his producers had decided that the need for another angle was necessitated, and this insert was added to the day's schedule.)

In a continuation of this sequence, the camera remains in the foyer to shoot Amy's frantic effort to flee the house after tripping over Martha's freshly killed corpse, only to discover that the key to the door is missing and she is unable to escape. (Apparently, many American Craftsman homes, some of which date from the turn of the century, feature door locks that can only be opened

with a key.)

Operating the camera, Levie executes a crisp whip-pan as Mädchen scrambles to the door, realizes that the key is gone, and performs a perfect 180-degree swivel as she turns back in terror. Her eyes dart madly around the room as she backs toward the staircase, feeling in the darkness for the banister, then spins on her heels and retreats up the stairs.

A brief shot in which, during Aickman's interview with Eddie following the arrival of the police, Amy slinks out the door to the garden, intending to tear the red dress to shreds, is excised from the schedule. Written in its place on the call sheet in bold capital letters is "SCENE DROPPED." There is no further explanation. (Because of this revision the call sheet has been reprinted and redistributed on blue paper to indicate a change to the schedule.)

Dee Wallace-Stone returns to the set late in the evening in Wanda's full regalia, black wig, red dress, spike heels, and bad attitude. Up next is a series of shots of Wanda prowling the upstairs landing in search of Amy, essentially pick-ups for portions of scenes (127, 131, 133) that had been shot earlier. (Her intrusion into Amy's home is a neat counterpoint to Amy's similar late-night trespass into Wanda's apartment.)

For the next scene scheduled, in which Wanda smashes her way into Amy's bedroom (130), the door has been removed and a breakaway replacement has been installed and scored by the art department so that the center panel splinters apart when Dee whacks it from the other side with the bronze statuette. The shot is a bit more involved than might seem at first glance, as the hallway behind Dee must be lit fully for when the door is flung open and her looming silhouette fills the frame.

On Hooper's call for "Action!," Dee strikes the door from behind with the statuette, instantly causing the panel to fragment. Urged

on by Hooper's amusing, insistent, "Whack it! <u>Whack it</u>!," she breaks a hole in the door with relative ease, then reaches through the breach, fumbling for the doorknob. When she pushes open the door and steps in, the camera tilts up slightly to reveal the crazed look in her eye and the disappointed sneer on her lips as she grasps that the room is empty (Amy having slinked through the window and out onto the eave at the last moment). "Cut, print, <u>great</u>!"

Dee has only one other shot remaining before she is released for the day (actually in the wee hours of the morning, being that she wasn't required on the set until 9:30pm), in which Wanda steps briefly into Aunt Martha's room in search of her elusive prey, Amy. The shot is a relatively simple one, and as such is accomplished with ease.

Daisy ebulliently returns to the set to film the first of her shots that have been postponed for the past few days (delineated on the call sheet with an asterisk as follows: *previously scheduled to be shot today), which takes place in the home's darkened foyer. Scene 39: Arriving home late at night from a date with her pent-up jock boyfriend, her cute purple flowered print dress wrinkled ever-so-slightly, Gloria lets herself into the house. As the script reads, "She lingers a moment to button up her blouse with a self-satisfied smile," having just teased Mason to near-agonizing sexual frustration, clearly pleased with herself, then flounces up the stairs.

With the camera moved to the top of the stairs, the continuation of the scene commences; swinging her conspicuously expensive purple designer handbag as she goes, Gloria climbs the steps to the shadowy hallway on her way to bed but can't help but notice the bright light streaming from Amy's slightly open bedroom door. (According to the script, the light streams from beneath the closed door, but once again Hooper chooses economy and composes the shot with the door ajar in the background,

obviating the need to shoot a time-consuming insert.) Apparently, Amy is burning the night oil. Gloria pauses a moment to ponder, then turns toward Amy's room. Instantly, Hooper calls "Cut!," and the shot ends there.

Daisy departs as gleefully as she had arrived, blowing a kiss to the assembled crew as she goes, and the difficult day's shooting draws to a close.

FIFTEEN

DRESS FOR SUCCESS

Friday, May 11, 1990

The location for Professor Jonas Wilson's home, where Amy fortuitously stumbles on the old trunk containing the infernal sacrificial cloak at a yard sale following the untimely deaths of the professor and his wife, is a charming single-family dwelling in a modest neighborhood on North Ivy Street in Monrovia. The manager of the estate sale (identified as "Matt Flanders" in the script, although he is never referred to by name) is played by jolly character actor David Carlile. Working steadily since the 1950s, he's amassed an impressive resume that includes cult favorite *Ma Barker's Killer Brood*, multiple roles in several episodes of the *Alfred Hitchcock Presents* television series, and guest appearances on virtually everything from crime drama *Hill Street Blues* to frivolous situation comedy *Night Court*.[62]

[62]Conceived as a vehicle for magician/comedian Harry Anderson, playing an eccentric jurist hoodwinked into presiding over the dregs of the judicial system, *Night Court* aired on NBC from 1984 to 1992, and also co-starred actor John Larroquette as an unc-

Relaxing in a chair on the home's front lawn before a large roll-up desk, jaunty fedora cocked at a rakish angle on his head, surrounded by what seems to be the entire contents of the house (tables, lamps, antiques, framed artwork, assorted furniture, etc.) haphazardly spread out over the yard, he strokes his grey cat while passively waiting for prospective customers to approach him.

The character's long speech to Amy, in which he details the tragedy that unfolded in the Wilson home, is severely truncated from the scripted version. As written, he asserts that Wilson wasn't satisfied with merely hacking his wife to death, but that the police determined there wasn't an ounce of blood left in her body, speculating that he must have drunk it. This little tidbit of information is eliminated from the speech and is never mentioned anywhere else in the screenplay. (Also cut is a bit of business where Matt assists Amy in jimmying open the chest, struggling with the metal hasp and even giving it a kick. Upon discovery of the sacrificial cloak, he offers it to her at no extra charge. Instead, Amy manages to open the trunk unassisted, and the proprietor is left wholly unaware of the existence of the red fabric.)

As planned, the sequence (Scene 25/26) consists of a wide shot of Amy arriving at the yard sale, emerging from her vehicle and joining the half-dozen or so bargain-hunters milling about the yard, a dolly shot following Amy as she seeks out the estate agent, complementary close-ups on Amy and Matt as they converse, and a low-angle close-up of Amy as she reacts to the shocking images of Mrs. Wilson's brutal murder arising in her mind when she touches the cloak for the first time.

tuous prosecutor, and who, as it turns out, not only narrated the opening crawl for Tobe Hooper's breakout film *The Texas Chain Saw Massacre*, but performed the same function as well on the extended cut of the director's spectacular but much-maligned space opera, *Lifeforce*.

Long dolly tracks have been laid across the lush green lawn for an establishing shot that spans the length of the yard in which Amy peruses the items on display in search of props for the school production of *Romeo and Juliet*, at the fussy student director's behest. The camera counters her move as she goes over to inquire about the price of the tattered old trunk that's caught her eye.

After haggling briefly with the estate agent and paying the agreed-upon price, Amy investigates the trunk, discovering the sacrificial cloak within. (The insert of the inside of the trunk from which Amy extracts the red cloak had already been shot two weeks earlier on the stage of Royce Hall at UCLA.)

Shooting the low-angle close-up of Amy reacting to the murderous images flooding her mind is postponed and tentatively rescheduled to be filmed tomorrow in the front yard of the Hyde House.

The second part of the sequence, featuring an urgent phone call to the estate manager from a mysterious inquisitor, is economically staged. With the proprietor's hulking antique brass cash register on the rolltop desk large in the foreground, in the background he helps Amy to secure the old trunk into her battered Honda Accord hatchback, waving and wishing her luck as she pulls away. The desk phone rings almost immediately, sending him stumbling through the flower bed to answer. After listening for only a bare second, he interjects, "*Heh*, no, you're just about *ten seconds* too late," before going on to carelessly betray Amy to the anonymous caller. While intended to be unclear at this point in the story, as the plot unfolds it later becomes obvious that it was Buchanan on the line asking after the old trunk, seeking the infamous red cloak.

As the sun touches the horizon, the set decorators load up the furniture and artifacts peppering the lawn into a rented four-panel truck for return to the prop house. Meanwhile, the camera crew prepare for a brief twilight shot, Professor Wilson's point of view

approaching the home's front door with murder on his mind, to be used as part of the montage of images[63] that invade Amy's consciousness when extracting the cursed cloak from the trunk. (The shot is listed as "day-for-night"[64] on the call sheet, but by the time the camera rolls, the sky is quickly transitioning to a deep, dark blue.)

The porch area is dimly lit, approximating night. Director of photography Levie Isaacks lifts the Panavision camera on his shoulders as his assistants flank him, 1_{st} AC Wayne Trimble pulling focus and 2_{nd} AC Bill Roberts spotting him. No sound recording is required, so sound mixer Craig Felberg and boom operator Cameron Hamza sit this one out, occupying themselves by packing up their equipment for transport back to the Hyde House for the remainder of the day's shoot.

Upon returning at twilight, the crew busies themselves by setting up for the next sequence (Scene 151), in which, following her harrowing encounter with Wanda and while Detective Aickman debriefs Eddie, Amy slips out to the garden shed, intent on destroying the evil red fabric once and for all. Finding the dress still on the ground where it had been discarded, she picks up the pruning shears that lay beside it, but something else catches her eye that sparks a better idea. She crosses to the industrial garden shredder on the other side of the shed and switches it on, then proceeds to feed the dress into it. (The script describes how

[63]In the finished film, this shot is broken up into three jagged "jump-cuts" that accelerate the action forward, another old trick of Alfred Hitchcock's.

[64]Referring to a circumstance in which a night exterior is filmed during the day, achieved by either adjusting the lighting and the camera's f-stop and/or tenting the area in question to create darkness.

the air is filled with the *screams* and *cries* of the cloak as it meets its miserable fate.[65]

Photographer Eric Lasher enters the makeup trailer to find actor Jason Brooks being primped for his upcoming scenes with Daisy Hall (in which Gloria once again frustrates Mason's sexual desires). As hair stylist Nina Paskowitz combs him out, Lasher snidely remarks, "Uh-oh, his hair . . . it's not his *real* hair! I knew it!" Brooks endures the mockery with a warm chuckle, pretending to shy away from the camera, joking, "Sorry, I get paid for this." Sitting in the next chair getting touched up by makeup artist Emily Katz, Mädchen greets Lasher with a cheerful "Hellooooooo!"

Facing the porch, the dolly is situated at the bottom of the sloping semi-circular driveway to shoot Amy's arrival home from her errands. The entrance to the home is beautifully lit in pools of white and amber, tempered by the shadows of the leaves of the great oak, like a pastoral, fairy tale dream house.

Hooper mounts the camera dolly. Looking through the viewfinder, he watches closely as Mädchen rehearses her action; stepping out of the car, going around to the passenger side to retrieve her belongings, then heading up the stone steps to the

[65]This effect is enhanced in the final cut by composer Nicholas Pike's superlative score interlaced with post-production sound effects. Prior to *I'm Dangerous Tonight*, Pike had already established himself as a reliable genre composer, having worked with writer/director Mick Garris on *Critters 2* and subsequently on *Sleepwalkers*, *The Shining* (Garris' television mini-series based on Stephen King's novel), several episodes of the *Masters of Horror* anthology series (among them Hooper's *The Damned Thing*), TV mini-series *Bag of Bones* (also based on a King novel and directed by Garris), as well as countless other film and television projects.

door. Before she actually enters the home, Hooper shouts, "Okay, cut, Mädchen! That's good!"

Mädchen is in a very happy mood this evening, kibitzing with the crew, dancing for director of photography Levie Isaacks while he checks the available light with his meter, all in all seeming very relaxed and pleased with herself.

Levie explains to Hooper, "I'm working on a 'special' for her in the car," meaning that his team is mounting a light inside the vehicle to illuminate her as she drives up. After a few adjustments made at Levie's behest, they're ready to roll film.

"Rolling!" assistant director Tom Blank calls out. Hooper quietly whispers "Action," and Tom transmits the instruction via walkie-talkie to Mädchen in the car. Pulling up to the house in the brown Accord, she wobbles a bit as she comes around the front of the car, then gathers up the books and packages from the passenger seat into her arms and goes up the steps toward the front door. Just as she steps onto the porch, a distant car alarm goes off in the neighborhood, squealing and honking in the background, prompting someone to sarcastically remark, "*Good for sound*," which sets the crew to laughing.

Isaacks suggests a few lighting tweaks before they roll on the first take, and Hooper has an enquiry for him. "Should that light be on upstairs?," he says, referring to Amy's bedroom window. "Oh, they could be on or off," Levie says, but it is quickly decided that it should be <u>on</u> for the shot, so assistant cameraman Bill Roberts bellows to the technicians on the second floor to "<u>Light 'em up</u>!"

Finally ready to roll, Tom radios Mädchen to begin, but while everything appears to proceed swimmingly, Levie is not entirely pleased with the result. Hooper, however, is fully satisfied, so they move on to the next order of business. Tom has the Honda back out of the driveway so that they may shoot a series of establishing

shots with various combinations of house lights being on or off. With no action occurring in the frame, script supervisor Sandy Mazzola simply counts out loud to track the duration of the shots. "How long has it been, Sandy?," Hooper asks. "Uhh, six seconds, seven, eight . . . ten," she counts off. "That's a cut!"

Standing by the camera, surrounded by his crew, drinking in the cool night air, Hooper seems blissfully happy to be doing what he loves most, making movies.

Next on the docket is a brief but pivotal scene (121) between Amy and Eddie on her home's front porch. Returning home after her confrontational interview with Detective Aickman, Amy is startled by Eddie emerging from the shadows (during the course of the film, he is constantly showing up unannounced). He attempts to comfort her, but her stress has been so great that she finally breaks down, bursting into tears and lamenting her situation. They share a passionate kiss and agree to speak at a later time. "I love you," Eddie tells her, to which she replies, with a wry smile, "You picked one hell of a time to tell me." She is soon after to discover her Aunt Martha's dead body in the kitchen.

Using lead piping and plywood, materials generally used in the construction of scaffolding, lighting director Robert Moreno and his team, in concert with the grips, have erected a three-story structure in the street adjoining the Hyde House, a tower designed to support a huge HMI light to illuminate the entire location for the night shoot. Using ropes and pullies, the grips and electrical crew exercise great strength and ingenuity to raise the lamp and successfully secure it safely to the tower's top tier, amid applause and cries of "Yee-haw!" from onlookers.

An ambulance, a police cruiser and several atmosphere players costumed as cops and paramedics are on hand for a series of shots which include Gram's broken body being carried down the steps

on a stretcher and loaded into the ambulance (Scene 58) as well as a later scene (148) where Martha and Wanda's bodies are similarly and summarily dispatched.

Shot from the sidewalk in front of the house, with the towering oak tree large in the foreground, the simple actions of the paramedics and cops allows the crew to make quick work of the sequences.[66] These shots are almost purely narratively functional and appropriately mundane. One of the earmarks of a good director is to know when to add dynamics or flourishes and when to be direct or uninflected.

On the grass easement between the street and the sidewalk in front of the house, a sandwich-board sign is posted which reads:

<div style="text-align:center">

NOW FILMING
"I'M DANGEROUS TONIGHT"
by
BBK
PRODUCTIONS
for
USA CABLE
To be aired
AUGUST 1990

</div>

While waiting for the lighting crew to complete their set up, boom operator Cameron Hamza, script supervisor Sandy Mazzola and wardrobe supervisor Julia Gombert enjoy the evening air,

[66] A scene appearing in the script at this juncture (56), wherein Amy, immediately following Gram's sudden violent death, greets paramedics at the door and surreptitiously scoops up the red dress from the scene of the "accident", is dispensed with. Although it's unclear whether the scene was ever even filmed, it certainly does not appear in the finished film.

relaxing in canvas director's chairs in the driveway adjoining the porch, and are briefly interviewed by the production's videographer. Cameron is silly and uncooperative, while Sandy and Julia amiably answer questions regarding their "stint" on the show, "Havin' coffee, readin' the paper. Just hangin' out, waitin' for the next set-up." Kibbitzing nearby, Jason Brooks, also waiting for his presence to be required on the set, is introduced to the video camera as "fabulous future superstar Jason Brooks," to which he responds by waving and declaring, "Hi, Mom!," then performing an embarrassing "Popeye, the Sailor Man" dance.

When asked with mock seriousness what his function is on the show, Jason playfully claims his job to be the key grip, who, as he says, spends his time "gripping the keys." Impudent sound mixer Craig Felberg steps up from behind his sound cart and chimes in, offering, "He plays the dolly and I play the dolly grip," grabbing Brooks by the hips and pushing him forward.

Stunt coordinator John Moio is on hand to oversee this evening's stunt. Scene 73: While Amy and Eddie nuzzle in his reliable Nissan pickup parked in the driveway, her cousin Gloria, having just dispatched her unfaithful boyfriend, drives up in Mason's Ford Bronco and smashes into them from behind, initiating the chase that ultimately results in her violent, fiery death. Stuntwoman Kerrie Cullen is also here to stand-in for Gloria as the driver of the four-runner.

The staging of this sequence is changed slightly from the script. The writers couldn't have known that the location for the Randolph home would have this wonderful half-moon driveway, so the action is shifted from the curb on the street onto the curved driveway. Instead of Gloria crashing into the rear of Eddie's pickup three times, as scripted, once is deemed sufficient. Interestingly, a mysterious sequence that was apparently intended to take place in the middle of the thrilling car chase has been

omitted from the screenplay, leaving no trace as to its contents.

Moio's professionalism ensures that this relatively simple stunt comes off without a hitch, with the Bronco ramming into the rear of the Nissan, seeming far more dangerous than it is and causing zero measurable damage to either vehicle.

Following the stunt, the camera is mounted on the hood of the Nissan to shoot Amy and Eddie as they share a moment of serenity before Gloria's brutal attack. Hooper has staged this moment brilliantly. As they laugh together and smooch, the blazing floodlights from atop the four-runner suddenly appear in the rear window, careening towards them at top speed, filling the cab with light. It's a stunning moment punctuated by the roar of the Bronco's engine and the deafening sound of twisting metal as it crashes into them.[67]

The next scene on the schedule (37) has Gloria and Mason returning to the Randolph house from their evening out. Mason parks his muscle truck at the end of the driveway, and they immediately lock into a passionate embrace. But just as things are heating up, Gloria extracts herself from Mason's wandering hands, frustrating his feverish arousal and provoking a strong objection from him, "Gimme a break! . . . You're driving me nuts!" (Later, when, under the influence of the red dress, Amy has been lured by Mason into his Bronco after the dance and suddenly "comes to her senses" once the dress comes off, he laments, "I thought your cousin was the queen tease, but you're something else!" Poor Mason, can't seem to catch a break.)

For the truck's arrival to the house, the camera is placed on a tripod in the street for a dramatic angle as the vehicle pulls up and

[67]Eddie's line, "I'm not waiting around to find out!" (in response to Amy's exclamation, "What's she trying to do?!"), does not appear in the script and is quite obviously overdubbed in post-production.

fills the frame, jerking to a stop at the end of the driveway. For the duration of this shot, only the beginning and end of the scene (in which Gloria hops out and "undulates to the door," leaving Mason to stew in his own juices and tossing an offhand "See you tomorrow!" [an addition not found in the script] as he speeds away) is played out by the actors. The bulk of the scene is captured by the camera mounted to the hood of the truck, looking in through the windshield as their sexual energy heats up, then instantly cools, descending quickly into bickering and resentment.

Daisy Hall plays the scene like a petulant tease, feigning ignorance of the effect of her tantalizing flirtation on Mason's libido, while Jason Brooks is all hands and heavy breathing until Mason is shut down and reverts to a pouting child, barely able to look her in the eye.

Which brings the night's shooting to a close, and so, yet another day (<u>and</u> week) of principal photography on *I'm Dangerous Tonight* is one for the history books.

SIXTEEN

KNITTED BROW

Monday, May 14, 1990

Due to the tight confines of Amy's bedroom, what with the camera equipment and essential crew members taking up the limited available space, personnel determined to be extraneous are discouraged from entering, making detailed observation difficult at best. Even still photographer Eric Lasher, one of Hooper's stalwarts, is politely urged to leave the instant he walks in by Hooper's vague but pointed, "Um, Eric . . .?," a request that he readily accedes to, despite obviously being irked by the suggestion.

First up on the schedule is Amy's side of the scene in which Eddie awakens her by tossing pebbles against her window (42), his portion of the scene having been shot the previous week. It really amounts to just the beginning of the scene, in which Amy stirs from her slumber, confused. Hearing another pebble strike the windowpane, she rises from her bed and crosses to the window, opening it and leaning out to address Eddie. (There's no need for her to exchange dialogue since her side of the conversation from outside the window had also been filmed a few days back.)

Dolly tracks are laid alongside the bed while Mädchen lies hugging the pillow, seemingly fast asleep, bathed in the glow of morning sunshine streaming into the room.

Hooper rides the dolly for this smooth tracking shot that begins on the gossamer curtains above Amy's bed, tilting down while

simultaneously gliding across the bed, coming to a gentle stop into a close-up on Mädchen's face, eyes closed and breathing lightly. Barely above a whisper, script supervisor Sandy Mazzola clucks "Tink, tink," providing the sound of pebbles tapping the windowpane for her to react to. Her eye winks open and she looks toward the window to the rapping sound. As she gets up and goes to the window to open it, the camera pans along with her. "Cut," says Hooper, with obvious satisfaction. All in all, an artful and efficient shot.

Scene 63: After lying to Gloria that she had thrown out the cursed red dress, Amy dashes off down the stairs to meet up with Eddie, leaving Gloria alone to pout about not being able to wear the dress to tantalize (and possibly to inspire jealousy in) her meat-headed boyfriend.

Daisy Hall is a vision in her revealing lingerie and lavender satin kimono/robe. She and Mädchen, dressed once again in her casual outfit of blue jeans and blue blazer, emerge from Amy's room into the upstairs hallway, already in the middle of an argument about the red dress. Gloria wants to borrow it (to seduce Mason), but Amy insists that she "got rid of it." Yet again, Hooper and his team stage the scene with great efficiency. The two young ladies exchange dialogue, and when Mädchen descends the stairs (basically Amy blowing Gloria off), the camera adjusts slightly as she passes. Daisy moves forward into a close-up, elbows propping her up as she leans on the newel post and sulks, the prototypical evil stepsister.

There are a few shots of the sequence (128, 132) in which Wanda terrorizes Amy remaining to be filmed; hiding from Wanda in her bedroom, Amy phones the police but is interrupted by Wanda using the statuette as a battering ram on the door. Also, back in Gram's bedroom, Amy cowers behind her grandmother's wheelchair when the phone on the bedside table rings. She reaches for it, then thinks better of it, not wanting to alert Wanda

to her presence.

The next shot (though not appearing on the day's call sheet) is a pick-up for Scene 45: While bringing her infirm grandmother her meal, Amy pauses for a moment and stares back at her own bedroom door for several seconds, ostensibly drawn by the lure of the cloak. No actors are required for this POV (point-of-view) shot of Amy's bedroom door.

As was done during principal photography on Hooper's *Spontaneous Combustion*, a sketchbook is being passed around for the cast and crew to commemorate their time on the show and to express their individual artistry. It so far contains contributions from lead actress Mädchen Amick (a stylized self-portrait), still photographer Eric Lasher (a pointillist pencil rendering of the Aztec sarcophagus), videographer Stan Giesea (a quick pen-and-ink caricature of Anthony Perkins as Buchanan and a smudgy pencil sketch of the Aztec mummy), a childish caricature of himself as the student director by actor Stuart Fratkin, another sketchy self-portrait by actor Dan Leegant as the security guard, and a host of others.[68]

Scene 60: Following her confrontation with Martha and Gloria about her complicity in Gram's horrific death, Amy returns to her room, distraught but determined to destroy the nefarious red dress. Immediately going to her sewing table for a pair of cutting shears, she kneels beside the dress, lying where she had left it, in a heap on the floor. She grabs it, intending to cut it to shreds, but the dress exerts its power over her, and she is unable to follow through. Faced with this seemingly impossible task, she finally wraps the dress in Mason's sport poncho (that she had covered herself with when escaping his aggressive advances after the

[68]See Appendix 2, page xvii.

dance) and tosses it into a corner of her closet, slamming the door behind it. Going to the mirror (yet another fairy tale reference: "Mirror, mirror, on the wall . . ."), she regards her reflection as if staring at a stranger, lamenting "My God, what's <u>happening</u> to you?"

Next on the agenda, a scene (35) postponed from an earlier date and which, as written, has Amy, racked by dark and disturbing dreams, awaking to the mysterious sound of the creaking garden gate echoing through her window. She goes to investigate, seeing nothing but the lonesome gate swinging in the breeze. Stepping back, her attention is drawn to the cloak draped over her bedframe. She reaches out to touch it, unable to resist its powerful attraction.

However, instead of waking up screaming, as the script has it, Hooper has Mädchen simply open her eyes, pause for a beat, and then rise quietly into a sitting position, staring out the window. Also, the bit with the creaking gate is dispensed with, and the scene plays as if it is the lure of the cloak itself that has awakened her from her fitful slumber.

With the camera positioned behind and above her, in a shot reminiscent of Janet Leigh's emergence from drugged catatonia in a dilapidated motel room in Orson Welle's *Touch of Evil*,[69] Amy awakens suddenly. The camera is situated immediately above Mädchen's head, looking down on her moonlit face. Her eyes snap open, black and lifeless as a doll's. She slowly raises her head from the pillow as the camera tilts up. In the screenplay, she wakes up screaming, but Hooper has decided to jettison that old cliché, so she rises quietly and robotically and goes to the window to

[69] This may not be as far-fetched a comparison as it might seem at first blush, as Hooper had acknowledged on multiple occasions that Welles' seminal film was one of his all-time favorites.

investigate the creaking sound that has awakened her. After a moment, she turns her attention to the red fabric draped over her bedpost and reaches out for the crimson relic at the foot of her bed, drawn to it as if seduced by its power. (This sequence immediately precedes Gloria's arrival home to discover Amy crouched over her sewing machine, furiously transforming the sacrificial cloak into an alluring cocktail dress.)

The next scene (57) entails Amy, having salvaged the dress from the scene of Gram's horrific death, returning to her room, slamming the door behind her, and dropping the garment to the floor, panting, weakened by the struggle to resist its powerful attraction and fearful of its deadly influence.[70]

Posted above the craft service table, an unidentified crewmember has drawn a clock on cardboard and has attached (*Pin the Tail on the Donkey*-style) a black paper penis as the minute hand, which can be manipulated from behind to rise on command. Above the clock face is written, "Bone Factor," and below, ". . . and still rising."

Following a wardrobe change, Mädchen returns to the room for a brief shot of Amy, restless and unable to sleep as the insistent sounds of the TV downstairs keep her awake (Scene 88). Giving up, she finally gets out of bed, pulls on her robe and heads down to check on her drunken aunt.

Scene 67: In what's certain to become an iconic image, Gloria appraises her reflection in her room's full-length mirror, her buxom figure undulating like liquid lava, virtually poured into the demon dress. Dismissing her mother's calls, and after calling her "a stupid cow" under her breath, she utters the immortal line, "I'm *dangerous* tonight!"

Constrained by space from entering the set, sound mixer Craig

[70] Yet another shot that fails to make the final cut.

Felberg and stand-in Courtney Wulfe sit outside by the sound cart and joke good-naturedly about their time on the show. "So, which producer did you sleep with to get your job?," Craig asks Courtney, to which she retorts, "I don't have a job. I'm just hangin' out."

Scene 140: Back in Amy's bedroom for a sequence that takes place immediately following her encounter with Wanda. The room is darkened, beautifully lit by director of photography Levie Isaacks and gaffer Robert Moreno, with deep, elongated shadows and streaming white moonbeams. Outside the window, a branch cut from a ficus tree is clipped to a tall c-stand to create a dappled chiaroscuro effect.

We begin with an extreme close-up on Amy's face, head on her pillow, lying unconscious. Her eyes flutter open. Moaning, she raises her hand to the back of her head, feeling the bruise inflicted on her by the heavy marble ashtray. The camera dollies back to reveal, shockingly, that the red dress once again adorns her body, her eyes widening as the realization dawns on her. Confused and frightened, she catches sight of her reflection in the full-length mirror and pauses to gander at her own stunning beauty, once more under the thrall of the sinister red dress. Quickly coming to her senses, Amy recalls her deadly struggle with Wanda, believing that she is responsible for the unfortunate woman's death. She is further startled by a dark shadow crossing the room. She backs away and, in what may be an allusion to yet another fairy tale, Lewis Carroll's *Alice in Wonderland*, seems to disappear into the mirror. (To Hooper's credit, all this action is captured in one exceptionally well-planned and executed shot.)

Her fear turns to relief when it is revealed that the shadowy figure is Eddie, seemingly possessed, driven by some lustful passion, reminiscent of his manner while wearing the cloak during the sword fight rehearsal. He seems to want to console her, but his mind is clearly elsewhere, now no longer the charming prince, but instead a relentless lothario accosting his princess.

Considering Eddie's demeanor, there is some sly humor in Amy's line, "Oh, Eddie, please help me get out of this dress," which has been slightly altered from the script's "I have to get out of this dress." Suddenly, Amy recalls her tussle with Wanda, fearing that she may in fact have killed her. Eddie reassures her that this is not the case, admitting that he had subdued Wanda to save Amy's life because "She wanted to take it from us." Amy realizes with horror that it was he that had slipped her into the dress while she was unconscious. Standing over her, his heavy-lidded eyes and dry, pursed lips suggest the aspect of an unrepentant drug addict.

The camera is repositioned at the foot of the bed and slowly dollies in as the action ensues. Eddie pushes Amy down on the bed, grinding on top of her and slobbering over her while she lays frozen in fear. "I love you," he grunts, "but just think how much <u>more</u> we can love each other with a *million volts* surging through our bodies!" He lifts his sweater, exposing his naked belly, and writhes against the sizzling red fabric.

Amy momentarily relents, relinquishing her will to the seductive power of the cloak, folding Eddie in her arms and surrendering to his sexual advances. But, with a herculean effort, she finds the strength to resist, snaps back to herself, pushes Eddie off her and flees.

It's uncertain whether young Corey Parker is a "Method" actor (an approach to acting originated in the early 1900s by Russian theatrical director Konstantin Stanislavski and later popularized in the United States by Lee Strasberg and The Actors Studio, which applies techniques to assist the actor to "get in touch with their emotions"), but his quiet intensity between takes would suggest that he is.

The last shot remaining on the day's call sheet is a quick insert

of the interior of the antique chest containing the Aztec sacrificial cloak as Amy removes it on the Wilson's lawn during the estate sale (Scene 25). The camera rolls. It's *one and done*, and the cast and grew eagerly bid farewell to the Hyde House for the final time.

SEVENTEEN

BOBBIN' AND WEAVIN'

Tuesday, May 15, 1990

Built in 1927, the Sawpit Dam overlooks the sleepy Los Angeles suburb of Monrovia, residing in the shadow of the towering San Gabriel Mountains. The dam and its surrounding areas have long been a cherished destination for campers, hikers and nature lovers.

Hooper, together with stunt coordinator John Moio (sporting his crew bomber jacket from *Eve of Destruction*, director Duncan Gibbins' recently completed science-fiction thriller, on which he served as both stunt coordinator and 2nd unit director), 1st assistant director Tom Blank, and the director's assistant Rita Bartlett spend the first part of the day scouting locations on the winding streets surrounding the dam, walking the road and planning shots for the evening's elaborate upcoming vehicle chase (Scenes 74-76), in which Gloria, fueled by the evil influence of the red dress, recklessly pursues Amy and Eddie at dangerously high speed. Tom discusses with Moio the fact that the action must basically be covered twice, once with the stunt team ("your people doing it") and once with the actors ("our people doing what your people did"), adding that "We have to go in continuity, sort of."

Hooper and company sit on the railing that protects heedless mountain motorists from careening over the steep drop-off while Moio addresses his concerns regarding the truck chase.

"See, you've got a major problem, we've got [only] one truck . . . I think we should go with actors first," Moio asserts as Hooper nods in agreement, "because once we screw that truck up, we can't . . . if we get all of that out of the way . . . at least we can end it there, if we had to, but if we do the stunts first, and then try to go back," he shrugs, "we're screwed."

"So, should we get on the insert car[71] first?," Tom queries. "Joe doesn't want to do that," Tom says, referring to mercurial line producer Joe Bellotti, "but . . ." causing Hooper to chuckle, "Well, we have to do it."

Later, strolling up the road, Moio walks Hooper through the schematics of the chase and multiple collisions, using hand gestures to illustrate the pursuit's literal twists and turns and detailing the shots needed. As always with Moio, safety is of paramount importance. The stunts should *seem* dangerous without *being* dangerous. Describing how to achieve a particular effect, he explains how they plan to "grease the front tires and take the lug[nut]s off" of Mason's Bronco to facilitate a more satisfying impact when smashing into Eddie's little Nissan. (Attached to the day's call sheet is a map indicating the locations for the chase in relation to the dam and its surroundings.)

But before they embark on filming the much-anticipated chase scene, the crew gathers in Monrovia Canyon Park in a vast asphalt lot overlooking the dam to complete a sequence begun weeks earlier. Scene 51: While Gloria has excused herself from their table at the dance, going to sulk in the lady's restroom, Mason is unable to resist Amy's brazen flirtation (her inhibitions relaxed due to the uncanny effect of the red dress), so he takes her by the hand and leads her willingly to his waiting Bronco in the parking

[71] Also known as a Shotmaker, an insert car is basically a truck equipped with a platform to carry a camera crew and equipment for the purpose of filming other vehicles while in motion.

lot. Once inside the cab, things heat up quickly as they merge into a passionate embrace (Mason panting huskily, "I'm gonna drive you out of your mind," to which she breathlessly responds, "Do it."), but when Amy, in the throes of uncontrollable lust, removes the dress, the spell is broken. Realizing with horror the position she finds herself in, she extricates herself from Mason's arms, wrapping herself in his poncho and dashing from the truck, whimpering her pitiful apologies as she goes, "I'm so sorry, Mason, I'm so sorry!," leaving him angry, confused, and blue-balled. (On the call sheet, the scene is notated as "Amy chickens out.")

As night falls, the air chills considerably. Most of the crew are decked out in bulky jackets, sweaters, and/or scarves. Craft Service[72] person Tammy Landry leans against a chain-link fence wrapped in a furniture pad, only her eyes visible. "Sure is cold," Jason Brooks observes, donning his tuxedo jacket and rubbing his hands together, "I picked the wrong profession. I should have been a *lumberjack*."

Because the scene takes place at a distance in the confined interior of the truck, disallowing the use of the boom mike, Jason and Mädchen are fitted with body microphones for sound. Needing to use the bathroom before they shoot, Jason asks generally if there's a Porta Potty (a portable toilet often used for remote location shoots or events) nearby. "Yeah, it's right over here," Levie replies helpfully, making a sweeping gesture indicating the wooded area surrounding the dam, "I'll come show ya'."

"Sound's on, Jason! Sound's on!," Rita shouts from a distance. Shameless sound mixer Craig Felberg offers to the videographer, "Stan, come here, I'll give you the headphones so you can hear

[72]Craft Service provides food and drinks to the cast and crew on the set of a film, television, or video production to snack on between meals.

everything and shoot him while he's taking a leak." Amid laughter from the crew, Stan blurts out, "It's your big moment, Jason! Cinematic history. It'll be <u>classic</u>!" "Oh, that's *great*!," Jason responds sarcastically. Hovering watchfully in the vicinity, with his navy blue peacoat girding him against the cold, Hooper chimes in, "Craig could tell ya' whether ya' pissed on a rock or on the ground." "Y'know what, I could just sing over it!," Jason quips, "I could just sing over it. Laaaaaa . . . as long as it's not 'It's a Small World!'"

For the first shot of the sequence, the camera is placed at a distant spot across the parking lot. This is the end of the scene, in which Amy rushes from the Bronco clutching the red dress, Mason's poncho hastily wrapped around her, protecting her exposed skin from making contact with the haunted fabric.

Standing in close proximity to the truck, communicating with the actors seeking last-minute clarification, Tom shouts across the lot to the director, "Tobe, where does she throw the red dress?" "In the front seat," comes Hooper's immediate answer.

After a few aborted takes due to technical issues, with wardrobe supervisor Julia Gombert standing by, Hooper instructs Mädchen that there is no need for her to go through the rigamarole of putting on the poncho, saying, "No, you don't have to button it. Just throw it over your shoulders. Actually, we get no value at all from Eddie seeing you . . .," referring to the fact that in the script, Eddie happens to witness Amy's flight from the dance and escape from Mason's clutches.

"And . . . we're rolling!" Tom speaks into his walkie-talkie. "*Aaaand*, <u>action</u>!" shouts Hooper, and the scene plays out. "Cut, cut, cut, cut!" cries the director, approaching the actress, "Yeah, Mädchen, now it was upside down," indicating the poncho and offering to assist her in adjusting it properly.

The next take proceeds like a charm, with Mädchen, clad only in

sheer bra and panties with the poncho loosely slung over her shoulders, jumping out of the truck and into Amy's strategically parked Honda as Jason, haplessly buttoning up his dress shirt, yells after her from the back seat as she drives off, tires screeching, "Hey, wait a damn minute! Where you gonna go dressed like that?" (Yet another example of someone shouting after Amy as she scurries away.)

It's a cramped squeeze into the cab of the Bronco. Director of photography Levie Isaacks crouches on the driver's seat with the camera hoisted onto his shoulder, holding Mädchen and Jason in a tight two-shot, while 1st assistant cameraman Wayne Trimble rests on the front passenger seat, pulling focus. Boom operator Cameron Hamza lodges himself into the open driver's side door to record sound while Hooper sprawls across a furniture pad spread on the hood of the truck to get an unobstructed view. A large bounce board (reflector) has been erected adjacent to the truck to provide fill light.

When Hooper calls "Action," they lock lips, making out furiously, petting and moaning uninhibitedly, their heated lovemaking, as the script has it, "melting the vinyl on the back seat." When Mädchen pushes him away, Jason projects just the right mixture of anger and sexual frustration as he fumbles with his shirt buttons.

Hooper is ecstatic about the take, "Cut. Great! Print." Levie: "Good!" Tom immediately takes charge, asking Hooper, "Now, sir, where are we?" "We're done here," he responds dryly. "Okay, we're done in the Bronco!" Tom announces, to a rousing cheer and applause from the surrounding crew.

This marks Jason's last shot in the film, and he mock-cries to commemorate the occasion. Hooper offers him a firm handshake and a subdued but sincere, "Thanks, man," after which Tom Blank shakes his hand, adding wryly, "Jason, you're finished. But that's only in Hollywood."[73]

Brooks seems genuinely moved, shyly murmuring, "Thanks a lot. I had fun. A lot of good times." He has a particularly generous goodbye hug for Daisy Hall, who has played his high-maintenance girlfriend for the duration of the shoot. On set for the upcoming chase sequence, she is barely recognizable, without makeup, wearing a frumpy robe, with her hair up in curlers and being tugged on a leash by her devoted Aussie hound.

Co-producer and co-screenwriter Bruce Lansbury, wearing a crew jacket from the film *Robocop 2* (with which he apparently has no affiliation), is on scene to observe the night's shoot, likely with a particular interest in the car chase scheduled for later in the evening.

"Guys, load up, <u>please</u>," Tom Blank calls as they prepare to shoot Amy and Eddie in the Nissan fleeing from Gloria's manic pursuit. Mädchen and Corey wait in the cab while the crew flurries around them, making last-minute adjustments to the camera rig on the Shotmaker truck, which will hold Hooper, the camera crew and stunt coordinator John Moio as they navigate the winding roads with the pickup in tow and the Bronco following perilously close, with stunt driver Debbie Evans (doubling Gloria in red dress and black wig) behind the wheel. Both bundled up for the cold night, Hooper and Moio discuss with the driver the route that they've planned for the shot.

By now, Mädchen and Corey are quite comfortable in each

[73]Jason Brooks was <u>not</u> finished in Hollywood. He has gone on to have a long, notable career that continues to this day, including a memorable appearance on an episode of TV juggernaut *Friends*, a starring role replacing David Hasselhoff in the reboot of NBC's silly lifeguard drama *Baywatch (Baywatch: Hawaii)*, and many roles in various J.J. Abrams projects. He is probably best remembered by a certain coterie of fans as the villainous Peter Blake in the long-running soap opera *Days of Our Lives*.

other's company, and engage in casual conversation while awaiting the go-ahead. For some reason, in response to her, Corey makes the silliest of faces.

The remainder of the evening's shoot is dedicated exclusively to Gloria's perilous pursuit of Amy and Eddie through the narrow mountain roads above the town. A short stretch of the highway has been designated and blocked off for the stunt chase, but being so late at night/early in the morning, there is little traffic to divert. The sequence in the script is reduced to a series of bullet points:

- EDDIE'S PICKUP – races down the street but the powerful Bronco is catching up
- AMY & EDDIE – are shaken but Eddie hangs on to the wheel.
- CLOSE ON THE BRONCO – as it rear-ends the pickup again.
- EDDIE – slams his foot on the breaks and yanks at the wheel.
- THE PICKUP – skids across the street towards a wall.
- INTERCUT – as Gloria rear-ends the pickup TWO MORE TIMES with a ferocious intensity.
- THE PICKUP – is now a wreck.

And so on.

During the chase, there is little in the way of dialogue, aside from the following brief exchange of disbelief and desperation between Amy and Eddie as the Bronco advances on them.

EDDIE: Why the hell's she doing this?

AMY: I don't know.

Instead, their performances mostly entail reacting with fear and

confusion to the powerful vehicle barreling down on them as they swerve and weave along the narrow strip of road.

Upon their return to "base camp," the Bronco is rigged to the Shotmaker's tow bar and readied to shoot Daisy Hall's turn as Gloria, gloating, snarling, and exulting as she plows into the Nissan pickup again and again in a preamble to the character's unexpected death in a fiery crash.

Moving on to the chase, in which the vehicles actually make contact, John Moio takes all the time necessary to ensure the safety of his stunt personnel and the film crew. Having worked together in the past and developed a mutual trust, Hooper defers to Moio on all questions of precaution and procedure regarding stunts. Checking and rechecking the stunt vehicle's mechanics and safety measures is extremely time consuming but unquestionably necessary.

As if pulling weeds, director of photography Levie Isaacks and co-producer Bruce Lansbury trim a roadside shrub that is encroaching on the shot while one crew member sings an old plantation work song, "Nobody knows . . . da' trouble I've seen . . .," and another snidely observes, "Harvest is good this year," eliciting chuckles from the bystanders.

For the first take, both vehicles speed around a blind curve and into view, the jet-black Bronco (with Cullen behind the wheel) slamming into the front quarter-panel of the pale blue Nissan (driven by stuntman Philip Romano, doubling as Eddie), pushing it into the barrier and scraping a long divot the length of the passenger side as they pass perilously close to the camera lens amid clouds of dust and the sounds of screeching tires and twisting metal. "<u>Cut!</u>"

"Real quick, let's go again, guys," Moio insists after the first attempt, lamenting, "That wasn't so good." The Bronco's right headlight is busted, and the front bumper is damaged from the

first series of collisions, bent outwards. Multiple crewmembers, all bundled up against the cold, attempt to "repair" it by pushing and/or kicking the twisted metal back into place, to little avail, while Hooper watches, bemused. Overheard among snickers from onlookers watching from the sidelines, "Prepare for take <u>two</u>," and "They'll never notice."

The camera rolls on the next take and on Moio's instruction, "Come ahead, <u>action</u>," the Bronco sideswipes the smaller truck multiple times, running it into the railing before both vehicles speed past. "Anything in there?," Moio asks Levie. "Yes!," Levie replies enthusiastically. "Okay, let's go on. We're not gonna . . .," Moio's voice trails off, clearly indicating that he's less-than-satisfied with what they've got, but that he's prepared to live with it.

The brightening sky and the sun's imminent rise indicates that morning is upon us, and the crew is gratefully released for the night.

EIGHTEEN

ATTIRE BURN

Wednesday, May 16, 1990

After a twelve-hour turnaround providing a much-needed rest, the production regroups at another location in the Sawpit Dam area overlooking Monrovia, just up the road from the previous night's shoot, a vast, secluded turnout that abuts a sheer incline above a ravine, where the final moments of the frantic pursuit are to take place, in which the Bronco "T-bones" the pickup, plunging headlong into the passenger door and sending Amy and Eddie scampering from the vehicle.

Levie and Moio engage in a protracted conversation regarding how best to achieve the desired effect while Mädchen and Corey receive a demonstration from the stunt team; to enact their characters fleeing from the pickup, barely escaping the Bronco's deadly trajectory, they are instructed how to properly dive onto the multicolored protective pads arranged in a large rectangle on the ground beside the dirt road. One might think that they were seeing double watching the stunt performers interact with Mädchen and Corey, both couples dressed in precisely the same wardrobe, the men in brown suede jackets, blue plaid shirts and jeans, and the women in greenish blazers, plain white t-shirts, and denim pants. Under Moio's tutelage, they practice again and again until they are fully comfortable with the requirements of the stunt.

While waiting, partly to gear themselves up for the shot and partly to buttress them against the cold, Mädchen and Corey bounce enthusiastically on the balls of their feet in a giddy display of childlike foreplay.

For this stunt featuring the film's two young leads, an additional camera has been acquired and both are placed low to the ground. 2nd assistant cameraman Bill Roberts slates the shot, shouting, "A/B, common mark!" When prompted, the pair run from the oncoming Bronco towards the cameras and fling themselves through the air onto the waiting pad, to resounding applause from the crew, especially Moio and his stunt team. Mädchen is evidently having a ball. "It's like a *cartoon*," she observes with a crooked smile, rising from the mat and dusting herself off. After multiple attempts, Hooper is finally pleased with the result. "Printing 1, 2, and 3!," script supervisor Sandy Mazzola announces.

What seems like the entire grip crew gathers around the pickup to adjust its placement in the road as if it had been pitted (abruptly turned sideways) by the impact of the Bronco, grunting as they lift and slide it into position. (It remains unclear as to why they don't simply drive it into position, but life is filled with mysteries.) Meanwhile, Levie consults with 1st assistant cameraman Wayne Trimble regarding the next set-up, "We'll go handheld, uh, let's look at a 35 [millimeter lens] . . .," when, out of the blue, costume designer Carin Hooper approaches him and asks pointedly, "Do you have a dog?" "No," he replies. "Want one?" "<u>No</u>," comes his curt reply, "My wife's allergic."

Isaacks lays prone in the pickup's cab with his back up against the driver's side door for a harrowing point-of-view shot in which the Bronco speeds directly for the two imperiled lovers. The stunt looks incredibly dangerous; the muscle truck, approaching at high speed, skids across the unpaved road and screeches to a halt, stopping short just before slamming into the Nissan's passenger

side, prompting someone from the crowd to shout, "Wardrobe!" (cheekily implying that Levie may well have soiled himself, bringing slowly dawning chuckles from the crew). Emerging from his reclining position in the driver's seat, Levie remarks with a grin, "All right, that's the 'Oh, shit!' shot, huh?"

The following shot is essentially the reverse of the previous set-up. Dolly tracks are laid perpendicular to the battered pickup and two lighting fixtures are appended to the dolly to replicate the reactive light of the Bronco's floodlights racing towards the vehicle. (Earlier, while planning the shot, Moio had worried that if this were the Bronco's point-of-view, the two youngsters would have no time to escape the truck's deadly trajectory, but Hooper allays his concern by explaining that it was not strictly a POV shot of the vehicle barreling down on them, but was rather a "dramatic dolly," which sets his mind at ease.) As Mädchen and Corey sit in the cab, Hooper goes over the details with them, even placing a Styrofoam coffee cup on the dolly to serve as their eyeline for the approaching truck. Hooper further instructs Corey to "make a broad gesture" in his attempts to restart the pickup before they are forced to fumble out of the driver's side door so that it will "read for the camera."

Always thinking a few steps ahead, Tom Blank confers with key grip Michael Colwell about the preparation for the next sequence on the docket, telling him, "We gotta put the rails up there for the next shot," in which both Eddie and Amy (doubled by stuntpersons Phil Culotta and Kerrie Cullen, respectively) dive headlong over the railing to narrowly escape being run down by the sinister black Bronco.

"*Aaaand*, action!" Hooper's raspy voice fills the cool night air. Right on cue, dolly grip Dave "Foots" Footman smoothly and speedily glides the dolly down the tracks toward the truck's passenger door, stopping just short of impact. Terror in her eyes, Mädchen shrieks, "Eddie!" and Corey shouts, "Get out! NOW!" as

he fumbles with the door handle in an effort to retreat from the impending collision. "Cut!"

As they back up and reset up for another take, Hooper informs his actors, "The dolly is going a little slower this time, so that'll give you more time to . . . um, do your business." Once the camera rolls and the dolly moves, Hooper paces alongside, hands behind his back and head craned far forward, like a watchful schoolmaster presiding over a final exam.

"Cut!" shouts Hooper, clearly pleased. "Perfect, print! Print those last two," he says, already in motion, immediately making his way to the site of the next shot.

"Now we're over there at the jumping off place!" Tom announces. The art department has erected a duplicate of the road barrier at the lip of the drop-off, which the stunt players will dive over as the Bronco, appearing dangerously close due to the use of a long lens, passes behind them. Most everyone pitches in to help dress the area by camouflaging the lighting equipment and cables with shrubbery and stones.

The camera is mounted on the tripod and secured partway down the incline, facing upwards toward the edge of the drop-off (where a gathering crowd of onlookers is growing quickly), with Levie and 2nd assistant camera operator Richard Hutchings flanking it on either side and Hooper hovering nearby. Probably due to the late hour, Levie is understandably punchy, "Now all those people gotta stop moving over there or they'll walk right into my shot!"

There are some persistent worries among the crew about the possibility of venomous snakes in the area. While waiting for the reset, Hooper and still photographer Eric Lasher share a conversation about similar concerns on the set of *The Texas Chain Saw Massacre*. Hooper explains, "That hill that, uh, they run down from Grandpa's old house, or grandfather's old house . . . they go to the other house, it's called Rattlesnake Hill, and there

were more rattlesnakes there, man . . ." "Really? *Greeaaat*," comes Lasher's withering, sarcastic response. "They have a line . . . running down that hill that Bill Vail[74] is saying,' Hooper continues, "'Scorpions, lizards, and snakes . . .'" "Oh, my!" an anonymous voice pipes up from the sidelines.

Meanwhile, 1st assistant director Tom Blank stands at the top of the hill, magisterially watching the proceedings like an emperor surveying his domain.

With stuntpersons Phil Culotta and Kerrie Cullen properly rehearsed and ready, the camera rolls. As the Bronco whizzes by behind them, kicking up a cloud of dust brightly illuminated by the vehicle's headlights, they hurl themselves over the embankment and into the brush below. Levie is unsatisfied, "All right . . . um . . . seemed awful slow to me." "Yeah, it seemed slow to me, too," Moio agrees.

"Wait, wait, hold it! Back 'er off a little bit!," Moio calls out before the next take, noting that the Bronco is visible in the frame. "I see the light already," confirms Levie, pointing out the floodlights mounted atop the truck's cab, and they pause for a moment to allow the vehicle to back out of the shot.

On the next take, after having consulted with Moio, Culotta soars over the railing, arms flailing, with Mullins diving headlong after him. After they've cut, and while Culotta helps Mullins to her feet and dusts her off, Levie exults, "Good here! I tell ya', that's the money for me!"

"Okay, let's move on," Moio proposes, "Let's go turn this thing over," eagerly anticipating the upcoming stunt, in which, after losing control, the Bronco tumbles down the hill, finally landing

[74]William Vail plays Kirk, one of the hapless youngsters caught up in an inexplicable web of murder, madness, and mayhem while on a road trip through Texas, in Hooper's breakthrough film.

upside-down at the bottom of the ravine and ultimately bursting into flames with Gloria trapped inside.

 The ravine is awash in the glow of the large Tungsten 12K lamp that illuminates the entire area, mounted high atop a Condor crane (also known as a "cherry picker"). Out of sight from below the hill, where the camera has been situated, the Bronco's engine can be heard revving in preparation for its dramatic plunge down the incline. At Moio's signal, stunt driver Debbie Evans accelerates, hitting a small ramp as it skirts the edge of the chasm, begins to slide precariously, then . . . comes to rest in the dirt only inches from the ridge.
 "Uh-oh. Okay . . . and, cut!" says Hooper, obviously disappointed, as the stunt team and assorted crew gather at the vehicle to try to determine what's gone wrong.
 "There's probably hardly any fuel in that," Lasher observes while waiting below, "Probably just enough fuel to make it get where it needs to go," rightly recognizing that for safety's sake and in the event that something goes horribly wrong, it's best to keep fuel levels to the bare minimum. (Incidentally, this is a <u>second</u> Bronco that has been rigged expressly for stunt work, in this scenario for the tumble down the hill and the explosive dénouement.)
 In the process of backing up the truck for another attempt, the vehicle flattens a large shrubbery deliberately placed by the art department to mask the ramp. Furthermore, the tires fail to gain purchase and the truck begins a slow slide backwards down the hill, prompting the assembled crew members to rush to its aid. Stuntman Phil Culotta even jumps in front of the truck to help halt its descent. "<u>Shit</u>! Don't get in front of the thing!" yells Lasher, barely stifling a laugh. With a Herculean effort, they manage to push the truck from the brink of the ledge back onto level ground. "A little moment of actual drama there," one crew member

remarks, adding, "Nice landscaping."

Multiple firefighters, an ambulance, and a fire department water truck are all in attendance at the bottom of the hill, prepared for any eventuality. Meanwhile, lined up along the crest of the ridge above the ravine, a surprisingly large group of onlookers has congregated to watch the spectacle.

After redressing the location (i.e., replacing the pulverized shrub with a fresh specimen), and while the spectators wait expectantly, Moio and his team settle in for another attempt. Again, the truck speeds for the cliff edge, and again the stunt fails to come off, leaving the Bronco again stuck in the dirt high on the hillside, teetering at an awkward angle.

Resetting is a much easier process this time around and they quickly gear up for a third effort. Speeding for the drop-off, the truck hits the ramp perfectly, tips over into a spin and rolls ass-over-teakettle down the embankment, kicking up clods of dirt, the floodlights shorn from the vehicle's roof during the tumble. It finally settles right-side up in a cloud of dust at the bottom of the hill as cheers and applause echo through the canyon, punctuated by a host of enthusiastic hoots and hollers from the bystanders.

The next sequence finds Amy and Eddie reacting to Gloria's horrific immolation as the Bronco bursts into flames at the bottom of the ravine. (As the script has it, Eddie has run to rescue Gloria, but his best intentions are foiled when she unexpectedly regains consciousness, grabbing him and inexplicably attempting to drag him into the burning vehicle with her. Frantic, he wriggles free from her grasp just in time to escape before the truck is enveloped in a ball of flame, running back to Amy's waiting arms.) Very somber, Mädchen nestles in the bushes on the steep hillside. Off-camera, Corey braces himself for the take using his patented method of huffing and puffing and bouncing up and down on the balls of his feet.

Hooper prompts the actress as the camera rolls, "Looking,

looking, Mädchen, burning . . ." "<u>Eddie</u>! Come back!," she pleads, her voice raw and her visage a mask of agony and terror, gesturing desperately for him to return to her, "Eddie, hurry! <u>Hurry</u>!" (The illusion of the light of the flickering flames from the burning truck playing across her face is achieved through the use of orange gels and gaffer Robert Moreno dangling strips of clear acetate in front of the lamp's beam.)

Corey runs into the frame and folds Mädchen into his arms protectively. "<u>BOOM</u>!," Hooper provides the sound of the explosion as Moreno ramps up the light's intensity, causing her to break down in tears and disbelief, shivering uncontrollably and screaming, "Noooo! NOOOO, <u>GLORIA</u>!," as Corey vainly attempts to console her. At the end of the take, Mädchen is overcome with emotion and has to take a moment to herself to regain her emotional equilibrium.

Leaving the crash site behind to allow the effects team to prime the Bronco with explosives, the crew regroups at a nearby spot to shoot the next scene on the schedule, in which Wanda succumbs to the lurid machinations of the cloak and commits a dastardly crime.

Scene 86: On the curve of a remote dirt road overlooking the lights of the city, Wanda meets up with greasy, Italianate drug dealer Joey (described in the script as a "slick reptile"), played by Edward Trotta, waiting impatiently in his shiny black Mustang convertible (downgraded from a BMW in the script). Trotta is frequently cast as a cop on assorted television series, but here he relishes this opportunity to play a world-class scumbag. He is also featured in the recently completed *Pump Up the Volume*, director Allan Moyle's teen thriller starring Christian Slater and Samantha Mathis.

Brazenly flirtatious and flippant in her interaction with her sleazy drug connection, this encounter marks Wanda's first significant appearance in the film (having previously only been

glimpsed as a mysterious shadowy silhouette in a seedy back alley), her once-pretty face hardened by drug addiction and the storm of a difficult life, a mere sliver of the demonic red dress barely visible beneath the folds of her black rain slicker.

Despite the cold, the area is bristling with activity; Hooper confers with actress Dee Wallace-Stone and Trotta about the particulars of the scene while they run lines. Meanwhile, hairstylist Nina Paskowitz teases Dee's frizzy black wig while makeup artist Emily Katz applies her fire engine red lipstick, grip "Roo" Flower applies dulling spray (an aerosol designed to reduce surface reflectivity) to the Mustang's passenger side door, propman Ray Anthony tries to remove the vehicle's rear-view mirror to facilitate an unobstructed shot for the camera (discovering in the process that it is permanently affixed to the windshield), with the remainder of the crew spread out in a wide circle surrounding the car, all bundled up tightly against the near-freezing temperatures and virtually everyone sipping greedily from steaming cups of coffee. "Real steamy scene," gaffer Robert Moreno quips, blowing on his piping hot coffee, sending clouds of steam billowing into the chilly night air.

While waiting for the set dressers and camera crew to make final adjustments, Dee requests something to help stave off the bitter cold, bringing wardrobe supervisor Julia Gombert running with a fur-lined Eskimo jacket to drape over her shivering shoulders.

"Okay, here we go!" Hooper calls out, signaling his eagerness to shoot, urging the hair and makeup team to finish their touch-ups on Wallace-Stone, "Okay, girls, let Dee . . . let Dee get over here," further muttering, "If we don't do this, we ain't gonna get shit."

There is much consternation and discussion about the issues regarding the presence of a gun on the set, especially in finding a camera angle that "sells" the effect without compromising the safety of the players and the crew. It being his responsibility,

Anthony is especially concerned, spending considerable time with Dee reviewing the necessary protocols and ensuring that the weapon is clean and functioning properly. Acknowledging Levie's insistence that "It's gotta work for picture," he nonetheless offhandedly dismisses Hooper's proposal that Dee "cheat" by firing the gun at the dashboard ("Are you worrying about it ricocheting?" asks Dee, helpfully suggesting, "Why don't we put a sand blank [a non-firing load with no projectile] in there?") Ultimately, it's decided that Dee should slightly alter her position and point the weapon towards the back seat, satisfying the needs of the camera and posing no danger to her scene partner or any member of the crew.

"Okay, guys, we gotta shoot this," Hooper insists, his sense of urgency evident in his tone. "Let's shoot!" Because of the glacial pace of the evening's progress, he seems at the end of his tether, loudly complaining to anyone within earshot, "Listen, we have to get this image if we're gonna get coverage. I mean, this is just [wasting time], we're <u>fucked</u>. We're *already* fucked, I'm afraid. I mean, we've <u>GOT</u> to go!" he insists, hoping to light a fire under the crew.

Script supervisor Sandy Mazzola tentatively hazards a question, "Tobe, did you want to . . .?" Cutting her off, Hooper interjects, "<u>No</u>, I want to *shoot the scene*. I don't care what else is missing or anything, <u>just shoot the fucking scene</u>!"

As the scene progresses, Joey quickly grows impatient with Wanda's flighty behavior and gets straight to business, warning her, "Don't blow smoke in my face, sugar . . . we're doing business here," when presented with her glib attitude. Repulsive but supremely confident in his snazzy Armani sharkskin suit, silk tie, and slicked-back hair, with a curl on his lip and a steely gaze, he has no intention of meeting Wanda's needs, instead expecting to rob and murder her on the spot. But he underestimates her,

letting down his guard when casually reaching for the revolver he has stashed in the Mustang's glove compartment. Unexpectedly, Wanda pounces on him, and with a single swift stroke cuts cleanly through his throat with the large kitchen knife that she has extracted from her purse, lasciviously running her hands through his hair in the process. While he gurgles for air, she removes from the glove box a dozen or so transparent packets containing a white powdery substance (ostensibly cocaine or methamphetamine, but never specifically identified) rubbing a taste on her lips and gums before shoving them into her handbag, fuel for her murderous rampage, taking almost orgasmic pleasure in the moment.

At the climax, having already sliced poor, scummy Joey's throat open, Wanda adds injury to injury by shooting him with his own pistol, which she had retrieved from his lifeless hands. Striking a defiant stance, she shrugs and empties the clip into him,[75] giggling, "Tsk-tsk. Oh, dear, Joey . . . now I'm gonna have to report you to the Better Business Bureau."

Bemoaning the lack of time and the encroaching daylight, production manager Joe Bellotti is overheard whispering conspiratorially with 1st assistant director Tom Blank, "Y'know what we must do is, we must talk to Philip [co-producer Philip John Taylor] and Tobe and explain to them that, instead of . . . we need to change the coverage of what we're gonna get . . . because we're not gonna have time tomorrow night to do all the stuff that we do have to do and put that car [the Bronco] in position and turn it over, upside-down, lights out there somewhere . . . we need to finish this in <u>one shot</u> and go down there and set up . . .," his voice trailing off, lost in the whistling wind.

Perhaps as a result of this discussion and of Hooper's insistent

[75] Wanda never fires a shot in the final cut, likely at the behest of the executives at the USA Network in an effort to render the film more "family friendly."

prodding, this relatively involved sequence is captured in three elementary shots: a wide master shot with Wanda's broken-down vehicle looming in the foreground, a two-shot from the driver's side encompassing her exchange with Joey, and a complementary angle from the passenger's side. (Inserts of Joey's hands reaching into the glove box for the revolver and of Wanda's similarly pilfering the drugs are slated for tomorrow's final day of shooting.)

At the end of her last take, in which her character shudders with pleasure while pumping bullets into Joey's lifeless body, Dee sighs, "I swear, if I have <u>one more</u> orgasm . . .," a fitting coda to her experience on the film.[76]

In the interim, while filming Wanda's grisly roadside drug murder, the Bronco has been upended at the bottom of the ravine and rigged to explode. Effects pyrotechnician Joe Mercurio pours a trail of gasoline along the ground leading to the truck. The crowd that had gathered earlier for the rollover has grown exponentially, and they watch with keen interest as the effects team conducts their last-minute inspections.

Actress Daisy Hall has contributed to the sketchbook a stunning "painting" of the Sawpit Dam area, done with an assortment of

[76]Wallace-Stone has continued to have a thriving career through the years, contributing noteworthy performances to Peter Jackson's *The Frighteners* (in a similarly demented role, although she rejects the comparison) and Rob Zombie's *The Lords of Salem*, among many others, as well as countless television appearances, and is not only widely considered to be one of the leading ladies of genre film, but also one of the kindest individuals in the business. In a later interview, she mused on her decision to play the role of Wanda, "[She] was off-the-charts weird, dangerous, pretty. All the attributes I never got to explore in my 'mom' roles," going on to admit, "It was fun being the bad-ass."

colored markers, and included an enigmatic poem handwritten in gold-leaf ink:

> "And the greed of the priest
> turned the pure blood red
> and the dye of the dead
> flowed down through the ages
> and spilled on the town
> where the nice people slept."[77]

The darkness of night has given way to a blue dawn. Before long, daylight will be upon us and the shot could easily be ruined, leaving no opportunity for a second attempt.

As Scene 77 in the script has it, in the wake of the accident, Eddie runs to the truck to check on Gloria's condition, only to have her regain consciousness and attempt to drag him into the burning cab with her. He wrestles himself loose from her vice-like grip just in time to escape being consumed in flames. Normally, a stuntperson would be enlisted to double for the actor, as it's generally considered reckless to unnecessarily endanger anyone,

[77] Sprightly actress Daisy Hall's fate remains something of a mystery. Following *I'm Dangerous Tonight*, she starred in Amos Poe's *Triple Bogey on a Par 5 Hole*, an unusual tale of small-time grifters and the effect of their grim deaths on their progeny (a movie probably most notable for the appearance of late Academy Award-winning actor Philip Seymour Hoffman in his first feature film role). Hall subsequently made a few negligible film and television appearances, and in 2003 co-produced *Wake Up Running: A Story of Losers*, taglined as "a dark comedy about the Social Darwinism of Nobodies in Hollywood." Her last listed credit on IMDB is from 2004 and her current whereabouts are unknown.

but Corey is eager to do it, and stunt coordinator John Moio has deemed it safe. At any rate, there's little time to debate the issue as the sun threatens to rise.

"All right, stand by!," assistant director Tom Blank's booming voice echoes through the gorge. "Okay, stand by, here we go!," 2nd assistant Keri McIntyre repeats. "Okay, Joe?," Blank calls down to Mercurio, seeking clearance to proceed. Receiving a thumbs-up, he continues, "All right! Rolling!" "Rolling!," McIntyre's repeats.

Hooper shouts "Action!" As planned, Corey scampers down the hill to the inverted vehicle, kneels at the door and pokes his head in. Mercurio creeps into the frame and lights the stream of gasoline on fire. As the flames creep toward the truck, Hooper, shouting, instructs Parker, "Okay, Corey, now wait until he gets out of the shot and . . . come back, Corey!," prompting him to dash back up the hill.

The Bronco EXPLODES, sending a plume of thick smoke and flames cascading into the sky. The wave of heat and the concussion from the fireball is so intense that many are forced to step back from the blast when it ignites.

All is still for a moment as the vehicle burns, then Hooper's voice pierces the air, "Cut!"

Firefighters rush in to douse the flames. A torrent of water streaming from their firehoses rains down on the smoldering truck, and the fire retreats into billowing clouds of dissipating white smoke.

With no time to spare as the sky lightens with each passing minute, Levie pronounces, "Okay, so I think we're moving on down the hill," and trudges down the steep incline, followed close behind by the film crew, lugging their equipment with them.

The race against time and the rising sun continues as the crew prepares for the last remaining shots on the day's schedule, in which Eddie's effort to rescue Gloria from the flaming wreckage results only in her flailing attempt to drag him inside with her,

forcing him to flee for his life.

Daisy, in full hair and makeup and once again decked out in the infamous red dress, scoots into the charred remains of the upended vehicle and plants herself awkwardly against the truck's open window.

This brief but essential scene entails Eddie rushing to Gloria, seemingly trapped in place by her seatbelt, hoping to extricate her from the battered, smoldering hulk. Suddenly, her eyes snap open and she grabs him, pulling him towards her with surprising strength. "Gloria, <u>stop</u>!" he cries, "Let me <u>go</u>!," grappling with her briefly before tearing himself loose and escaping to the safety of Amy's embrace. Left behind, Gloria shrieks in agony as the flames overtake her. A flame bar (a metal shaft attached to a propane accelerant) is lit beneath the camera lens to cause the air to shimmer and to create the illusion of Gloria's being immersed in fire. The effect, unfortunately, is not altogether convincing. (Attentive viewers will note that it is this development that sets in motion the chain of events that lead to Wanda acquiring the red dress and ultimately becoming enchanted by its power, subsequently complicating our heroine's life immeasurably.)

This constitutes the final shot of the film for Daisy and Corey[78] both, and they receive a warm send-off from Hooper and the rest of the crew, with many hugs and tearful goodbyes.

"That's a <u>wrap</u>!" Tom announces just as the sun finally peeks out from below the distant eastern mountain range.

[78]Since *I'm Dangerous Tonight*, Corey Parker has maintained a long and respectable career, appearing in such widely varied projects as Paul Bogart's television adaptation of Neil Simon's play *Broadway Bound* (playing the same character that Matthew Broderick had originated in Simon's *Biloxi Blues* on Broadway and in famed director Mike Nichol's film adaptation, which also

featured Parker in another role), as a series regular on the ill-fated 1998 reboot of frivolous 1970s romantic comedy *The Love Boat*, and as Debra Messing's diffident boyfriend for the third season of groundbreaking sitcom *Will and Grace*, along with a host of many other film and television projects.

NINETEEN

PATCHWORK

Thursday, May 17, 1990

Every call sheet includes a section at the bottom of the page enumerating what is scheduled for the following day. On this, the last day of principal photography, that section reads: "Window 'E' and/or VACATION!!!!!!," "Window 'E'" being a reference to the intake line at the Unemployment Office.

Also on today's call sheet, scrawled in large capital letters, is the announcement, "THURSDAY IS WEAR RED DAY!!," and many in the crew have obliged. Director of photography Levie Isaacks is crimson from head-to-toe in red sweater, red sweatpants, and matching red Budweiser baseball cap, gaffer Robert Moreno is sporting a red polo shirt, 2nd assistant director Keri McIntyre is bundled up in a fire-engine-red fleece coat, key grip Dave "Foots" Footman also styling in a bright red polo shirt, and Hooper himself wears a red button-down shirt (which he has already been wearing with some regularity during the shoot) beneath his black flight jacket.

Among the crew, competing emotions permeate the air: excitement, anxiousness, exhaustion, happiness, sadness, relief. This final day of shooting is dedicated primarily to tying up loose plot threads and closing loops in the film's narrative - a patchwork quilt of shots and scenes from virtually every stage of the screenplay.

Established in 1893, Monrovia High School rests in the foothills of the San Gabriel Mountains, its splendid campus a charming agglomeration of Neo-Spanish architecture and lush landscaping. The site of many motion picture and television productions throughout the years (notably nostalgic 1960s sitcom *Leave It to Beaver*, but most recently Hooper's frequent collaborator Robert Englund's 1988 film, *976-EVIL*), the school is nevertheless probably best remembered as the host of a 1946 congressional debate between incumbent Jerry Voorhis and his challenger, Richard Milhous Nixon, who would go on to be elected president of the United States in 1968 and 1972, before resigning in disgrace in 1974.

The shooting day begins at early evening, just as the sun sets behind the mountains to the west. Apparently unsatisfied with the footage shot weeks earlier, director of photography Levie Isaacks and his camera crew have assembled on a side street adjoining the school to reshoot the second shot in the script (Scene 2), in which the massive 18-wheeler with its trailer containing the ancient Aztec sarcophagus (the blood-red, evil-spirit-infested sacrificial cloak secreted within) mysteriously arrives at the college museum.

1st assistant cameraman Wayne Trimble has moved on to another project[79] and has been replaced for this last day of production by additional assistant cameraman Pete Berkson, a studious worker, an amiable fellow, and a welcome, if only temporary, addition to the crew.

Assistant director Tom Blank admonishes the crew members milling about, "Quiet, please, 'cause we're rolling sound!," the goal being to catch the live sound of the truck's rumbling engine and

[79]Director John Carl Buechler's tepid direct-to-video installment of the Ghoulies franchise, *Ghoulies Go to College,* which incidentally features actor Matthew Lillard in his film debut.

grinding gears on audio while the camera rolls. As the vehicle sits idling half a block away, Tom communicates with the driver via walkie-talkie. "All right, we're rolling!" he informs him, and the truck jerks forward, crossing the white lines in the center of the darkened city street and barreling directly for the camera, screeching to a halt mere inches from the lens. Hooper ganders through the viewfinder to check the final image and seems pleased with the result.

(The art department had fabricated a weathered sign reading "Tiverton College" and posted it on a pillar at the entrance to the campus, but, as it turns out, it is never seen in the shot.)

The sequence in which Amy barely escapes Mason's leering advances after their flight from the dance (Scene 51) was essentially completed two days earlier, but still remaining to be shot is Mädchen's extreme close-up as Amy comes to the frightening realization that the red dress has led her into the arms of her cousin's randy jock boyfriend. Interestingly, the shot does not appear on the day's call sheet.

Apparently miraculously reconstituted, the Bronco has been transported to the location and parked in the school parking lot. (This is the "beauty car," as opposed to the stunt vehicle that had been used during the car chase and rolled down the slope to explode.) Mädchen has stripped down to her revealing lingerie and climbed into the truck's back seat, joined by stand-in Mark San Filipo, wearing Mason's tuxedo shirt to double for the off-screen character in this very tight close-up of Amy's face as she expresses sudden bewilderment and fear.

Her key light is intensely bright, accentuating her porcelain skin. When the camera rolls (with Levie once again situated in the driver's seat), her big brown eyes open wide, darting around, trying to get her bearings, appalled and dismayed at the circumstance in which she finds herself. "Cut!," Hooper shouts, thoroughly satisfied with the take, effectively declaring the scene

"in the can" as wardrobe supervisor Julia Gombert comes running with a robe to brace Mädchen against the cold and to hide her nakedness.

Pink fliers are distributed among the cast and crew bearing the epithet, "NAME THE ONE-EYED BABY CONTEST," along with the image of an infant cyclops with a legend beneath reading, "In the past, babies with such deformities were killed." The flier invites anyone with the five-dollar entry fee to submit the name of their choice for a chance to be chosen from a list of finalists at the production's wrap party, further going on to say that the winner will be awarded "ONE HUNNERT BIG ONES!!," with additional prizes to be awarded at the producer's discretion.

The school's basketball courts are located next to the parking lot. Lacking a basketball, some members of the crew decide to pass the time attempting to jump for the rim of the hoop, with little success. Diminutive electrical technician Ellis James' effort is particularly weak, partly because "You're six inches shorter than the rest of us," as one participant wryly observes. When his turn comes, instead of making the leap himself, "Roo" grabs newbie electrician Rob Lewbel by the legs, lifts him up and carries him to the backboard, where he still manages to miss the hoop! Meanwhile, on the sidelines, stand-in Courtney Wulfe and hair stylist Nina Paskowitz flip through the cast and crew sketchbook, enjoying the contributions of their colleagues.

Also not listed on the call sheet but added to the schedule because of the previous night's struggle with time, Hooper and a contingent from the crew shoot the close-up inserts of Joey's hand retrieving his revolver and Wanda's theft of his stash from the Mustang's glove compartment. The Mustang also resides in the lot, with Wulfe taking the passenger seat to double Wanda's hands

while San Filipo, now wearing Joey's sharkskin jacket, occupies the driver's seat.

Pete, the replacement cameraman, operates the camera, which is placed on the console between the driver and passenger seats and stabilized with a sandbag. A branch from a nearby tree has been cut, clipped to a c-stand and lit from behind to create a moody, chiaroscuro effect. Hooper supervises from a perch above the convertible's back seat, thoughtfully stroking his graying beard, an unlit stogie in his hand and, as always, a can of Dr. Pepper well within reach. Barely audible, he whispers his instructions to the two stand-ins as the camera rolls, overseeing the filming of these inserts with the same intensity he reserves for any other shot.

The Monrovia High School library's[80] façade has a modernist design, with sliding glass double-doors, stone masonry walls, a broad, overhanging portico and a large, circular window allowing an expansive view into the large but otherwise unremarkable facility. Under the watchful gaze of producer John Philip Taylor, Hooper and Isaacks work out the logistics of the upcoming shot (Scene 97), in which Amy leaves the library and crosses the entryway, passing by as the camera dollies into a close-up on a newspaper dispenser containing the current edition of the fictitious Tiverton Union, with its provocative headline proclaiming, "Drug Dealer Brutally Murdered" (and a sub-headline that reads: "'Lady in Red' Hunted in Drug-Related Slayings"), an allusion to Wanda's savage late-night dispatch of her would-be assassin.

[80] Re-christened the "Frank Jansson Library" in 2018, honoring the beloved English teacher whose 43-year tenure at the school left a lasting impression on generations of students and colleagues and who had sadly passed away in 2003.

(The newspaper itself is a mock-up contrived by the art department, the "articles" consisting of repeating blocks of barely literate text, for example:

> "Many persons feel at this stage that some legal
> action is forthcoming but it now becomes common
> knowledge knowledge that there is pressure from
> the inside which will materially change the aspect
> of the case.")

Hooper envisions the shot as a smooth dolly move, first panning along with Amy as she exits the library and crosses the frame, then quickly rolling forward into a close-up of the newspaper in the dispenser. He has craft service person Tammy Landry double for Amy, demonstrating for the assembled crew what he'd like to see by framing the action with his hands and executing the move as if he *were* the camera.

The grips lay dolly track across the library's veranda and the camera crew rehearses the shot meticulously while Mädchen, back in Amy's brown blazer and jeans, watches from the perimeter, nursing a steaming cup of hot chocolate. Hooper, meanwhile, leans against the wall, sporting a broad grin and a twinkling eye, thoroughly enjoying himself.

"Shh!," assistant director Tom Blank hushes the set. Levie sits astride the dolly as assistant cameraman Bill Roberts slates the shot. "Settle . . . and, <u>ACTION!</u>" Hooper calls out. On cue, Mädchen walks through the library doors with her book bag in hand and strides across the entranceway as the camera pans with her. Once she crosses the frame, dolly grip "Foots" Footman swiftly pushes the rig down the tracks toward the vending machine, while new assistant cameraman Pete Berkson adjusts focus as the shot resolves into a sharp close-up on the newspaper's screaming headline. "Cut."

"Let's do one more, please," Levie requests. "Once again, please," Tom intones.

For the next take, Hooper suggests, in his halting manner, "Levie, when you, when you get down there, if it's good, uh, to, to yourself, uh, y'know, read the headlines and then leave enough time to read that little print down there, I mean, not that we'll ever see it but, 'The Lady in Red,' uh . . ."

Before rolling on the next take, Levie cautions the dolly grip, "Y'know, we got a little close to her too fast on that one . . ." "'Kay, so . . . make an adjustment," Footman acknowledges. This time, Roberts counts down their progress as the camera approaches its final mark," Ten, nine, eight, seven, six, five . . ."

Still not satisfied, Levie says quietly, "Let's go again." Tom: "All right, we'll go again."

Mädchen returns to her starting position inside the library, as do the extras playing students in the background. After the next take, while Levie doesn't seem entirely satisfied, together he and Hooper agree to "live with it" and move on.

In the meantime, the bulk of the crew have moved inside the library to prepare for the next scene on the docket, in which Amy, while studiously poring over the materials for her class project with Eddie, is spooked by the sudden abrupt appearance of the librarian, pointedly informing her that it is "closing time."

The library's interior is bland and functional, a nondescript school facility lit by the pale-yellow glow of buzzing overhead fluorescents. Patiently standing by in her frumpy sweater and skirt, bespectacled Felicia Lansbury, daughter of producer and co-screenwriter Bruce Lansbury, has returned to conclude her small role as the school librarian.

Hooper, Levie, and Tom Blank discuss their options regarding where to set the scene and where to place the camera for the upcoming shots featuring Amy and the librarian. Hooper wants a view of the stacks behind Amy and Levie is concerned about

lighting such a large area with limited means and relatively little time.

Seated at a study table, waiting for the crew to complete their preparations, Mädchen makes a remark that seems to sum up the day, "Doesn't it feel like the last day of school?"

"It does," Hooper agrees, "It does at that."

A handwritten sign taped onto the camera dolly by some prankster reads, "The LEVIE-VALDEZ," an irreverent reference to the recent catastrophe in which an Exxon oil tanker, the "Exxon Valdez," struck a reef off Alaska's Prince William Sound, spilling over 10 million gallons of oil into the sound over the course of just a few days, considered by many to be the worst such disaster in history.

Discussing the scene while sitting across the table from Mädchen, with Felicia eavesdropping nearby, Hooper explains the plan, referencing his handwritten notes, "*Studying*. Okay, so, so, so, Mädchen, so what we have to do is, uh, start wide-ish, uh, glide into this [framing the shot with his hands] . . .," speaking in fragments, as he often does.

Keenly aware of the minutes ticking away, Levie furtively checks his watch and interjects, "Uh-huh, she gonna be here?" Nodding, Hooper continues, "Uh, we'll . . . we'll cheat her somewhere so there'll be, y'know, literally the stacks in the background . . . okay, and she's working with *The Psychology of Animism* . . . all right, at which point we move into a close-up of her, and she, she's looking at the book. She closes it and finds amongst her papers this Rolodex card [which Amy had appropriated from the coroner's office] . . . and then, uh, we'll play a light gag over her face [the librarian's shadow crossing Amy's face, startling her] . . ." then his voice trails off, descending to inaudible levels (appropriately enough, considering the surroundings).

Lounging on the dolly, Levie points out how appropriate the

section headers in the background of the shot are to the themes of the film, "How about this? We're in, uh, Non-Fiction, Metaphysical, Parapsychology, <u>Psychology</u>, *Christian* . . . [then, with a chuckle] <u>Other</u>." As he recites, the ceiling lights flicker a bit, prompting lighting technician Ellis James to react, "Hey, hey, <u>hey</u> . . . look what happens when you start readin' those things! <u>The light</u>! Jesus Christ!"

Scene 96: Amy has Professor Wilson's huge tome *The Psychology of Animism* (a prop created by the art department) open on the desk in front of her. She studies it intently, taking copious notes, until the librarian's shadow crosses her face, causing her to look up, startled.

Consisting of two reasonably simple shots (Amy sitting at the table studying her materials as the camera dollies in close, and a reverse close-up of the librarian entering the frame and tapping her watch as she approaches Amy, indicating that it's time for her to leave) and an insert (Amy's point-of-view reading Wanda's address from the Rolodex card she'd pilfered from the coroner's office), Hooper stages the sequence with his usual economy. After checking Mädchen's close-up through the camera's viewfinder, he briefs the two young women on the particulars of the shot, giving special attention to Felicia's position relative to the camera and the lights. Sprawled across the tabletop in front of her, Hooper provides Mädchen with a few bits of business to include, e.g., rifling through the professor's book, chewing on her pencil's eraser, examining the Rolodex card intently, etc.

"Okay, watching, please," Tom announces, further asking Hooper, "Uh, does that put you in 'rehearse' or 'shoot' mode?" "Uh, <u>one</u> rehearsal," comes his answer. Running through the shot for timing and performance, the dolly rolls quietly and smoothly over the library's carpeted floor into a close-up of Amy caught up in her studies, when the librarian stealthily steps into the light, occluding Amy's features with her long, dark shadow. She speaks

her line, then backs away like some ghostly apparition as Amy gathers up her belongings to leave.

"Okay, let's shoot one," Hooper urges, eager to keep the momentum going.

Between takes, while Felicia stands by patiently awaiting her cue, Hooper advises Mädchen not to "jump" when the librarian sneaks up on her. "Let's . . . I tell ya', don't, don't jump, 'cause deeper into this scene, you jump, uh, you jump a coupla' times . . . with, well, when she comes down and scares ya' [while later walking alone across the darkened campus to her car] . . . so just make it . . . kind of *subtle* . . ." "Okay," she says, nodding in assent. Turning to script supervisor Sandy Mazzola, he tells her, "Put that one on hold. Up, uh, the top of the take, the studying was good . . ."

While much time is expended in preparation and rehearsal for these shots, once they are situated and ready to roll, they manage to complete the scene efficiently and with few hiccups.

Alas, this constitutes Mädchen's final bit of acting on the film. Not really one for public displays of emotion, she offers a few fond farewells and then discreetly slips away.[81]

[81]Mädchen Amick's sterling career trajectory continues to this day. After *I'm Dangerous Tonight*, she revisited her role of Shelly Johnson (née Briggs) in David Lynch's 1992 feature film follow-up to his groundbreaking television series, *Twin Peaks: Fire Walk with Me*, starred in Mick Garris' sly and horrific tale of feline incest (based on an original screenplay by horror maven Stephen King) *Sleepwalkers* (1992), co-starred alongside James Spader in director Nicholas Kazan's (son of controversial filmmaker Elia Kazan) steamy romantic thriller *Dream Lover (1993)*, portraying a mysterious seductress who upends her new husband's life, and also appeared as a regular in multiple television series, including *Californication* (with David Duchovny as a writer struggling with

It's time to move back outdoors to the library's exterior for some good ol' blood-spatterin' fun. The art department has constructed from plywood a freestanding inverted L-shaped unit to serve as the wall and partial ceiling of the Wilson home for the planned inserts (Scene 25B) of Mrs. Wilson's bloody murder, specifically the shadow of the axe as it descends upon her and spatters the wall with crimson droplets. The camera is placed low and angled upwards to catch the wall and a portion of the ceiling in the frame.

Standing in as Professor Wilson, co-producer Bruce Lansbury wields the battle axe, dipping its blade into a viscous pool of blood swirling in a plastic trashcan lid held aloft by propman Ray Anthony. Wearing Wilson's beige corduroy jacket, Lansbury bears more than a passing resemblance to the graying countenance of William Berger, who assayed the role in the early days of filming. As the camera rolls, he swings the axe slowly forward, dipping the blade into the pool of fake blood (Karo corn syrup with a dash of red food coloring) before withdrawing it sharply and repeating the process with increasing speed, at Hooper's instruction.

"That good, Levie?" Hooper inquires as Isaacks watches through the viewfinder. "Yeah," he responds, "Havin' a *ball!*," inspiring guffaws from the crew encircling the sarcophagus.

sex addiction), *Damages* (featuring Glenn Close and Rose Byrne as ethically challenged high-powered attorneys), *Riverdale* (a dark, modern update of the popular *Archie* comic book series), and returning once again to her *Twin Peaks* role in the series' brilliant, confounding third season on Showtime in 2017. Privileged to have been contracted to direct several episodes of *Riverdale*, she has recently made her feature film directorial debut with *Reminisce,* a 2021 drama of lost identity featuring Julia Ormond and acclaimed actor and counter-culture icon Bruce Dern.

"That good, Levie?" Hooper inquires as Isaacks watches through the viewfinder. "Yeah," he responds, "Havin' a *ball!*," inspiring guffaws from the crew encircling the sarcophagus.

Failing to get the desired result, at Hooper's behest wardrobe supervisor Julia Gombert steps in to assist. Sidling up beside Anthony, she scoops her hand into the blood, flinging it at the wallas Lansbury lowers the axe. "One more, FOOM! As soon as he comes down with it, Julia, do it," Hooper encourages her, "As soon as it touches down, go!"

"I saw your hand," Levie advises Julia, also imploring Lansbury to "Turn that blade, turn that blade!," hoping to catch a bright glint of light refracting off the axe's sharp edge. They continue until the wall unit resembles nothing so much as a cheap knock-off of a Jackson Pollock painting. "Okay, all right. That's good," Hooper crows, seemingly satisfied, "We got something. We've got enough." Then, surveying the carnage, "Good God."

Levie concurs, "Good God, we've got blood, *blood everywhere.*"

Minus the lid, the base of the Aztec sarcophagus has been transported to the site and raised on blocks in the space under the library's threshold. Special makeup effects artist Steve Neill's creepily accurate sculpture of the Aztec mummy, bearing a frozen, shrieking visage locked in an eternal scream, has also been brought to the set and placed lovingly inside the sacrificial altar, wrapped in the scarlet cloak and dressed with Fuller's earth (a crumbly clay material) and autumn leaves. These last few shots on the schedule comprise flashback inserts of the interior of the sarcophagus as Professor Wilson, having removed the cloak and draped it over his own shoulders, murders the unfortunate, oblivious security guard, spattering the mummy with his blood (Scene 25A).

Always a hands-on filmmaker, Hooper cannot resist the urge to adjust the placement of the mummy's papery hands folded across

its sunken chest. A moment later, however, when Levie rechecks the viewfinder, he notices a difference, asking loudly, "Did we change the hands?"

Caught, Hooper mumbles, "I don't know, maybe," while mock-surreptitiously returning them to their original position.

A plywood plank is placed across the top of the sarcophagus to accommodate the camera (and the camera operator) for this next set of extreme close-ups on the mummified cadaver, the lens hovering mere inches from the shrunken eyes and hollow cheeks of the withered, desiccated corpse.

Contributing to the giddy, late-night party atmosphere, Hooper jokes about the mummy, "He's staring Billy [William Berger] down."

"Gotta do somethin', the poor bastard," Levie joins in, "He looks too good! He's got too many teeth!" Hooper agrees, "He's got all his teeth!"

Referring to the mummy's fancy duds (the sacrificial cloak), with a wink and a sly grin, "He's *dressed*," says Levie.[82]

[82] Now happily retired, cinematographer Levie Isaacks enjoyed a long and varied career in Hollywood, following up *I'm Dangerous Tonight* with 1991's *The Guyver*, Steve Wang and Screaming Mad George's film adaptation of Takaya Yoshiki's popular manga, *Texas Chainsaw Massacre: The Next Generation* (1994), Kim Henkel's (Hooper's co-writer on the original) fourth installment in the franchise, was lighting cameraman (alternating with colleague Bill Weaver) for the 1994-1995 season of *Tales from the Crypt* (including Hooper's episode *Dead Wait*), and not only served as director of photography on subversive situation comedy *Malcolm in the Middle* (2001-2004), but also directed multiple episodes. In 2020, Isaacks made his feature film directorial debut with indie release *Glenn's Gotta Go*, a gay coming-of-age story set in the American Southwest, starring veteran comic actor and alumnus of

"Immediately after this, let's leave that camera there and I'll get that cloak [out of there] . . . now let me sneak in there and throw some blood on it," Hooper says, navigating through the forest of light stands, bounce boards, and flags surrounding the sarcophagus. Dipping his hands into the cistern of stage blood that photographer Eric Lasher holds at his disposal, he deftly flicks rivulets of Karo syrup across the ancient mummy's contorted face.

Once they've cut, as Hooper stands there with crimson goo dripping from his fingers, Lansbury playfully suggests, "Let's get some pictures of Tobe like that . . ."

"Aw, no, no, we wouldn't want to do that," Hooper chortles, already in retreat, "*Blood all over my hands.*"[83]

Which is perhaps a fitting coda to this dark fable of lust, betrayal, and murder.

wacky 1960s variety show *Rowan and Martin's Laugh-In*, Ruth Buzzi. His resume contains countless other film and television projects, too numerous to mention. He is that rarest of things, a true gentleman.

[83]Tobe Hooper passed away peacefully in his home on August 26, 2017, at the age of 74, leaving behind a legacy of dozens of distinctive feature films and television projects, and a legion of devoted (sometimes obsessive) fans, assuring him an unchallenged place in the history of cinema. He is much missed.

AFTERWORD

ALL DOLLED UP AND NO PLACE TO GO

Principal photography on Tobe Hooper's *I'm Dangerous Tonight* took place from April 23rd, 1990, to May 17th, 1990, airing originally on the fledgling USA TV Network on August 8th, 1990, and later re-aired as part of the network's *Up All Night* series on July 3rd, 1993. At the time, it barely registered as a blip on the cultural radar, and has since been essentially ignored, forgotten, or dismissed, but for a small contingent of rabid Hooper fans. It would, however, be wrong to say that the film received a chilly reception. In fact, in some cases it was quite warmly reviewed. However, critics' insistence on comparing each new Hooper project to his justifiably lauded *The Texas Chain Saw Massacre* ensured that *I'm Dangerous Tonight* would suffer by comparison, which is hardly fair to a film to which it bears no relation - a charming thriller rather than a brain-searing experience in terror.

Hooper's television work is often given short shrift, especially considering the phenomenal success of his initial effort, the celebrated 1979 mini-series adaptation of Stephen King's novel *Salem's Lot*. Following *I'm Dangerous Tonight*, Hooper's ventures into TV include a memorable episode of *Tales from the Crypt* entitled *Dead Wait* (1991) featuring versatile actress, comedian, and horror fan Whoopi Goldberg, cable film The *Apartment Complex* (1999*)*, a comedy/thriller starring Rob Lowe's younger brother Chad as a naïve psychology undergrad swept up in a labyrinthine murder mystery, the pilot (and second

episode) of cult series *Nowhere Man* (1995), starring Bruce Greenwood as an arrogant anthropological photographer whose life is pulled out from under him by a shadowy conspiracy, pilot episodes of extraterrestrial series *Dark Skies* (1996) and *Taken* (2002), as well as a multitude of others.

A complete and detailed examination of Hooper's career in television is long overdue and would be a welcome addition to the growing appreciation of his unique, idiosyncratic cinema. Scout Tafoya's book *Cinemaphagy: On the Psychedelic Classical Form of Tobe Hooper* goes a long way towards realizing that goal, with its focus on the breadth of Hooper's catalogue and the inclusion of even his most obscure television projects (including an exhaustive chapter on *I'm Dangerous Tonight*) as worthy of critical study, and belongs on the shelf of every Hooper fan's library.

Of *I'm Dangerous Tonight*, Tafoya writes incisively:

This is a film with a terrifyingly accurate depiction of male power dynamics. It would seem outlandish, thanks to Hooper's usually excessive style, but it all registers as truthful . . . [it] doesn't cloak its intentions in metaphor; it's all right out in the open, as bold as the red dress. And what the terrified and frustrated men don't like is that for once "their" women think twice about giving in to every man's desire.

Another recent publication dedicated to Hooper's impact on the cinematic horror genre is *American Twilight: The Cinema of Tobe Hooper*, an academic compendium of essays edited by Kristopher Woofter and Will Dodson and released by The University of Texas Press. From educator John Paul Taylor's astute contribution, *The Past Infects the Present: Abjection and Identity in Tobe Hooper's 1990s TV and Video Productions*, regarding *I'm Dangerous Tonight*'s themes of lust and brutality:

The suspense in the film is driven by the movement of the "cursed" fabric from person to person, first as a ceremonial cloak and later as a revealing red dress that produces sexual desire in the men who lay eyes on its wearer. The artifact thus represents how violent and twisted pasts may linger in and infiltrate the present, and also present a dangerous allure.

For decades, *I'm Dangerous Tonight* had not been available in North America in any format, although VHS copies and European DVDs could be acquired online. However, that situation has finally been rectified by the recent Blu-ray release of a beautifully remastered print of the film by Kino Lorber, a distributor of vintage and iconoclastic films. (Not incidentally, the disc also features behind-the-scenes footage shot by the author and photographer Eric Lasher and edited by blogger and filmmaker Julius Banzon.)

John Philip Taylor and Bruce Lansbury's script (very loosely based on the novelette by Cornell Woolrich), embellished by Hooper's keen eye for composition, trademark restless camera, and unique sensibility, along with the contributions of dozens of technicians and artisans, makes *I'm Dangerous Tonight* an unquestionably worthy entry into Hooper's eclectic filmography[84] and just good, solid entertainment.

<div style="text-align: right;">Stan Giesea, July 2022</div>

[84]Oddly enough, the film inspired <u>two</u> episodes of joint British/Canadian horror anthology television series *The Hunger*, the first of which (<u>also</u> entitled *I'm Dangerous Tonight*), directed by Russell Mulcahy *(Highlander, Razorback)* and starring Terence Stamp and Esai Morales, features a storyline that hews more closely to Woolrich's original story than Hooper's film. That

episode was followed up by a sequel of sorts (entitled *I'm Very Dangerous Tonight*), telling the tale of a neglected housewife acquiring the accursed red garment, but other than that bearing very little resemblance to the source material. The episodes aired on Syfy (formerly the Sci-Fi Channel) in September of 1997 and January of 2000, respectively.

APPENDIX 1

I'M DANGEROUS TONIGHT CREDITS

Director - TOBE HOOPER
Based on the short story by - CORNELL WOOLRICH

Teleplay by - BRUCE LANSBURY
PHILIP JOHN TAYLOR

Producer - BRUCE LANSBURY
Executive producer - BORIS MALDEN
Producer - PHILIP JOHN TAYLOR
Co-executive producer - MICHAEL WEISBARTH

CAST

Amy - MÄDCHEN AMICK
Eddie - COREY PARKER
Gloria - DAISY HALL
Aickman - R. LEE ERMEY
Gram - NATALIE SCHAFER
Mason - JASON BROOKS
Jonas Wilson - WILLIAM BERGER
Martha - MARY FRANN
Wanda Thatcher - DEE WALLACE-STONE
Buchanan - ANTHONY PERKINS
Coroner - LEW HORN
Victor - STUART FRATKIN
Frank - DAN LEEGANT
Landlord - JACK McGEE
Joey - EDWARD TROTTA

Matt - DAVID CARLILE
Librarian - FELICIA LANSBURY
Anchorman - HENRY C. BROWN
Server - ELLEN GERSTEIN
Romeo - IVAN GUERON
Enrique - JUAN GARCIA
City Worker - FRANK DiELSI
Parademic - RICHARD PENN
Tybalt - XAVIER BARQUET
Punk #1 - BILL MADDEN
Punk #2 - MATTHEW WALKER
Janitor - ROBERT H. HARVEY

CREW

Director of photography - LEVIE ISAACKS

Composer - NICHOLAS PIKE

Film editor - CARL KRESS
First assistant editor - MICHAEL PHILIP

Production designer - LEONARD A. MAZZOLA
Costume designer - CARIN BERGER
Makeup artist - EMILY KATZ
Hair stylist - NINA PASKOWITZ

Production manager - JOSEPH BELLOTTA
First assistant director - THOMAS L. BLANK
Second assistant director - KERI L. McINTYRE

Property master - CHALO GONZÁLEZ
Assistant art director - JOHN KERSEY

Sound mixer - CRAIG FELBERG
Boom operator - CAMERON HAMZA

Stunt coordinator - JOHN MOIO
Stunts - KERRIE CULLEN
PHIL CULOTTA
DEBBIE EVANS
BILL MADDEN
PAULA MOODY
PHIL ROMANO
CRIS PALOMINO

Gaffer - ROBERT W. MORENO
First asst. cameraman - WAYNE TRIMBLE
Second asst. cameraman - BILL H. ROBERTS JR.

Key grip - MICHAEL L. COLWELL
Dolly grip - DAVE "FOOTS" FOOTMAN

Script supervisor - SANDY MAZZOLA
Still photographer - ERIC H. LASHER
Videographer - STAN GIESEA

Special effects provided by - SPECIAL EFFECTS UNLTD.
Special effects coordinator - JOSEPH MERCURIO
Special effects - VINCENT MONTEFUSCO
TOM FICKE
CHARLES BELLARDINELLI

Supervising sound editor - DAVID JOHN WEST M.P.S.E.
Supervising music editor - ALAN ROSEN
ADR supervisor - LYNN R. SCHNEIDER
Foley artist - MIKE DICKESON

Re-recording sound mixers - DAVID JOHN WEST
JOHN MACK
RAY WEST
Post production sound - WEST PRODUCTIONS, INC.

Casting - ROBIN LIPPIN C.S.A.
Casting associate - DAN BERNSTEIN
Casting assistant - GARY A. GIBSON

Location manager - RALPH B. MEYER
Asst. location manager - LENNY NEIMARK

Set medic - BUNDY CHANOCK
Dog trainer - STEVEN RITT
Production coordinator - ANNIE SAUNDERS

Color by DELUXE

Filmed with PANAVISION lenses and cameras

APPENDIX 2

CROODOODLES

During the course of principal photography on *I'm Dangerous Tonight*, a sketchbook was passed around to the cast and crew to express their creativity. Here are a few select examples of their eccentric contributions.

Author Stan Giesea's vibrant color sketch of the malevolent sacrificial cloak springing to life.

Actor Stuart Fratkin's childlike rendition of his character, student director Victor Morrison.

Costumer Julia Gombert's impression of the evil red cloak as a fashionable shoulder wrap, entitled "The Godess & The Cloak."

Actor Dan Leegant's itchy, bloody self-portrait as Frank the security guard, who is horrifically murdered by Professor Jonas Wilson while under the influence of the red sacrificial cloak.

The author's quick caricature of Anthony Perkins as Buchanan.

Still photographer Eric Lasher's sketchy drawing of the production sound cart.

Still photographer Eric Lasher's pointillist reproduction of the carvings on the sarcophagus.

Actress Daisy Hall's lovely watercolor landscape of the hills and the blue night sky overlooking the city of Monrovia and the Saw-Dam (inscribed with a lovely, enigmatic poem).

Author Stan Giesea's quick pencil sketch of the cadaverous Aztec mummy.

2nd assistant director Keri McIntyre contributed this whimsical drawing of an emerald green snake.

Actress Mädchen Amick's minimalist self-portrait as Amy O'Neill in the sexy red cocktail dress, complete with rosettes at the hip.

Director Tobe Hooper's signature cigar and Dr. Pepper, drawn by still still photographer Eric Lasher.

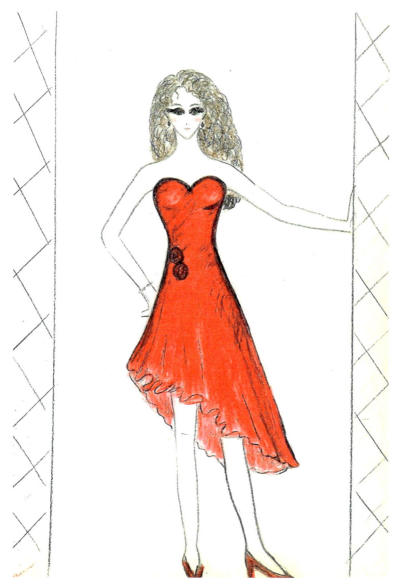

Costume designer Carin Hooper's sketch of Amy's haughty entrance to the dance, resplendent in the stunning party dress made from the fabric of the enchanted red cloak.

SPECIAL THANKS

The author would like to extend his heartfelt gratitude to Julius Banzon, Tony Hooper, Dee Wallace, Will Dodson and Kristopher Woofter for their unwavering support, Scout Tafoya, John Cribbs and C.A. Funderburg of the *Pink Smoke Podcast,* as well as the entire cast and crew of *I'm Dangerous Tonight.*

NAME THE ONE EYED BABY CONTEST

As you may or may not be aware, the One Eyed Baby has been selected as our production mascot, but as you may or may not know, the O.E.B. has no name!!! (Or Gender)

You have been randomly choosen to enter the Name the One Eyed Baby Contest. For a mere $5.00, you can enter the name of your choice into the raffle.

The winner will be choosen from a list of finalists at the I'M DANGEROUS TONIGHT Wrap Party. GRAND PRIZE WILL BE ONE HUNNERT BIG ONES!! (Or one hundred one eyed babies, your choice) with additional prizes awarded at producer's discretion.

So don't miss out on this chance to have fun and win a prize!!

Send your $5.00 back with this entry form to Annie at the Production Office.

● IN THE past, babies with such deformities were killed

one-eyed baby

your entry_____

your name_____

Made in United States
Troutdale, OR
08/25/2024

22299990R00140